John Baldessari

Jonathan Borofsky

Richard Diebenkorn

Mark di Suvero

Jasper Johns

Ellsworth Kelly

Edward Kienholz

Nancy Reddi

Roy Lichtenst

Malcolm Mor

Claes Oldenb

Ken Price

Robert Rausc

Richard Serra

Saul Steinber

Artists
at Gemini G.E.L.

Celebrating the 25th Year

Mark Rosenthal

Introduction by Michael Botwinick
Photographs of the artists by Sidney B. Felsen

Harry N. Abrams, Inc., Publishers • Gemini G.E.L.

Project Director: Margaret L. Kaplan
Editors: Douglas Gordon and Sherry Babbitt
Designer: Nathan Garland

This publication was prepared in conjunction with the exhibition
Both Art and Life: Gemini G.E.L. at 25, at the Newport Harbor Art Museum,
Newport Beach, California, September 22–November 29, 1992

Library of Congress Cataloging-in-Publication Data
Rosenthal, Mark (Mark Lawrence)
 Artists at Gemini G.E.L.: celebrating the 25th year / Mark
Rosenthal.
 p. cm.
 ISBN 0–8109–1933–8
 1. Gemini G.E.L. 2. Prints, American—California—Los Angeles.
 3. Prints—20th century—California—Los Angeles. 4. Printmakers—
 United States—Interviews. I. Gemini G.E.L. II. Title.
 NE538.L67R67 1993 92–43357
 769.9794'94—dc20 CIP
ISBN 0–8109–2559–1 (pbk.)

Published in 1993 by Harry N. Abrams, Incorporated, New York,
a Times Mirror Company, in association with Gemini G.E.L., Los Angeles

Printed and bound in Japan

Contents

Preface

"Painting relates to both art and life," Robert Rauschenberg has said, and he operates in the "gap between the two." It seems appropriate to call upon and modify this well-known quotation to characterize the atmosphere of Gemini G.E.L. (Graphic Editions Limited). At Gemini, *both* art and life provide joint stimuli in the daily routine. Not only have significant prints and edition sculptures been produced at this Los Angeles institution, but an inherent spirit of freedom and antic creativity fuels its motor.

When Sidney Felsen, co-owner of Gemini, asked me to guide a book project to help celebrate the workshop's silver anniversary, I was motivated by two factors. First, an outstanding history of Gemini had already been written by Ruth Fine (*Gemini G.E.L.: Art and Collaboration*, Washington, D.C.: National Gallery of Art, 1984), and second, an unusual approach seemed fitting to the exhilarating atmosphere of the place. We arrived at a book concept that would not only reflect Gemini's spirit but also, we hoped, contribute to the field of contemporary art studies. We placed the emphasis on the artists themselves—on their works, ideas, and visible presence.

Beginning in 1990, artists were asked to create works in celebration of Gemini's anniversary; the prints and edition sculptures reproduced here span the period from 1990 to 1992. Taking these as a point of departure, I conducted interviews of varying lengths with the artists; often we moved beyond discussion of the illustrated objects to more general matters concerned with their art. As for the physical presence of the artists, we have included some of the wonderfully candid photographs that Sidney Felsen has taken over the years at Gemini and at the nearby La Paloma workshop of Ron McPherson, who collaborates on many Gemini projects. The Checklist at the end of the book provides a complete list of all the objects issued by Gemini during the anniversary celebration period.

This project has brought pleasure to me in various ways. It permitted me to collaborate with my friends Sidney Felsen and Stanley Grinstein, who, along with Rosamund Felsen, own the Gemini workshop. I have long admired their enterprise and their generous spirits. Having the opportunity to spend considerable time with a virtual who's who of the American art scene has been an enormously rewarding experience as well, for I have learned a great deal about the work and ideas of these artists. I am grateful to them for their patience in answering my questions.

A project of this scale requires the help of many people. I am deeply indebted to Nathan Garland for his sensitive book design; to Margaret Kaplan of Harry N. Abrams, Inc., for her thoughtful contributions to the book's development; to Douglas Gordon for his skillful production assistance; and to George Marcus and Sherry Babbitt for editing suggestions. Among the many helpful people connected with Gemini, I am especially grateful to Nancy Ervin, Suzanne Felsen, and Jane Goldfarb for general assistance; to Ron McPherson and Jim Reid for technical information; and to Elyse Grinstein and Joni Weyl for all-around help and good cheer.

From the book came the idea that an exhibition ought to occur, and Michael Botwinick, Director of the Newport Harbor Art Museum, jumped into the project with characteristic enthusiasm and energy. We are grateful for his help and for the fine introduction he contributed to this volume. Following its showing at Newport Harbor, the exhibition has been circulated throughout the United States under the capable administration of Graham Howe, Gwen Hill, and Curatorial Assistance, Inc.

M.R.

Introduction

Michael Botwinick

In February 1966 Sidney Felsen, Stanley Grinstein, and Ken Tyler opened Gemini G.E.L. (Graphic Editions Limited).[1] It was built on the preceding "contract shop," Gemini Ltd. A contract shop is a facility that makes prints for others on a contract basis. The role Gemini G.E.L. aspired to and quickly filled, however, was that of publisher/atelier. A publisher in the art world develops a point of view, an aesthetic bent. It provides a total support system for the artist to realize a work; it helps the artist develop the concept, assists in solving the problems of execution, supports the work financially, and sees to the distribution after the work has been created. The atelier or workshop part of the Gemini equation represented a commitment to develop, in-house, the skills necessary to actually produce the work rather than job it out to a contract shop. To this end, Gemini assembled a staff of printers, curators, and others who would collaborate with the artist to create the edition. The effect of combining these two functions, publisher and atelier, was a seamless web of support from artistic idea to distribution. The grace of this total support system flows from the commitment of the Gemini partners and is in no small measure the key to their success.

To appreciate Gemini's role in its entirety requires some historical context. Printmaking has its roots, in part, in the ateliers of the Middle Ages. While the purpose of these workshops was largely ecclesiastical or royal, their rationale was to make "copies" of manuscripts in a collaborative manner. The collaboration achieved a number of ends. It introduced a form of specialization in which various tasks — lettering, historiated or illustrated initials, backgrounds to illuminations, major figures, gold leaf — were each pursued in sequence, the monastic analogy to the assembly line. Another purpose was to create something that was, by virtue of its multiplicity, accessible. This is not to be understood in the sense of wide public accessibility, a concept not useful in the social context of the Middle Ages. But the development of texts that could be distributed throughout a monastic order, that consistently reflected the practices of that order, was a result of the ability to produce "editions" of a text in a fairly efficient manner.

Many manuscripts of that time were copied without illustrations. However, because grandly illuminated manuscripts have survived in large numbers, our impression of that time links the word and the image. By the fourteenth century the handmade illuminated manuscript had a companion in the printed block book, a woodblock in which the words and the image were carved on a single block. A similar rich history developed in the East. In the West the invention of movable type ultimately broke that bond between word and image, freeing the word to grow explosively as the conveyor of knowledge up through the middle of the twentieth century. The multiple image went off on its own. Freed from its craft and manuscript origins, it attracted the sensibilities of painters throughout Europe in the centuries following the Renaissance.

What captures our imagination, as we look at the prints of Dürer or Rembrandt, are the rich possibilities of the medium. The expressive qualities of printmaking are immediate and compelling. We see clearly the interaction of carved wood, or etched or engraved metal, with paper and ink. The physical sensation of both the resistance and embrace of materials lies close to the surface of the experience. This proved to be a powerful medium, its impact greatly amplified by its essential reproductive nature. However, the artists of the fifteenth through seventeenth centuries based their work more on the qualities of the medium itself than on its possibilities for producing multiple copies.

The eighteenth and nineteenth centuries offer many examples of artists who extended this expressive tradition. But the high point of the late nineteenth century, seen in the works of artists such as Toulouse-Lautrec, may very well carry, in its com-

mercial base, the seeds of the decline of appreciation of printmaking well into the twentieth century. While the range of exceptions, from Picasso to Chagall, is notable, the commercial applications of printmaking strongly affected the acceptance of prints as fine art. The chromolithograph evolved into a means to popularize famous paintings; the photolithograph became a key technique in the explosion of visually interesting advertising. And while there was no shortage of artists working in prints in the 1920s, 1930s, and 1940s, it is the message-laden side of the medium — as advertising, as WPA project, or as World War II propaganda — that dominates our perception of printmaking in that period.

In his introductory essay for *Gemini G.E.L.: Art and Collaboration*, Bruce Davis identifies the emergence of a new spirit among a group of young artists of the sixties who embrace the idea of collaborative editions.[2] Aesthetically, they may be understood as running contrary to the prevailing hegemony of Abstract Expressionism. The elements of figuration and design that inform their work very soon found an enthusiastic response in curators and collectors. What they initially lacked was a mechanism through which they could satisfy this appetite. They found at Gemini G.E.L. an environment and sensibility ideally suited for the kind of long-term collaborations that interested them.

From the beginning, Gemini allowed artists to explore and expand the traditional limits of editioned work. The workshop's artistic integrity and technical expertise — the atelier side of the enterprise — made it difficult for critics to dismiss the work as unrealized or uninteresting. At the same time, Gemini's sense of the "real world" and its savvy as a publisher ensured that the artists' creations would not be marginalized as superficial or commercial.

It cannot have been a hindrance that Los Angeles was an emotionally and climatically gentle environment in those beginning days.[3] The founding partners, Grinstein, Felsen, and Tyler, together with their wives (all of whom played an active role in the early history of Gemini), had the chemistry and skills to provide both nurture and expertise. They created a workshop with a corporate memory that encouraged artists to return again and again to ideas and solutions that interested them. That early workshop served as a magnet for the newly developing cadre of master printers who were being trained in the other important early centers, Tatyana Grosman's Universal Limited Art Editions (ULAE) in the East and June Wayne's Tamarind Lithography Workshop in the West. Gemini G.E.L. kept this essential nature even as its structure changed. As Tyler went on to found Tyler Graphics and Felsen emerged to handle day-to-day activities, with Grinstein dealing more with outside projects and issues, the core attraction of Gemini remained. It was a place where almost anything would be attempted.

Gemini stands in an awkward half-world as both publisher and workshop. The publisher needs to be profitable at all costs; the workshop needs to solve the artists' problems regardless of cost. But the personalities of the principals, as well as the expertise and genuine dedication of the staff, have turned this inherent conflict into a virtue. There is everywhere in Gemini a sense of possibility. From the beginning, special projects have been taken on, new skills have been developed, new forms of fabrication have been introduced. Claes Oldenburg's *Profile Airflow* (page 113) is an early example. This work, a polyurethane relief over a two-color lithograph, forced Gemini to move beyond the piece of paper as art object. This open-ended sensibility has made Gemini perhaps the most inventive contributor to the expansion of our notion of what constitutes a print. Since *Profile Airflow*, Gemini has ventured into many forms of editioned objects. Each successive editioning challenge — whether Edward Kienholz's cinder-block televisions, Jonathan Borofsky's figures in aluminum, Robert Graham's porcelains, or Isamu Noguchi's galvanized steel creations — has contributed to the artistic dialogue and pushed the boundaries outward.

Perhaps what makes the artistic experimentation work so well is the counter-weight of Gemini's role as publisher. The sense that anything is possible is always balanced, made serious, by the fact that Gemini can and will send this work out into the world. This seriousness is part of what has engaged the artists so fully. Gemini is demonstrably capable of realizing their work successfully. They are not engaged in mere coffeehouse intellectualizing.

The twenty-fifth anniversary celebration has brought forth a flood of new work. As we have come to expect, it reflects the diverse interests of Gemini. It is a satisfying capsule of what has remained attractive and strong about the collaborations on Melrose Avenue. While Felsen and Grinstein's invitation to the artists was undefined —along the lines of "Why don't you do something for the twenty-fifth?"— some of the best results have a quality that epitomizes the artists' work over the last quarter century. John Baldessari, Jonathan Borofsky, Richard Diebenkorn, Mark di Suvero, Jasper Johns, Ellsworth Kelly, Edward and Nancy Reddin Kienholz, Roy Lichtenstein, Malcolm Morley, Claes Oldenburg, Ken Price, Robert Rauschenberg, Richard Serra, and Saul Steinberg all responded. In some cases the artists return to familiar ideas or images; in other cases their work is yet another attempt to push Gemini and themselves a little further out. Among all these works there is an effervescent, celebratory mood, and it gives some of them a special presence. There is neither the space nor the need to comment on all the artists who contributed; their work stands on its own. But the following paragraphs offer some of my strongest impressions of the new work.

Roy Lichtenstein's prints of room interiors fit comfortably within his visual iconography as we have come to know it. But we are surprised when the image of a room's corner is realized on such a scale (over 8 feet high and 12 feet wide) that it becomes, in fact, the wall of a room (*Wallpaper with Blue Floor Interior*, page 93). Using his particular interpretation of the patterned effect of the commercial printing process, Lichtenstein takes the work up to a scale that undercuts all our notions about art as object. In the other works of this group his control of the fields, color, and pattern is masterful as he creates a compelling sense of dimension. The most satisfying of the group, *La Sortie* (page 107), not only exhibits a convincing dimensionality, contrary to the expectations produced by the flattening effect of the visual vocabulary, but also creates a psychological space with the evidence of the departing leg to the right. The gesture makes the image a room that someone has just left, producing in the viewer an unresolved sense that something has happened.

Robert Rauschenberg's contributions to the anniversary carry his work forward on more than one track. With *Borealis Shares I* and *II* (pages 154–155) he has demonstrated, once again, his importance to the history of Gemini. These screenprinted brass chairs are fully rooted in printmaking, but they challenge all the conventions of what a print should be, how it should be used and seen, and how it is to be understood. This is the protean Rauschenberg, tapping into the artistic tradition of furniture and using the methodology of the print, to create objects whose presence oscillates between the regalness of the throne and the intimacy of the double hammock.

While *Murmurs* and *Hollywood Sphinx* are vintage Rauschenberg, *Blue Line Swinger* (page 151) dramatically de-layers the expected overlapping imagery into a clearly serial image. Reading from right to left, we find a rhythm, visual in the movement of the swing, iconographic in the sequence from locked fence to palm to chair pad, that we would have missed had the images been layered as we have come to expect.

Jonathan Borofsky returns to themes that he has pursued at Gemini for some time. His image of a man holding a briefcase made its Gemini debut in the 1982 aluminum cutout *Man with a Briefcase*. For the twenty-fifth anniversary, Borofsky returns

to his Everyman with a suite of woodcut/collages that explore space and line. They begin with a version (page 36) that captures the voided quality of the 1982 piece with the negative-space image. The series then goes on, using collaged paper of a heavier weight, to create a strong thrusting presence. In the third of the series the direction of the cut of the collaged paper is forward, reinforcing the line created by the cut, and in the fourth the grained and textured background is brought into a more comfortable balance with a more restrained black figure. It is significant to note the support Borofsky has been given in revisiting this image over the course of a decade. It is a hallmark of the way Gemini works.

Claes Oldenburg also draws deeply on his earlier Gemini work. From his earliest visits to Los Angeles, Oldenburg was taken with the physical and cultural aspects of the landscape. As early as 1968 he pursued a vision of the southern California landscape that was populated by Mickey Mouse, palm tree monuments, and zoomorphic bow ties and sneakers that drew their life from the mouse ears. Nearly twenty-five years later, the imagery, reconsidered, comes together in a series of palm tree monuments that grow organically out of the laces of energetic sneakers (pages 117–120). As sure-handed as ever, Oldenburg takes the invented props of his mind and makes them into real things, monuments for our time. His *Apple Core* series of *Summer, Autumn, Winter, Spring* (page 123) is a basic expression of the pleasures of the print as a series, as rich an exploration of what we see and how we see it as Jasper Johns's memorable "Color Numeral Series" made at Gemini over twenty years earlier.

Throughout the twenty-fifth anniversary works, the theme of constancy of purpose and support of the artists' long-term interests reasserts itself. Without a commitment to the authenticity of the artists' experimentation — no matter how long it lasts or what form it takes — the publisher side of Gemini would seek to limit the extended explorations before they bore full fruit, or would encourage artists to revisit images solely on the basis of their earlier popularity. In fact, Gemini often devotes months — even, in some cases, years — to helping an artist pursue his or her own idea. This is perhaps the clearest evidence of the integrity of the collaboration practiced at Gemini.

Notes

1. For the most complete introduction to the origins and development of Gemini as well as a survey of the major artists who have influenced the shop, see Ruth E. Fine, *Gemini G.E.L.: Art and Collaboration* (Washington, D.C.: National Gallery of Art, 1984), published on the occasion of the National Gallery's retrospective of Gemini.

2. Bruce Davis, "Print Workshops at Mid-Century," in Fine, *Gemini G.E.L.*, pp. 9–14.

3. In conversations with Ruth Fine, Felsen and Grinstein described the appeal of Los Angeles to New York artists, especially in the wintertime, and the impact of the color and informality of the West Coast during the 1960s. See Fine, *Gemini G.E.L.*, pp. 18–19.

Artists at Gemini G.E.L.

John
Baldessari

It seems to me that there's much less emphasis on words in your work now than ever before.

I think that's accurate. When I first started, I elected to use a more common language to join text and photographic imagery [Figure 1]; there wasn't much of that around. I stopped using words and text when it became permissible to have that kind of material in art galleries and museums, when the point, so to speak, had been made. It had become less interesting for me. But I hope that in the works I have done since then, one can sense the presence of language and words behind the images. One of the things that has propelled me is the paradox of looking at an image like a word or a word like an image. I tend to build these images more or less as a writer would build a structure of words into some meaning.

If language is less a concern for you now than before, it still seems to play a role in your titles.

I think you're right, and that's a good observation.

Compared to the earlier phase of your career, do you still feel the presence of controversy about whether photography is an art form?

That was another issue, like that of the use of text. I remember that the first time Eugenia Butler, at her gallery here in Los Angeles, told me she had sold a piece of mine with straight photographs in it, I was amazed. But now that fight has been won as well.

But I do still see a subtle, or sometimes not so subtle, ghettoization of photographs, even now. Let's say a museum wants to get one of my pieces: the photography department will say it's not photography, and the painting and drawing departments will say it's not one of those either. The structures of museums do not allow for a spill-over. You also can see it in the marketplace: photographic works do not achieve the price levels that paintings and sculpture do. In exhibits, there is still, sometimes, a tendency to separate painting from photography, rather than mix them. Still, considering the short span of years, progress has been made. I never thought photography done by artists would be as acceptable as it is.

Has there been similar progress for the photographer who turns to prints?

I had never sold my work too well before I was approached by Peter Blum to do some prints. I had done very few, and had always felt a little sorry for the publishers, thinking they would be stuck with these things. Within a year the Blum edition sold out; he was surprised, and so was I. I asked him how he accounted for this, and he said that people didn't know I could do real art. So when photographic imagery was translated into etchings, it was art; but if it was just on photographic paper, it wasn't art. I think that's it in a nutshell.

To the extent that you're conscious of the process, what attracts you to use one image or another in your work?

That really is a tough one. What comes into play are all of the decisions that I have made in my life as an artist. I've always likened it to the process of skimming through the index in a book: some topics jump out at you. Why? I think it is the same thing with the choice of imagery. Perhaps it bears on some current ideas, but I don't always know.

A few years ago I finished a small book called *The Telephone Book* [Ghent, 1988], which dealt, in part, with pearls. That came about because I had started randomly to go through photographs that I had collected, and began to especially notice telephones. Maybe they were on my mind, or maybe the telephone is so much a part of our lives that I thought I could use it to say something metaphorically. Then I began to notice, where I had never before, that in certain of the stills involving telephones, all of the women were wearing strands of pearls.

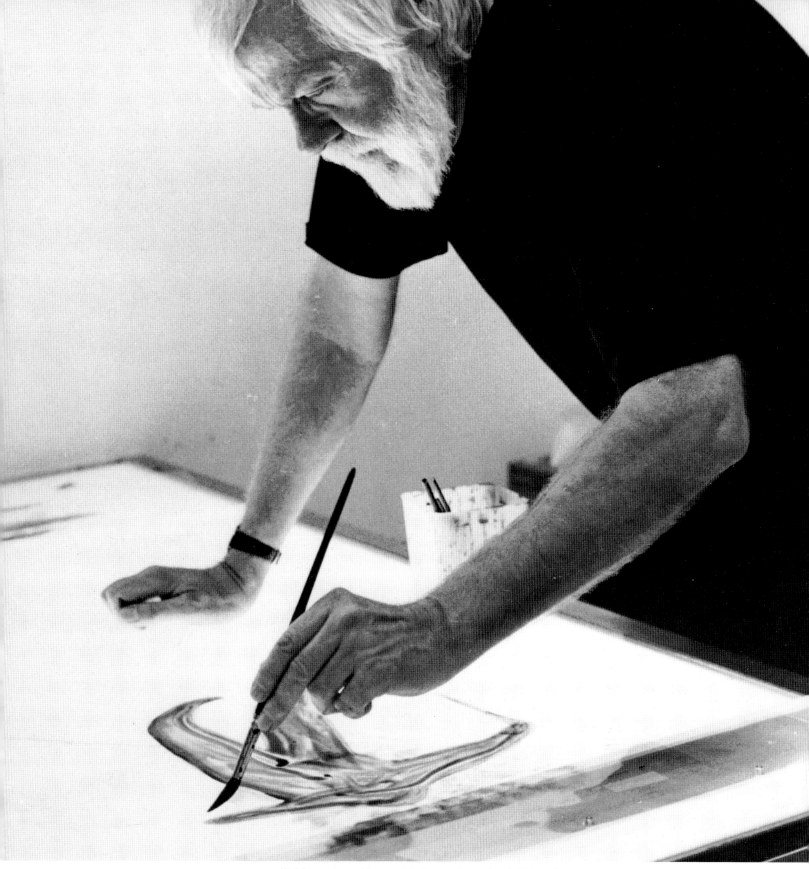

Baldessari working on Mylar for *Jump (with Volcano)*, 1992

handwritten margin notes: Use of Animal / human V.S. Animal

ECON-O-WASH
14 TH AND HIGHLAND
NATIONAL CITY CALIF.

Figure 1. John Baldessari, *Econ-O-Wash*, 1968. Photographic emulsion and acrylic on canvas, 59" × 45". Collection of the artist.

handwritten margin notes: Use of movie stills, cheap

handwritten margin notes: When two images come together

I think this is where language came to bear on my work, as I remembered certain sayings such as "casting your pearls before swine," "string of pearls," and "string of words." I began to see more and more of a connection between things that heretofore had been quite disparate.

Another pattern in your work seems to be the frequent occurrence of animals.

Yes. I included them, I suppose, as a foil for human behavior. It's like the idea that you can better understand white if you are surrounded with black, or vice versa, or that animals can be compared to humans.

The appearance of an animal always gives a tremendously exotic touch to your work.

I've always had the attitude that while we are looking over here, we should be looking over there as well. If something is happening here, something is also happening somewhere else. That's the point that I want to convey: that while we're immersed in all our own problems, life goes on.

How about the repetition of violent imagery in your work?

I don't think I would normally have been attracted to that kind of image if I were just to sit down in front of a blank canvas. It's a moot point, but when I was painting, those sorts of things didn't occur so much.

I was attracted to movie stills, not because they were from the movies but because they were cheap photographs. This point is sometimes missed, because also in these store bins I explored were newspapers and magazine photographs and the like—throwaway stuff. The bulk of the images I found are violent. At first I was repulsed and cast them aside, but then I wanted to deal with what was there, to see if I could make art out of it. Since violence is in our vocabulary of images, in movies and television, why not see what can be done with it.

So much of your early work was concerned with art per se and with art history, but at this point you hardly ever use an art historical image. You seem to be more concerned with pop culture now.

I think so, although an artist friend of mine once said a very nice thing to me. She told me that when she looks at my work, she gets a crash course in art history. But I'm kind of glad that element is gone from my work, although it did help my make-up. I think that a lot of times, even now, I am unconsciously alluding to certain art historical things. It's pretty hard not to.

To what extent do the images you choose drive your thematic concerns, or do your thematic concerns determine your choice of images?

Sometimes I will start with an image that I have had around for a long time, and that somehow has imprinted on me and obsessed me (but I won't know why). I'll start from there, and that will go out into a larger issue. Another time, the process will be inverted. More often, though, the theme germinates with some image and then another disparate image—or more—will enter my mind. (They could be completely unrelated.) Finally, while I'm brushing my teeth for example, all of a sudden, whammo, it happens, and I see a connection. Then the procedure goes on from there.

To expand on that idea, it's as if you were inclined to a kind of collage aesthetic: starting with preexisting things, using what's there, and happily taking advantage of images as you find them.

That's more or less correct. Since I gave up painting, I very seldom can deal with a single image. I'm interested in what happens when two images come together and in the meaning that ensues, although this occurs in a painting too. But, in that situation, it happens within a rectangle, which is a typical state. I've tried to fight against the givens, such as a rectangle or square; the canvas shape always irritates me. That's just something that we have inherited. You'll see that in a lot of my work I'm trying to puncture that idea with odd shapes and combinations.

John Baldessari, *Jump (with Volcano)*,
1992 (checklist no. 3)

John Baldessari, *French Horn Player*
(with Three Contexts—One Uncoded),
1992 (checklist no. 2)

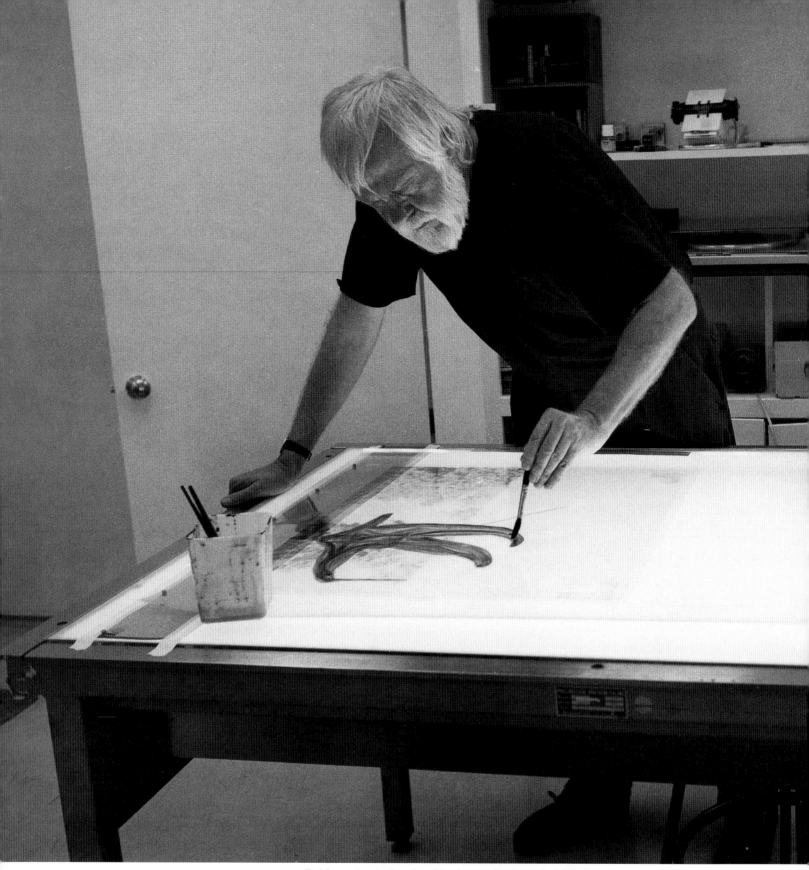

Baldessari painting the skier image for *Jump (with Volcano)*, 1992

How does the process evolve as you move from image to image?

In an idea I'm working on now, for example, there's a little bird on a guy's shoulder, ostensibly whispering into his ear; in another one, a little man is sitting on his shoulder. I think this combination came about while I was dealing with a book I did on Laurence Sterne's *Tristram Shandy.* He talks a lot about Homunculus, and I zeroed in on this because I had been collecting images of people admiring or grasping trophies of miniature human figures (such as bowling trophies, for example). So this idea has been growing and growing. One variation is an image I used of a woman holding a teddy bear, a sort of transitional object; another shows women grasping pillows.

Have you ever been jealous of or tried to emulate the movement one sees on film?

Yes, I think so. In the late sixties and early seventies, I began doing films and videos. The reason was that I felt, somehow, fenced in by the givens, by having to work with the rectangle and being static. Also, I had the benefit of having taught next to very good music departments at the University of California at San Diego and then at California Institute of the Arts in Valencia. I began to think more rhythmically, and in terms of design, and in time rather than space. So I began to do movies and videos in addition to still photography, just to see what I could do with these mediums. As a result, a lot of my early photo pieces were serial, and at the same time my movies and videos became almost like still imagery. I had almost switched purposes. I had an insight at the Metropolitan Museum in New York one day; I began to see the paintings like frames in a film. I looked at a Van Gogh, and wondered what the next frame would be. If the scene were shot with a zoom or a wide-angle lens, what would be included or excluded with the Van Gogh? I began to think photographically and cinematographically. This is why the idea of collage comes into play; the collage is like a string, and you can orchestrate that string in space and in time. There are a lot of collections of my thinking among my works, collections in which I'm sort of spilling over into thinking like a film-maker. *Collage string of music*

Except that, it seems to me, you are offering up another kind of scenic movement, a kind of disjunctive, dissociative set of events that finally does separate your work from film.

I've always been attracted to hybrid areas, the spaces between things. What I do doesn't seem to me to be unlike somebody sitting in front of the TV making his or her own movie with the channel changer, or reading one story and then another and then the next in the newspaper, as if all of a sudden there is a common thread going through them. Life tends to be like that; it's not seamless.

It doesn't seem that you ever recycle an image. Is that true?

It's not 100 percent true. Occasionally I will recycle some images.

What are your major, recurring themes?

When you are as immersed in the work as I am, it's hard to see the overall picture.
Along with the collage idea, I am continually fascinated with parts and wholes, with what holds two parts together and makes them a whole, and with what causes them to fall apart. It's that tautness or tension that interests me, and spills out to a larger philosophical view of life. If things were too unified, that would bother me; also, apparent seamlessness tends to bother me. I have a world view that one's life is not that seamless, that it is always on the verge of cracking open. I think that's what propels me. *parts & whole*

So you believe there can never be a visually unified whole?

Yes. I guess, as a kid, I was so shaken by the Holocaust that civilization never again seemed to be seamless. It always seems to be a veneer.

Figure 2. John Baldessari, *Throwing Three Balls in the Air to Get an Equilateral Triangle (Best of 36 Tries) #3*, 1972–73. Third panel of five color photographs mounted on board, each 14¹/₂″ × 20″. Collection Wexner Center for the Arts, The Ohio State University; purchased in part with funds from the National Endowment for the Arts, 1976.18. Photo courtesy of the artist's studio.

What was your experience of the Holocaust?

I just couldn't believe that people could do that to other people, that there could be this barbarousness. Now I feel that it's just there, beneath the surface. For instance, two cars are in a rear-end accident; words escalate into a fist fight; somebody pulls a gun. In a flash! It's that sort of thing that I think is there a lot in my work.

Your work intentionally seems to undo strict logical storytelling in order to bring about a surprising outlook.

For me there is an image junk pile, and I'm a scavenger. Images are like random words that one might cull from a dictionary, and I'm trying to put them back together in some way, reassembling them.

Do you subscribe — I suppose everyone does — to the old Duchampian idea that the viewer completes the work of art?

It's a delicate balance. My attitude about that comes in part from having taught for most of my life along with making art, and from subscribing to the notion that it's unwise to be an authoritarian or to be so totally opaque that the student doesn't know what the hell is going on. It's best to operate somewhere in between these two extremes, so the student is intrigued and the situation is slightly open. Your skill as a teacher comes in how you achieve this balance. I think I've tried to do the same thing in my work; I don't want to have the final word. Yet, on the other hand, a lot of the ideas I have when I'm doing my works are not far off from the thoughts other people have about them.

Would you tell me how the floating balls began to appear in your work?

Willoughby Sharp had an idea for a show, called *Pier 18*, that was done at the Museum of Modern Art in New York in 1971: the various artists who were then engaged in the emerging idea of conceptual art would have at their disposal some art photographers, at Pier 18 in New York, who would document whatever the artists wanted to do at the pier. The documents would then be the exhibit. One of the projects I had designed was to bounce a rubber ball on the pier; I told the photographers that all they had to do was center that ball in the middle of the frame. My subtext was that in doing just that, they couldn't make a very beautiful picture.

I liked the idea very much because, in having to produce those photographs, you would get compositions in the frame that you'd never frame otherwise. It was, again, a way to escape the conscious mind, and I began to employ the technique in other pieces. I set up schemes such as, "What would happen if?" For example, within the space of a roll of film with thirty-six exposures, somebody would toss three balls in the air; would an image result in which all of the balls line up or make an equilateral triangle [Figure 2]? I think the last of these projects (after which I abandoned the idea) is a piece I never showed. I had somebody throw up sticks and arcs to see if any letters and, beyond that, a word would occur (I think I actually did get something like "rat"). In the end I realized that I was becoming totally baroque in my notion, and decided to drop it.

At what point did these balls become the colored disks that cover sections of the photographs in your works?

It's interesting that you would move from the early pieces with balls to the colored disks. I've never seen the connection before; it might have started with those projects.

The idea of the disks occurred when I was going to those stores I mentioned earlier, where film stills and newspaper photo stills are sold. Time and time again I had by-passed certain photographs that, to me, were very ugly and repelling —

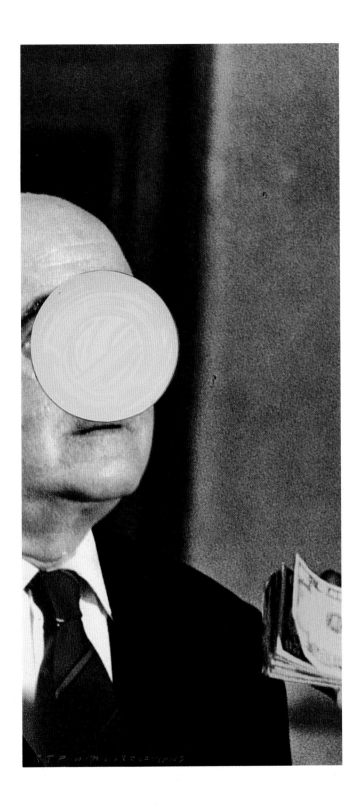 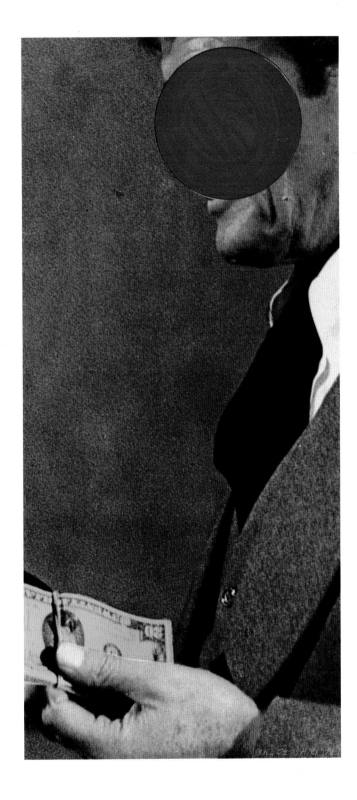

images of such events as a ribbon being cut in front of a department store, with all the public officials present, or a cake being cut, or a gavel being handed to a retiring Kiwanis president. These images stood for a kind of life that was going on in the real world, and I was living in this fantasy world as an artist. I had always avoided those pictures because they made me feel awfully bad. Yet I figured that I should try to tap into anything with that much power, but I could never do it. Then one day, while working on the *Blasted Allegory* pieces, I was using little dots to make periods and punctuation marks. I put some of these dots on the faces in the photographs because I just wanted to get rid of the people, and I felt so good when I did that. All of a sudden I had somehow, in some strange way, gained control of my life by doing that. And I had also reduced the figures to generic types rather than particular people. I could begin to make sort of morality plays. I almost felt as though I was moving the individuals around like actors. I began to color-code the disks. First they were white, then black, or black and white; then I began to introduce color. A red disk on someone, no matter how the person looked, made that individual seem dangerous. Or I could control a person who might look dangerous by putting a green disk on him.

I remember that Nam June Paik, when we were both teaching at the California Institute of the Arts, said that what he liked about my art was what I left out. I do think that the theme of what I exclude is present a lot in my work. I've always been intrigued by Mafia gangsters who put their hats in front of their faces. Also, I can remember from teaching life drawing that if a full figure is in front of the students, they'll spend an endless amount of time on the head. One of the most difficult things is to get them to distribute their attention equally, so I would put a sack over the model's head so they would see the rest of the body.

It just dawned on me now that in my early works I had started to exclude things, to white them out, after looking at Greek vases in the Met and seeing that plaster filled the spaces where shards were missing. There again comes this idea of parts and wholes. How many shards would have to be missing before that vase was no longer a vase? How many shards make a vase? Those ideas really attract me.

Didn't you say in an interview that you actually developed a kind of color symbolism?

Yes. It started out with red and green standing for stop and go. My next color was blue, which I used to represent some sort of aspiration, a platonic idea. The next was yellow, which symbolized chance and chaos, iffiness. Recently I've gone into a flesh color, standing for just that.

You were saying before that an image is like a word?

Yes. Certain facial expressions, other than benign expressions in portraits, intrigue me. Again, I guess it's this idea about civilization being only a thin veneer. People are not always placid, even though they might have their peaceful public masks. Images of ephemerality would be a signal, I suppose, again for impending chaos in some way; associated themes are smoke and light.

You mentioned the emotional quality of life. This often seems to be avoided by contemporary artists.

I think that's the reason I got into it, because I could see it was another "no-no." While my predilections are probably more those of a minimalist, I wondered why emotion is so repellent. What's so bad about it? Let's give it a crack. So I think that was one of the reasons I got into it.

Is there a particular Los Angeles outlook on art?

There's a certain "why not" attitude out here. In Los Angeles artists tend to think less about art history, whereas if you get into a conversation with artists in New York, there's an immediate concern about how something will fit with art history.

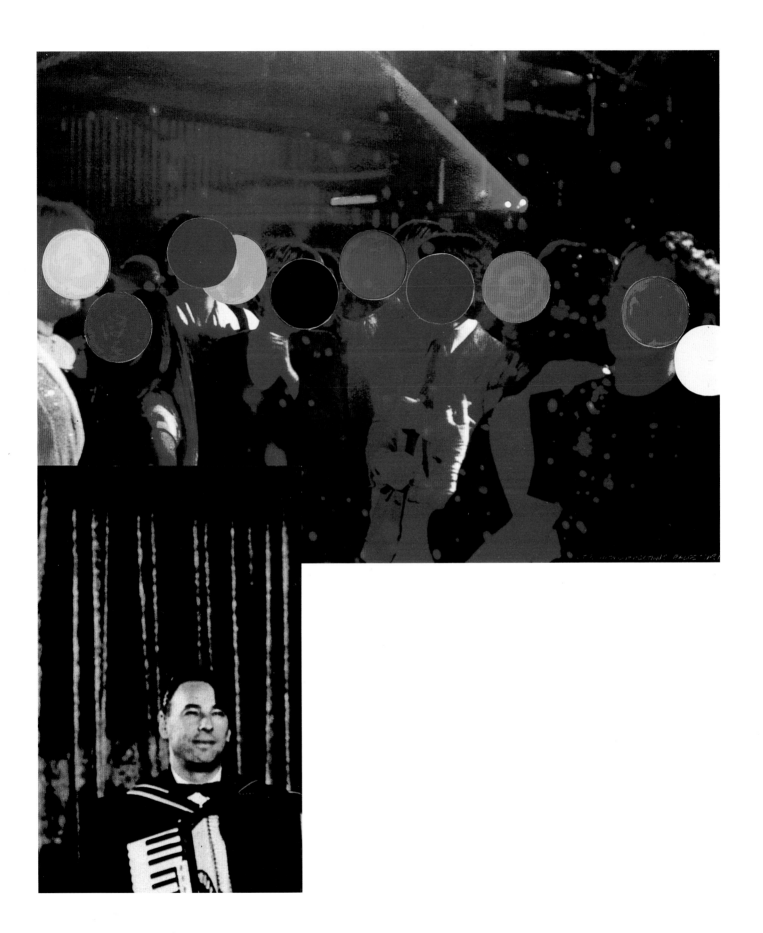

John Baldessari, *One and Three Persons (with Two Contexts — One Chaotic)*, 1992 (checklist no. 6)

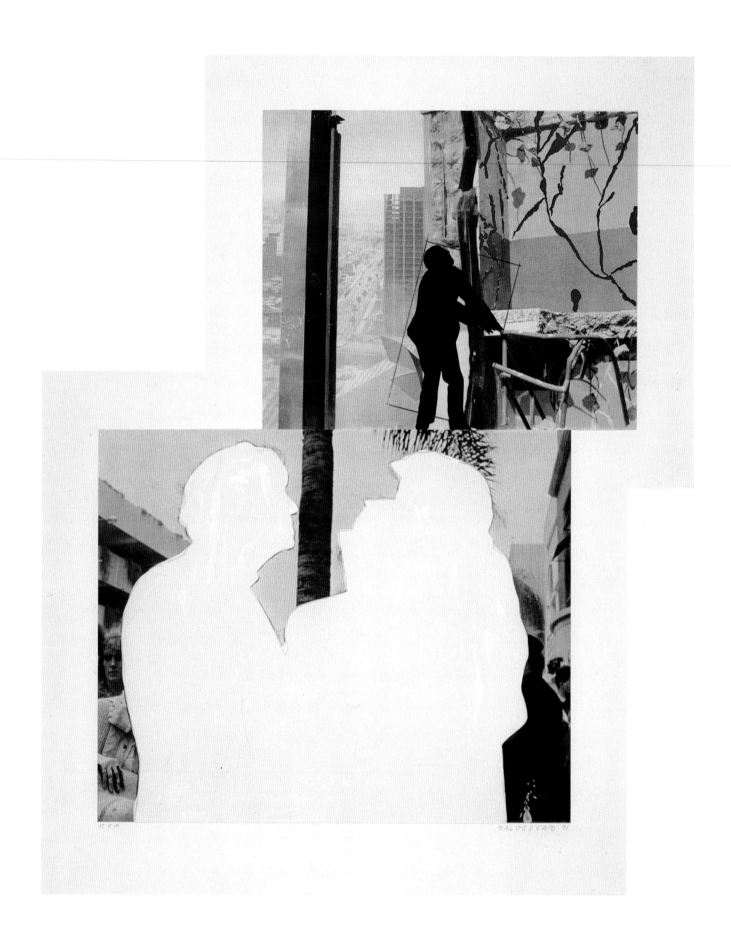

Sometimes I've thought of your work in relation to Gilbert and George in that each of you has carried photography onto a heroic scale.

I've always liked their sensibility, and I have a lot of their early postcards and books. You know, we were all showing in the same galleries. I guess one big difference between us is that after the mid-seventies I removed myself from my own works, which they haven't done. I did that because it is very hard to be critical of your own self. I thought that in order to be really uncritical, I couldn't be in my works, and so I removed my own presence. The reason for a lot of this thinking came out of video. Every interesting artist, it seemed to me, was trying his or her hand at video, and since the artists themselves were the cheapest models, they were always in their own works.

Do you ever see yourself as being related to Pop?

I have always been very much interested in Pop imagery, and I could well have been a Pop artist. However, the field was too well covered, and parts of it seemed a little bit too indulgent, not quite as stringent as I would have had it. On the other hand, I always thought that conceptual art, at a certain point, threw out the baby with the bath water; it became too arid.

To what extent is irony or even humor implied in your work?

I am attracted to borderline situations, and I think that's one of the reasons that a lot of Pop art banality and the unglorification of art interest me. But I do get bothered when the term "humor" comes up in reference to my work, because I don't intentionally try to be humorous, as let's say Bill Wegman does.

Would you avoid using something in your work if you suddenly got a laugh out of it?

Yes, absolutely. I always have. To me, that's too easy. I don't mind humor as a by-product; that's fine. But I don't have it in mind as a priority. If it comes out, it's simply that my vision of the world is slightly askew. It goes back to that feeling of being a little reluctant to let down my guard about the world being civilized.

Does humor suggest civility?

I think it's a matter of priorities. We could talk about gallows humor: we could set up a beheading so that it's funny. Or, it could be a real beheading, and somebody might see something funny in it that nobody else would see, but it wasn't meant to be funny; it was deadly serious.

Has your work become more personal in recent times?

Certainly, if you look at the range of my work, I think it's gone from being cerebral to being more interior. But if I zero in on this recent work, such as the Gemini pieces, I realize I am still pretty distanced from a lot of topics I would like to deal with, some that are still a little bit too potent for me.

Is that distance necessary for an appropriationist?

I don't know. For me appropriation came about very early. If I wanted, let's say, an image of a house, I would send an assistant out and say, "Photograph me a house." I wouldn't have to go out and select it: I just wanted something that read "house." Then I became more economical, realizing that there are plenty of photographs of houses. I don't have to go out and commission them; it's sort of a Depression-era mentality. The photos are there, so why not use them.

On other occasions, there's an image I want but can't get easily, so I photograph it myself, or have somebody shoot it for me. For instance, when I wanted a piece of torn red cloth on a bush and a feather floating in the air, I couldn't find those images, so I created them.

So appropriation for you is very simple and economical.

Yes. To me there are images out there in the world just as there are words. I don't have to make up new ones.

Does your approach to making prints differ at all from your approach to unique works?

I think so, especially in formal concerns. I look for areas where I can use a large expanse of color to employ the aquatint, and for ways that I can manipulate the light and dark patterns. With the prints I'm doing at Gemini, I decided to do some very large color pieces. For these, I'm employing the Ben Day process, in which certain imperfections and color mixes occur.

So you are taking advantage of the process?

And of its limitations. We have an ad hoc attitude as we go along.

How did the image of the figures handing money to each other [page 23] come about?

I've made a series of prints involving images with money, the latest being one where money is flying up into the air. The exchange of money is archetypal and shows up a lot in movie imagery. Again, like violence, it's certainly part of the world. You can't pick up a newspaper without some amount of money being mentioned in some story. Calvin Coolidge said the business of America is business. It's like that feeling I had with the images of civic figures: there are activities that I'm ignoring but that give vitality to the world, and one of them is the exchange of money. So I decided to bring images of money into my work.

I split the Gemini print down the middle, as I have often done before, because of the issue of parts and wholes. Here I'm pulling the sections apart and slashing the money. It's the idea of the torn dollar bill, with one person having one half and another the other half. When the dollar is complete, the relationship is somehow complete. I am exploring the transaction, which involves two parts becoming whole.

In so much of your work of the last decade, you've created striking overall silhouettes, almost like shaped canvases. Has that structural impetus, to give it a term, become a driving force for you?

No, very seldom do I think about particular shapes. I think it's just my anger or my bristling with dealing with the givens that has led to those unconventional shapes.

So much of our thinking is shaped by certain givens, such as the fact that camera viewfinders are certain rectangles, and that certain proportions shape our image of the world, and that movie screens do the same. I used to have a theory that the size of a New York painting was affected by the height of elevator doors. I thought it's okay if you know when you're accepting the given, but it's bad to accept it unthinkingly.

Are you especially drawn to using the lobby cards of third-rate or forgotten movies in your work? Do you deliberately avoid the famous stars or scenes?

The only reason I avoid them is because they bring too much baggage. Then you the viewer starts thinking about the particular movie, and I don't want that to happen.

It seems like you are especially drawn to overwrought, melodramatic situations.

That's part of my penchant for banality. I like overused, clichéd images.

And images of people bowling.

Bowling is such a stupid activity, yet there are large proportions of the population that invest it with a lot of interest. It's those sorts of things that fascinate me, like the images where I obliterated the faces. That's real life for a lot of people, although it may not be for me.

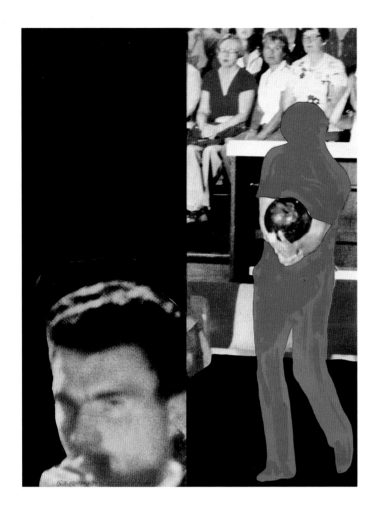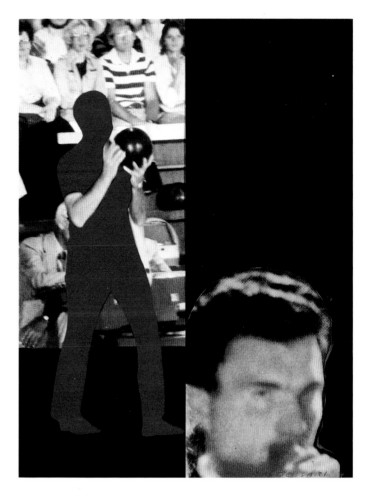

About Two Sunsets, *someone said that you called it the Hallmark Card piece.*

I delayed doing that work for a long time.

It seems like you've never gone as far as this in the realm of banality.

I have another one in which there is a log cabin down below and a sea gull flying into the sun.

Brinksmanship does interest me. Pushing art to the limit, and pushing myself further and further.

June 28, 1991, Los Angeles

John Baldessari, *Two Sunsets (One with Square Blue Moon)*, 1992 (checklist no. 8)

Jonathan Borofsky

When did you begin to make prints and multiples?

I made a few etchings in college, as most art students do, but I didn't do any real printmaking until I started working with Gemini, in 1982.

How did you first approach the printmaking process?

I made the process accommodate certain of the things I was doing. I remember doing wall paintings of two Molecule Men coming together at several exhibitions and thinking that I would just paint that on a large sheet of paper, screen it, and see how it read as a big image. I felt that since it never was reproduced or "sold" as a wall painting, here was a way to make it a portable, reproducible image. It was a simple print to make, one color, one screen, but it was a way to get into the process. I probably haven't taken full advantage of the printmaking medium, but I really haven't been that drawn to it per se. The people at Gemini know that, and they work with me accordingly.

I really see printmaking as a vehicle for ideas. All art making is basically just an illustration of an idea for me, so printmaking is an extension of that.

How has your work at Gemini over the years fit in with the rest of your activity?

In the prints I tend to be redoing ideas and making many copies of them, and I haven't done too much experimentation with these images. However, with the sculptures, I often start with fresh ideas; for instance, the cutout Briefcase Man was first made as a multiple at Gemini. It was such a strong piece that I got the idea of making it 20 or 30 feet high, which we finally did in Minneapolis. The same happened with *Heart Light* [page 43], which also began as a multiple at Gemini; I have visions of making it as an outdoor piece 40 or 50 feet high.

Do you enjoy the collaborative process?

There was a period when it worked for me; then I must say it became a little uncomfortable. I'm not that comfortable working with a lot of people watching over my shoulder, or with a lot of people in the same room. I really feel more private.

Are you pleased that your art is disseminated widely through the vehicle of a multiple?

That's what print editions and multiples are for: to disseminate the idea on a larger scale that's financially available for more people. There are many people who can afford $4,000 or $5,000 for a print but who are never going to be able to afford $50,000 or $100,000 for a painting—that's not even going to enter their minds. So in that sense, I believe in using the printmaking process. But when the prints get to be $30,000, then it's a different ball game. When I started, my prints were between $900 and $3,000.

If you have a good idea, I see nothing wrong with having twenty or thirty examples of it in the world. Otherwise, that one good idea ends up in somebody's living room, if you're unlucky, or in somebody's museum, if you're lucky, but either way only a limited number of people get to see it. This way I can move the image around, make it more portable, and get more people to see it. That was what felt good at first, and has felt good up to now.

How do you feel about returning to certain images after a long period of time, as you have with the turtle [page 35]?

Leaving an area that you have been working on and traveling to another for two, three, ten, or twenty years, then coming back to that first area and catching up on it again for a while, seems very normal and logical. Each time you work with an image, you learn something, including what it feels like to do it again after fifteen years, and maybe you get new insight into why you were doing it earlier. The only danger is if

Borofsky at work on his *Molecule Man* screenprint, 1981

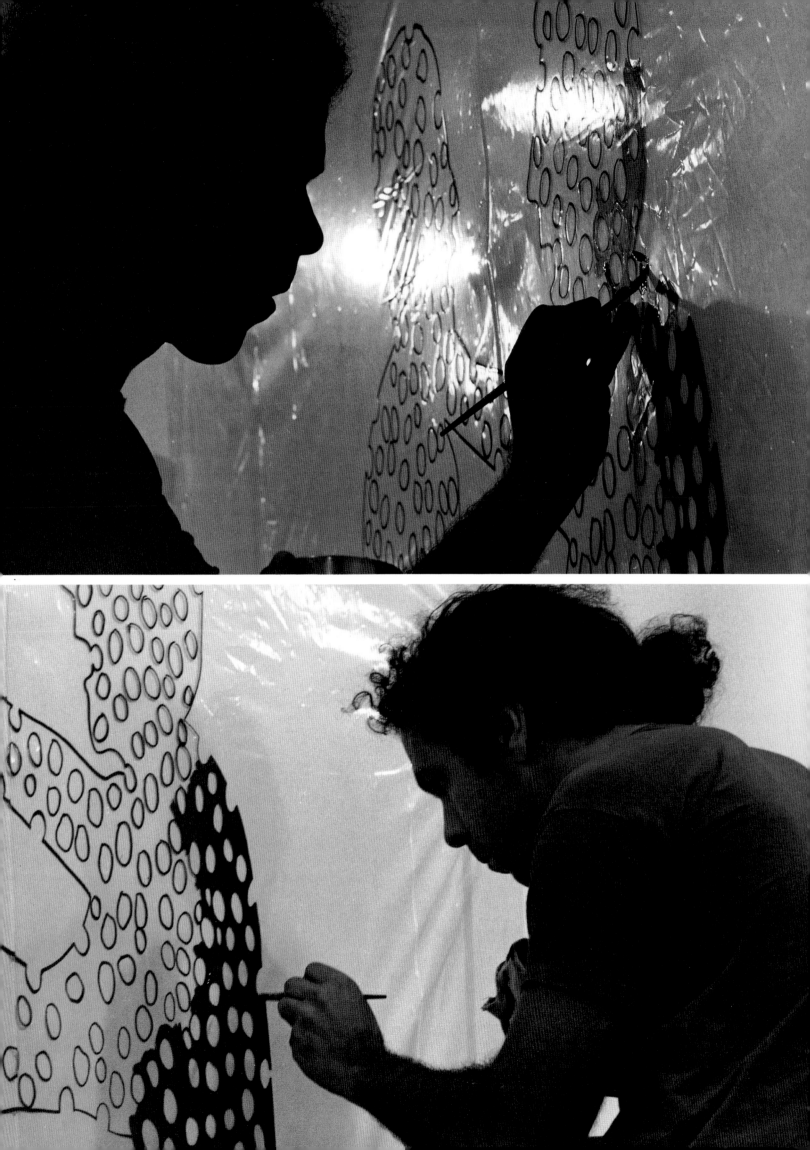

you don't seem to be progressing but are working in a closed circle instead of a spiral, just coming round and round and repeating the same image year after year. I really enjoyed doing this turtle, which I had only done once in my life—on the wall of my studio. I have a photo that was taken with me standing next to it [Figure 3], and we ended up putting that image into my Philadelphia Museum of Art catalogue. That was the only time it has ever gotten out anywhere; I never put it on a canvas. I looked at the photograph one day, some fifteen years later, and felt that I would like to do it as a print. It was interesting to go back and touch that image again, and to peek at my feelings as to what I was doing and why I was doing it, and how far I had come. It's a normal procedure for artists to go back and touch.

I see now that each time I go back to an image, it's really a visit to an older place, but one that is never as vital as it was the first time.

It doesn't accrue any new meaning?

No. Hammering Man, Briefcase Man: they're all very simple ideas, simple in the sense that people can add any meaning they want.

What association does the turtle, with the boat in the center, have?

The sailboat is, for me, a symbol of motion, natural motion, of being pulled by the wind. There might even be a touch of nostalgia there regarding my father, who is a sailor. The turtle was definitely a self-portrait for me at the time. It's in a shell, protected. But in the middle, on the underside of this shell, I put the diamond shape that further houses and protects this rather personal sailboat image.

Did the egg forms that you did as a multiple [checklist no. 13] originate with the Bubble Wrap Man?

Yes. I put the egg forms around the Bubble Wrap Man [Figure 4], which is really a Molecule Man. I thought it would be good to have these eggs just to add a little more fantasy to what this figure is doing. Then I made the grouping of four similar egg forms, in bronze, as a multiple at Gemini.

And you have added your numbers to these organic forms.

I wanted to add something new to my work, to bring my numbers, which are sort of a conceptualization of pure consciousness, to this bright organic grouping, and to try the two together.

Recently you've done many prints and multiples that deal with your numbering system.

In the last two or three years, I've given a greater focus to the numbers. In the middle sixties that's all I focused on; then slowly imagery came and overtook the numbers, although the numbers still always coincided with each image. It's just an ebb and flow, I think, of my whole mental activity. Now I'm beginning to make the numbers out of wire. I like the fact that, as objects, the numbers are what they are, not number images; the number *is* the image. It becomes real, in a sense.

The numbers have always given me an overwhelming feeling of oneness, of having a more secure center. It was a way of quieting the mind by bringing it down to one thought as opposed to many thoughts. What finally happened is that I couldn't hold on to that one thought that well, so I just decided to let my mind loose, and there was an explosion of paintings and sculptures. I have the feeling I'll eventually see the imagery as a distinct period of my life, when I just let go to fly around, to see what the mind can conjure up. But ultimately my center, and my driving force, is the counting. That's what holds it all together. It probably is quite correct for me to come back after this fifteen-year flight, to lock into it again, and to feel comfortable casting the numbers in aluminum, or making them in steel, or printing them.

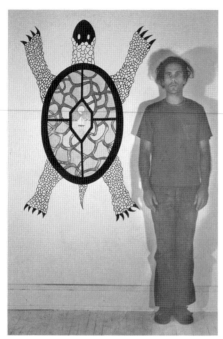

Figure 3. Jonathan Borofsky, *Painting on My Wall at 2,321,767*, c. 1975. Acrylic, chalk, pencil, gold leaf on wall (destroyed). Courtesy of Paula Cooper Gallery, New York.

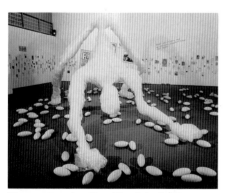

Figure 4. Jonathan Borofsky, *Friendly Giant (Molecule Man at 2,908,463)* and *250 Urethane Eggs*, 1984 and 1986, respectively. *Giant:* bubble wrap, aluminum, steel with motor, 10′ × 19′5″ × 12′12″. *Eggs:* urethane, each 9¼″ × 10¾″. Installation at Museum of Contemporary Art, Los Angeles, March 17 to May 18, 1986. Courtesy of Paula Cooper Gallery, New York.

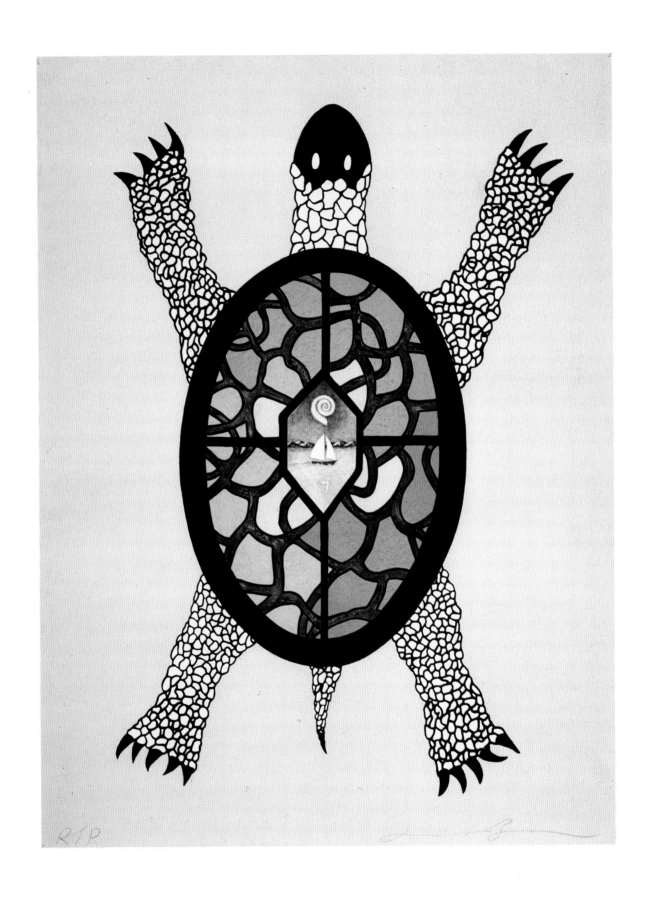

Jonathan Borofsky, *Man with a Briefcase*, 1990 (checklist no. 22)

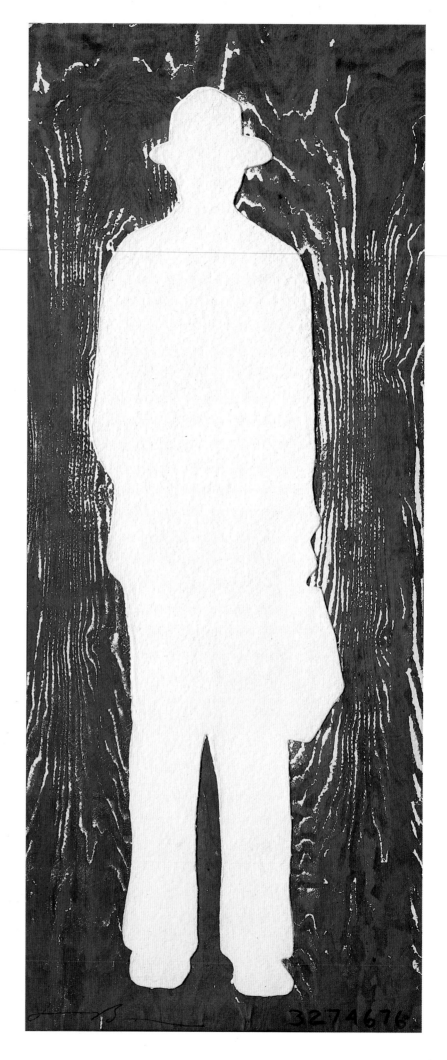

Jonathan Borofsky, *Man with a Briefcase (A)*, 1991 (checklist no. 23)

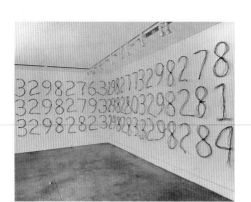

Figure 5. Jonathan Borofsky, *Counting (3,298,276–3,298,284)*, 1990. Steel wire, each digit 24″ × 12″, approx. 9′ × 36′ overall. Courtesy of Galería La Máquina Española, Madrid; photo courtesy of Paula Cooper Gallery, New York.

What is it about the numbers that offers security?

I think it's something about their perfectness, cleanness. They're not ambiguous, and they're concise. They're specific while everything in the world is not.

Except that they are part of the world also.

Absolutely. And in fact they are extremely natural, because they come out of our minds, and that's also fascinating. They're our way of making structure, and how they've infiltrated our lives is fascinating—from clocks to VISA cards to computers. Numbers are our structure, and our structural device. They are really at the bottom of it all; at least it works that way for me. They're kind of magical, too, literally figures of our imagination, coded, just like language. Really, they're just a specific kind of, or part of, language.

Somehow your flags [see Figure 6, page 41] resemble the numbers also.

What those two images have in common is that they are what they are. The other images don't have that in common; they allude to something—a surreal image, a fantasy, or a dream. But the number is what it is, and the flag is what it is; they are both extreme conceptualizations for that reason. They are very pure in a sense. Something feels good about that. They are not alluding to anything else. They are themselves. To feel like that as a person once in a while, if you can, is rather good.

You never treat the numbers in any kind of subjective way, as you do, say, with the series of fifty-three men with briefcases.

I don't get too cute with it, or artsy. First of all, Jasper Johns did quite a good series with his numbers; he gave Expressionism some structure and at the same time bled the numbers through Expressionism. I feel like I'm a step down the line, cleaning it up even more, and making the concept purer. The number does not need the Expressionism to make it palatable within art terms, and yet in art it is much more real than just a number. My numbers are not done as an artist would paint them. I'm making numbers out of steel wire [Figure 5], and they look like that. They are a little more emotional than the numbers that have been printed at Gemini, which are clinical, textbook numbers. I am always flirting with different ways of doing them.

Do you ever think of Johns's numbers in relation to yours?

Not when I started, but of course the thought hit me a few years ago. I can think, too, of some Surrealists who have used numbers, and Stuart Davis, too.

Listening to your description of the numbers, I thought of parallels with the work of On Kawara.

I think we're very close. On Kawara's is a world system, and my numbers are, too. His are just more specifically related to an idea and what is conjured up when you think of a man painting a date; what he is getting at and what he is thinking about is the statement, "I am still alive."

When you speak of your mind arriving at "one thought," is that the idea of ordering and the underlying structure?

The number is itself. That is the thought. The counting is very repetitive, but a slight alternation exists in each revolution. Every seventh, every eighth digit, it kicks over one number. It's both change and repetition at the same time. It's just a pure, mental action. As a conceptual artist, I thought that was the purest statement I could make for myself and for the few people I knew when I was working in those years.

Are you still counting?

As long as I make objects, I'm still counting, and each object then represents the number and is so labeled. And as I've said, lately the numbers have become the objects. Consciousness creates the world.

Borofsky (right) and Ron McPherson collaborate on *Man with a Briefcase*, La Paloma,
August 1990

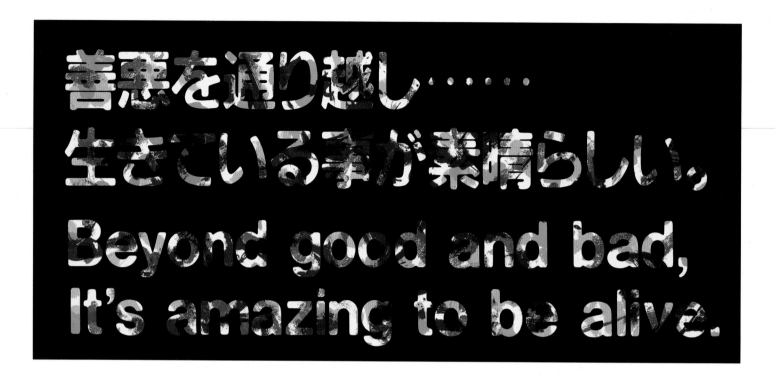

Figure 6. Jonathan Borofsky, *Flags of the World*, 1988. Acrylic on canvas, various sizes (most 30″ × 45″ or 30″ × 50″). Installation at Paula Cooper Gallery, New York, April 2–30, 1988. Courtesy of Paula Cooper Gallery; photo copyright 1988 D. James Dee.

How did you get started with the Japanese language pieces?

They started with my practice of writing my dreams on the wall wherever I went to do a show. Usually I would meet with somebody a few days in advance, and I'd have a dream translated into German, Swiss, or Japanese. That way, the people in those countries would be able to read what I was saying and thinking about. In the case of the prints I made for Gemini, I just took some of the Japanese dreams and transmitted them by screens to a print form. Then I added things to it.

Why, when you're back in America, did you do something in Japanese?

I like the way words look, just as I like the way numbers look. In fact, it's like my print *Object of Magic;* I don't even read it anymore. I just like to see the big letters — black on white. The Japanese looks great, and to think that it means something and actually represents ideas is even greater.

Was this the first time you brought something back from another country and used it in a print?

I didn't do it with German. Japanese is a fascinating language because the letters and words are like pictograms. They are more than just letters, which fascinated me just a little more. The only letters that I can think about that are similar to it are Hebrew letters; that fascinated me in Israel, where I had my dreams translated also, but I didn't bring those back.

What about your "all is one" sign in Persian?

That didn't come from doing a show in another country. Again, I loved the way it looked as a drawing, and it happened to mean something important to me.

Are you trying to suggest a universal approach to what you are thinking about by using a language other than your own, hence "all is one"?

I think it's nice to have different languages in a show. Maybe it's a little trite to say that it represents global awareness, so I don't know if I want to say that.

That desire for different languages recalls again your Paula Cooper Gallery show in 1988 [Figure 6], and your prints of flags.

The flags were a definite attempt to break away from myself and from a lot of the work I've been doing. But they were also an attempt to make a very specific outward prayer. The idea was to do all of the flags of the world, to signify that all is one in a more obvious symbolic way.

Among your latest works, too, is the printed Hammering Man *[page 47] that you made at Gemini. How did this come about?*

The Hammering Man represents the worker in all of us. This image still seems to have a fair amount of importance for people who see it, so it has naturally now been translated into print form. It was done earlier as a very small print, but now, since its strength seems to lie in its size, it made sense to form it as a large, 12-foot figure.

Pulp was poured into a mold in the shape of a figure. After the pulp image was produced, it was glued to another piece of paper to give it three dimensionality. Each figure has a printed arm placed in the halfway position, which for me is the strongest. The *Hammering Man* is black, and the sections of the arm that are reproduced to show movement are white, so they are just vaguely there, but enough to give the illusion.

What is the source of your line, "Beyond good and bad, it's amazing to be alive"?

That's in the most recent, multicolored, Expressionist print in Japanese and English. When I did the show at the Tokyo Metropolitan Art Museum in 1987, that was the statement that ended the exhibition, written on the wall in Japanese.

In any installation I would do, I would always write on the wall some statements that were meaningful to me at the moment, that I was talking to myself about, preaching to myself. All these statements are tied to a spiritual quest for wholeness.

This latest, "Beyond good and bad, it's amazing to be alive," seems especially optimistic. Is that indicative of your current state of mind?

It's a state of mind I'm always seeking rather than actually having. That feeling and its accompanying thought only come to me at certain moments. But there is enough that goes on during the day to contradict it. So it's always a struggle. "Beyond good and bad" is really just another way of saying that "all is one."

I have always said that all my work is really a visual record of a trip, of a learning process, and of a spiritual process as well. I would like to think that I am evolving and learning to become peaceful with myself; before too long I also will become one with everything around me.

It seems to me that your work is less frenetic than it once was.

At the moment, I feel like I'm far away from the chaotic installations. Maybe I'll come back to them, like I've come back to the turtle.

I suppose this means a change of mood rather than image?

The sensibility is cleaner. Like I said, the numbers represent coming back to a kind of quieter state, to being as quiet and as pure as I can become, without getting too symbolic. The sun I did in the back room of the show at the Paula Cooper Gallery — that big half-dish that was brightly lit — is a symbolic vision of light, of the moment of enlightenment. But for the everyday representation of pure consciousness, for me nothing seems to beat my numbers. They give me a feeling that life goes on; they're an energy and a force, and that's all one needs to know. Anything else is just the mind's travails, or ego, or whatever.

Do you feel that where you live has a significant role in these things we are talking about? In other words, how do they relate to your choice to move to Maine now?

There are a lot of reasons for this move to Maine, and some of them do relate to these subjects. I've always been attracted to the ocean and to spiritual places, places that are natural. Yet, at the same time, what could be more natural than New York City, with a lot of ants running around doing their business. But I tend to be attracted to nature, other than human nature. I probably have a sense of reaching a new level on the spiral. I'm up one stair and on the climb, so to speak.

We've had many conversations over the years about politics; there was even a moment when you thought about being a politician.

It was after my sermon at the Cathedral of Saint John the Divine in New York, given on the occasion of my *Fish with Ruby Eye* being installed there in 1987.

Do you still have those thoughts?

Not political thoughts in the sense of being a political animal, but my *Heart Light* is a very political piece. Some might call it spiritual, or downright naive. For now I've broadened the definition of politics; beyond the lunacy of leaders are the positive aspects of myself and others. It seems that when you are younger, you want to kick somebody's ass a little for what you're facing in the world and in your own life. So punk rock and heavy metal exist to help you get that feeling out there and shout it. But as you grow a little older, either you ultimately bottle it up inside and shrivel up and die, or you learn to filter it out, release it, and begin to realize things like, "It's amazing to be alive."

Is your public work the most exciting area for you now?

Above: Jonathan Borofsky, *Heart Light*, 1991 (checklist no. 20); right: detail

Jonathan Borofsky, *Self Portrait — Bronze Head*, 1991 (actual height 3″; checklist no. 28)

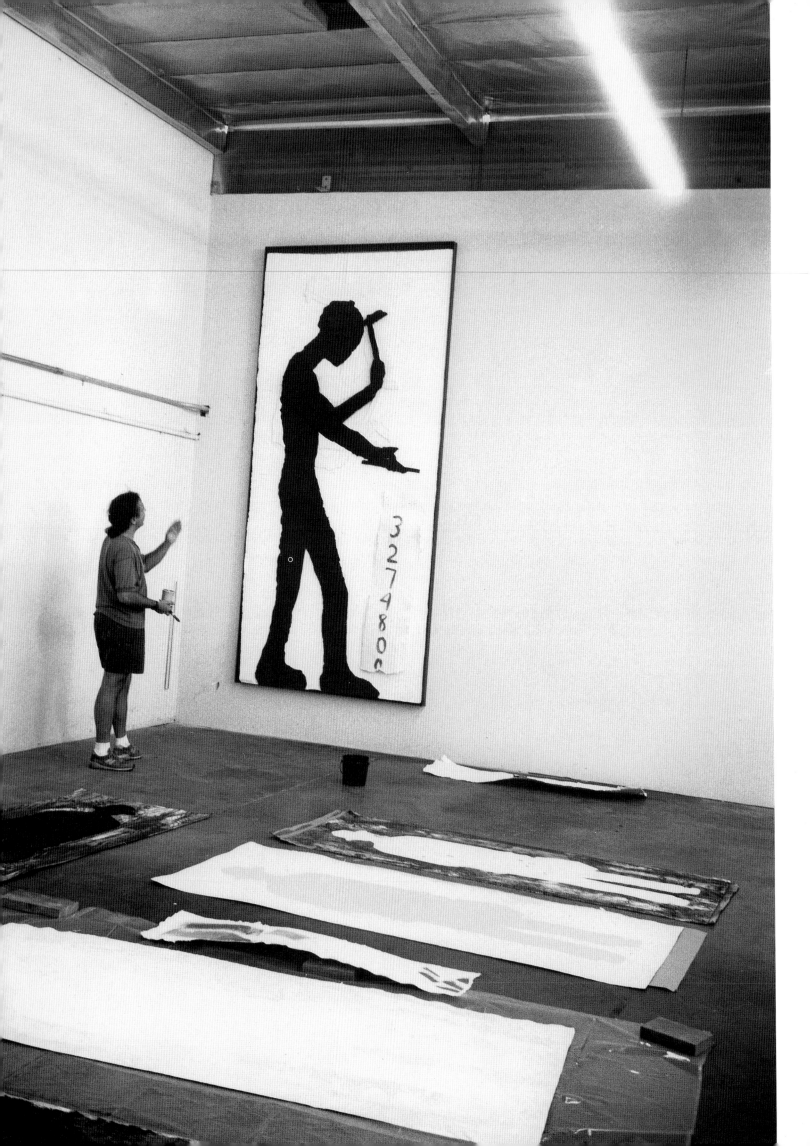

Facing page: The artist with *Hammering Man* and *Man with a Briefcase* in progress, La Paloma, August 1990

Right: Jonathan Borofsky, *Hammering Man*, 1990 (checklist no. 19)

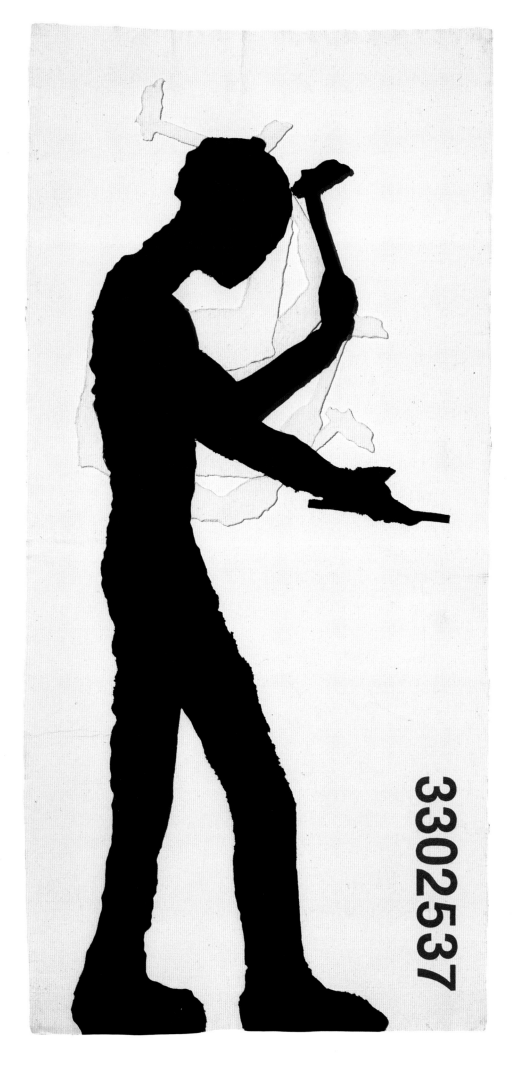

Borofsky (right) and Robert Rauschenberg at Gemini, August 1990

There seem to be two extremes. First are the very grandiose works like these large Hammering Men in different places around the world. It feels like a great idea for me to have several going in different countries or spread around the globe, all hammering at the same time. There is a charge to that idea for me, in that they are all workers of the world assembled for humanity, all working.

My second excitement comes when I sit down at my notebook and write my numbers. It's like a very personal charge, relating to nobody, nobody. This is mine. It's making art, or whatever you want to call it. It doesn't have to be called art. It is something very personal that carries on, and I think it still gives me a real charge when I come back to it. So those are the two extremes.

Regarding your aspirations for the Hammering Man, maybe you still are a politician.

My art is, I think, an illustration of thoughts and feelings. I am illustrating a vision I have in my better moments, that we are one living organism, pulsating and charging forward with energy.

What's most important is for you just to put out some energy that's usable for the moment for other people, and maybe some of that traces into the future when you're dead. Maybe it lingers on, but there's nothing more important than the moment, I guess. So what I did in the past or what I'm going to do in the future isn't so important. And what's left after I'm gone is not so important either.

You don't want to think of artistic immortality?

No. If I did, I'd be censoring for the great moment, for that great work. By not thinking about that, I allow myself to let a lot of things pop out that I might not let pop out otherwise.

January 1991, Ogunquit, Maine

Richard Diebenkorn

Have you used the arched structure seen in these two untitled prints before?

Yes, I have. I've often used it as a relief element, in terms of what occurs within. I don't mean it's representational, or that suddenly we have a doorway or architectural construction. But it's a plastic matter, and a change in format.

I was struck by the gestural or linear quality in these works, which I don't associate with your art of the last fifteen to twenty years.

That's very interesting. I think of these pieces as carried much further than a work of that size usually would be.

I've pressed the work in the name of getting everything altogether "right." Often with a painting there can be, to my mind, a kind of casual "right" or there can be an absolute "right." To me there is nothing wrong with the casual "right"; it doesn't mean that I'm leaving out aspects that I should take care of. But, occasionally, I want to just follow the work through, and if there's the slightest possibility of furthering an image, whatever it is, I do it. I think that is true of these prints.

And the Gantt piece? [See page 182.]

Now that could be called casual "right."

Do these ways of working change when you are faced with making a print as opposed to painting?

If I'm comfortable with the medium, then I think it's just the same.

I haven't painted in oils for some time because I haven't wanted to work that large. (I have been ill, as you know.) But if I'm working with acrylics, or just black ink, it's the same — after the initial decision to work in a different medium, which perhaps is going to bring different characteristics out of my work.

Another special condition of these prints is the intimate scale, which is so different from your big paintings. Does that scale change the way you work?

Working on the small scale has been a condition of my health problems over the last four years. If I'm working in the house, as opposed to my studio, I have limited material and I sit. (I usually stand when I work.)

Early in your career, you occasionally used letters among your gestures, as you do here. Did you, perhaps, intend to refer to ART in the print with the large letter forms?

I could have; I just don't remember.

Regarding the print you did for the Harvey Gantt campaign, was that the first time you used the image of eyeglasses?

I have had eyeglasses in drawings for some years, especially in the mid-sixties, when I did a lot of still lifes. They have some meaning for me.

It's such a witty kind of image: the eyeglasses looking at one of those spade forms. Is that a musical staff on which the spade is sitting?

No.

I could not help wondering whether this image was at all a comment on the issue of censorship, which had a tremendous part to play in the Gantt versus Helms campaign. Was that intended?

I think eyeglasses suggest that you look harder than you might without them, but it's hard bringing that kind of thing to my work. I've always been wary of it. If things come out at the end, that's just fine, a dividend. But to try and insert them in the early stages is for me no good.

August 27, 1992, telephone interview

Diebenkorn at Gemini, 1985

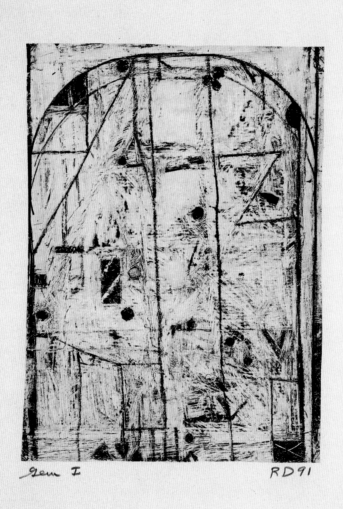

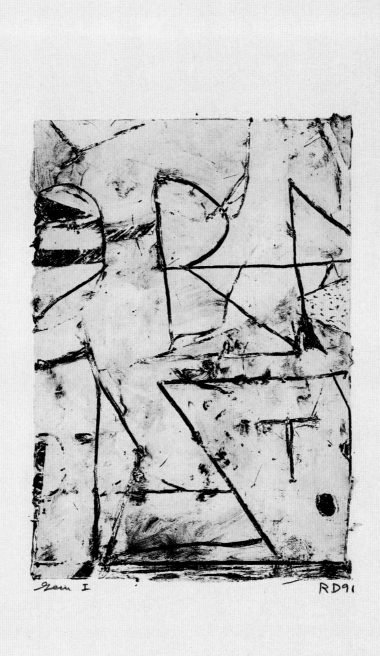

Mark
di Suvero

How did Santana Wind *[page 57] come about?*

It's two etchings superimposed. I had done two different drawings on copper, which Jim Reid printed. I looked at them on the wall, and I thought they would look good on top of each other.

Why do you use a V form so often, as in Santana Wind?

I deal with structure in the sculptural world. This is a structuralist work; all of the expression is in the structure. Certain forms deliver their force in the clearest possible way: V's, X's, K's. Those have a special, structural significance.

I use tetrahedrons very often, too. Just as the Euclidean triangle is rigid in the plane and the square is deformable and weak, the tetrahedron is naturally strong in three-dimensional space. I'm interested in four dimensions, and for more than twenty-five years I've made work that moves. *Praise for Elohim* [Saint Louis Museum], a tetrahedron that balances and moves, is still one of my best pieces.

Santana Wind *looks like an image of one of your sculptures. Does it relate to any one piece?*

I do a lot of drawings for pieces of sculpture. I see the piece in my mind's eye—or what I would like the piece to be—and then I do a drawing of it in order to remember. I think drawing has the capacity for that kind of emotional shorthand. You can get the essential quality of something if you're going well.

Peter Forakis changed my drawing style. When I studied with Beate Wheeler and people like that in Berkeley, I learned to draw like Goya, Rembrandt, and Degas. I studied and emulated them. I ended up with Tiepolo-like washes that were vague and very abstract. Then Peter Forakis showed me how he grabbed a pencil, not holding but grabbing it in his fist; he'd do these very clumsy kinds of technical drawings that suddenly showed me a different way of drawing, a way that illustrated what you were really thinking of.

It's interesting that you mention Goya. I think of his use of black in relation to the black in your etching.

Real black is the real color of all sculpture.

Your work is always labeled a sculptural version of Abstract Expressionism. Does that make you uncomfortable?

I think it's debasing that people need a label for artists. I deal with imaginary structures, meaning that they have to do with the geometry of imagination. I think my work deals with a certain level of symbolism that we all use. It's abstract in the sense that it isn't representative; but what I do is very concrete. If you bumped into it in the middle of the night with your head down and your eyes closed, you'd know it was absolutely real.

Regarding your symbolic interests, is that one of the reasons you like to play with titles?

I think a title is like a handle on a cup. A handle has nothing to do with the contents.

I'm really moved by the way Paul Klee used titles; you have another dimension with a title. I've always thought that titles offer a special kind of freedom. I understand those people who would title a work, say, *10-11-365*. They don't want to have any handle; they want the work just to be itself. But hopefully, whenever we do a piece of sculpture or a drawing, it is itself.

How about the title Santana Wind?

Have you ever lain down naked in a Santana wind?

I wish.

Di Suvero proofing the edition of *Longing*, April 1981, with Gemini curator Lisa Schachner in background

Ah, you should. For me, it blew out of the Los Padres Desert, across Santa Barbara. If you're naked in the middle of the night and you are walking through the fields, and this hot, dry wind is blowing, it's like something that comes out of dreams, yet it's completely real. It's not disturbing, but dislocating in a weird way.

Tell me about the piece you have been working on for years at Gemini.

That's much more radical. It uses one of my computer drawings etched onto an electronic circuitboard panel. This panel is suspended above a movable magnetic field. The piece will move in a wind created by a miniature fan powered by a solar panel; it will turn and gravitate.

It sounds sci-fi to me. How close are you to completing it?

We've had one or two models that don't look good enough. That's the real problem with conceptual art. They say the object itself, since it's only an illustration of an idea, is not important. But in fact our only link to Rembrandt's brain is through the brush.

To return to an earlier point, how do you think of yourself in relation to abstraction?

There's a beautiful math teacher named Yves Heutte in France, who was talking about something being "abstract." He said, "Oh, they just call it abstract if they can't understand it." You learn to use symbols according to their own rules. As artists, we have a special kind of visual iconography that has been given to us through history. What is called realism is never real: a dog will never go up to a painting of a dog and sniff it to see if it's going to bark. It's a type of false representation, and that is what people oppose to what they call abstraction. Both end up being symbolic expression, or symbolic manifestations.

In other words, you think it's a false distinction.

Yes. I think we live in a world that is very abstract. Look at money; it's a piece of paper that has symbolic value. The symbol is the important part. Symbols denote an idea, and dealing with these symbols becomes for people an abstract effort. But every time we talk we are using words that are nothing but symbols.

So the most authentic or "real" thing is our emotions.

Those are totally real to us and invisible to others.

Whether we like it or not.

Whether we like it or not, and they're not falsifiable. They can't be rendered objectively except through various forms of art. Emotions are really locked away.

But how does art relate to emotions?

[Screams and beats his fist on the table.] People need artists in order to funnel back what is still inchoate. The artist forms it for all people. Then, suddenly, people whistle that tune; they are able to express that emotion.

I believe many viewers have not realized the depth of emotion in abstract art.

I used to ask young poets this question: "Suppose you were making love and a great line of poetry came to you. Would you stop and write it down, or would you finish your lovemaking?" I mean a great line, life-changing, like one from Rilke or Rumi. And all poets know that to misremember a line is to lose it: for example, "To be or maybe not to be."

I'd finish lovemaking.

In the discipline of emotion, in order to achieve maximum art, I think the great poet would STOP.

November 5, 1992, New York

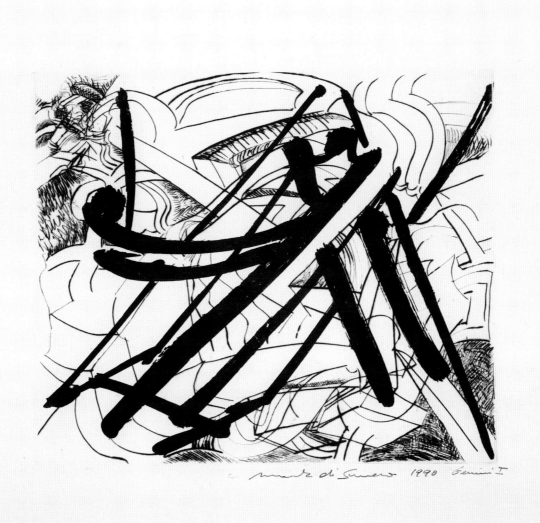

Jasper Johns

How many plates were used with each of these lithographs [pages 64–65]?

I counted five, some of which were used for more than one color.

Does a print with so many plates involve more planning than usual?

Oh yes, since you can only put certain things on a plate, and if you are going to use colors, you have to use different plates.

Do you enjoy that process?

Well, of course, or I wouldn't have been doing it since 1960!
Working with this medium is interesting because it has to do in part with time: whether you think of something before or whether you think of it after, whether you do something that shows or whether you do something that doesn't show when you did it or how you did it. It's very different from painting or drawing, in which everything on the surface can at any moment be changed. When something is printed, it has to be done in an order. You have to consider how it can be printed, and how it will be printed. And, of course, it's also a problem in economics, because every new plate you add to a print means that much more work for the printers. One thinks of their time and interest in the project. Part of the pleasure of printmaking is, of course, that you work with other people, whereas in painting you don't. At least I don't.

What was it like to go to Los Angeles to work at Gemini? Was it in part a vacation?

No. I never go anywhere to work that I think of as a vacation. I feel too much anxiety about my work. But I enjoyed it very much, working at Gemini. It was there, I guess, that I developed a pattern of working in series, because I would go out there for a certain length of time. Here in New York I was used to going to a print workshop for just a day. At Gemini, I usually thought of a group of related works that I could concentrate on during several weeks.

Is there a particular painting that relates to these latest prints?

Several paintings relate to them, but in a piecemeal fashion. And a number of recent drawings contain similar elements.

Is that a trompe l'oeil frame?

You mean the wooden part? I think of it as the back of a stretcher. I hadn't thought of it as a frame. You see, here I have the little stretcher keys.

Are the letters reversed?

The letters are not reversed; they are simply upside down. I intended that they be reversed, but after I had drawn them I realized that I had drawn them backwards, so they print forwards.

Have you ever before played with the illusion of the folded-over piece of paper?

I have on occasion. There is a drawing of flags from 1969 in which a corner has been bent back, something like this. But it began again when I made a poster for the Festival d'Automne in Paris last year. Someone had given me a Piranesi [Figure 7, page 62], and I was taken by his representation of folded paper, curling paper, so I used something like that in the poster. I have used it a couple of times since.

How did you decide to use the device of the folded paper at Gemini?

It was something amusing to play with. At first glance the Piranesi seemed to represent architectural studies. Later, I saw another level of representation, suggesting that the studies were on several unrolled sheets or pages. This complication, this other degree of "reality" or "unreality," interested me.

Johns deleting imagery from a lithography plate for *Cicada*, November 1981

Johns painting onto a lithography plate
for his *0 Through 9* project, 1978

Figure 7. Giovanni Battista Piranesi, *Del Castello Dell' Acqua Giulia*, 1761. Engraving, 21¼″ × 16⅛″. Collection of Jasper Johns; photo by Dorothy Zeidman.

Figure 8. Jasper Johns, *In the Studio*, 1982. Encaustic and collage on canvas with objects, 72″ × 48″. Collection of the artist.

What is the image you've paired with a Barnett Newman drawing?

Both small images represent drawings of Barney's, maybe upside down or backwards.

And the general background of the pictures is from the Grünewald altarpiece [the Isenheim Altarpiece, *c. 1510–1515, by Matthias Grünewald]?*

Yes. The tracing was made from the detail of the fallen soldiers [in *The Resurrection*, a section of the *Altarpiece*]. I think they're in a state of awe.

What is the source of the swirling pattern?

That's based on a photograph of a spiral galaxy. As I worked on copperplates for my "Seasons" etchings, some of the stars turned into small spirals. More recently, I've worked with the galaxy image on a larger scale.

In the last decade or so, it seems as if your work has increasingly been based on a kind of collage aesthetic, combining things that you've used before. Is that a fair comment?

It's certainly an ongoing activity, though countered by other things. Existing units become details in other works; something connects the images, but I don't know what it is. It's difficult to understand because it's not based on a decision, but on the activity of making pictures.

I've been fascinated by seeing the combination of Newman and Grünewald in your work of the last few years.

One thing that is interesting about art — about painting — is that we accept so many different kinds of things as painting. And certainly these seem superficially to suggest two poles — the Grünewald and the Newman.

It seems as if the 1982 painting In the Studio *[Figure 8] was the beginning of a very dramatic change in your work. When you look back, does that seem true?*

I continue to use the indication of a receding plane, which I think I first used there.

The familiar vase that you've used, with the profiles of Queen Elizabeth and Prince Philip, seems to have a new coloring here.

The patterning was suggested by George Ohr's pots, that kind of stippling and spotting.

Will the imagery in these two new prints continue into other works?

I have no idea. I'm working on a painting that somehow relates to these. I don't know what will follow it.

I find that if I use something (I don't know what "something" means, but "something"), I tend to use it again, even though I had no intention of using it again. In such circumstances, I don't know if something is a resource or a kind of habit — whether it's a good thing or a bad thing. I just know that I do it. I've used the Newman drawings in too many things for my taste, but that's the way my mind works. I can't do what I don't think to do.

Is it fair to call your frequent citations of Newman and Grünewald an act of homage?

I don't know whether that's the word or not. Obviously, it reflects an interest of mine. But I don't know whether "homage" is the right word.

In other words, inclusion doesn't show a lack of interest.

Yes, exactly.

Have you titled these prints, or do you plan to?

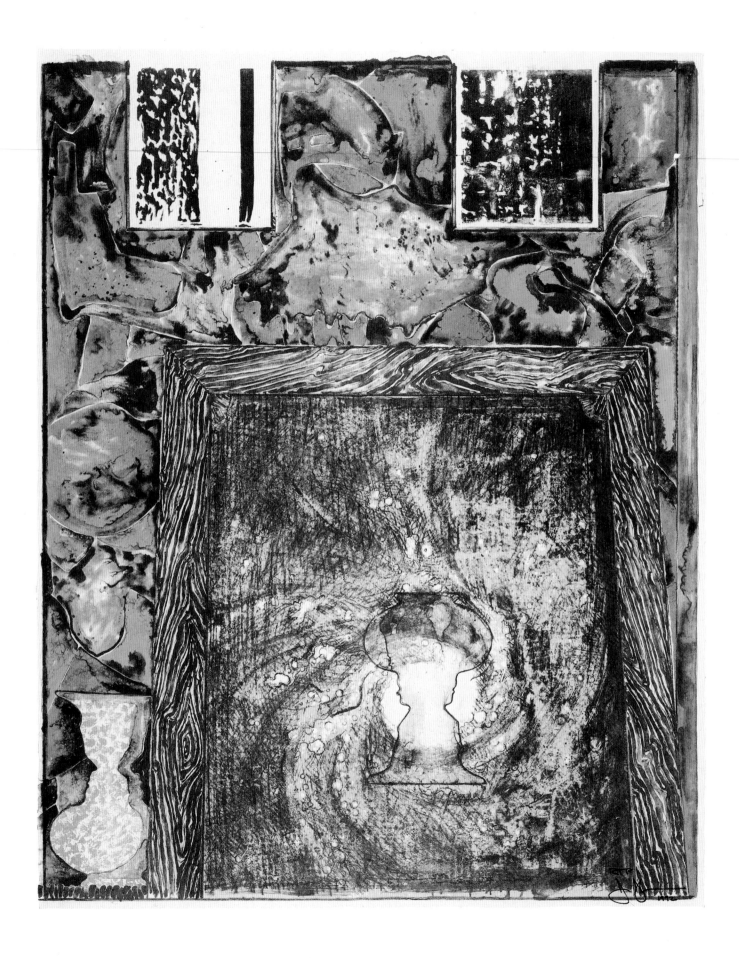

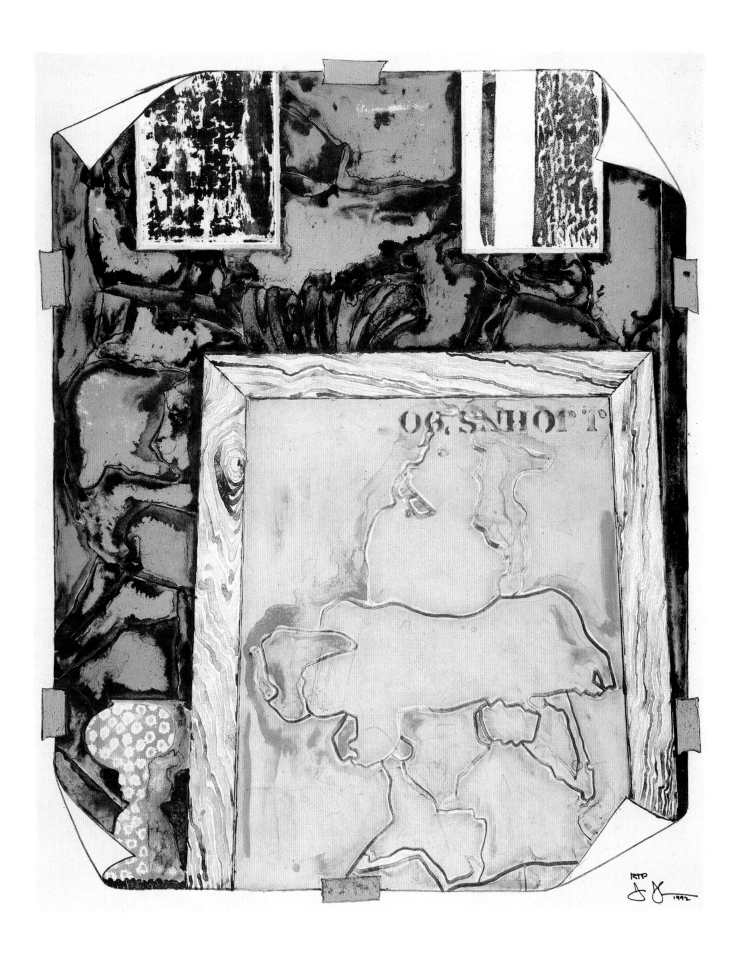

No. I think they will be untitled. I've thought about that. I would like to give works titles; but when I repeat so many images, I have to title them all the same, or number them. So I think they'll just be untitled.

Regarding the print you did to benefit the Harvey Gantt campaign [page 183], is the Grünewald detail that of the demon of the plague, from the Temptation of Saint Anthony [another section of the Altarpiece]?

He is the demon, yes, upside down.

How did you begin to use that shroud-like effect?

That started in some untitled etchings I did in Paris, and then appeared again in *Perilous Night* [1982]. It may have been triggered by a print of Picasso's that hung in Aldo Crommelynck's room, where we often had lunch — a print of a weeping woman with a handkerchief. In her hand? Between her teeth?

Such things are represented, but they're thin somehow. They are, as you were suggesting earlier, like collage, because they have no great depth.

The image that can be seen as either a duck or a rabbit has its source in the writings of Ludwig Wittgenstein, but was your interest in it based on a philosophical point made by him?

No. What interests me, in part, is that something can be seen in two different ways, and the question whether seeing it one way necessarily obliterates seeing it the other way. Or whether it's possible to see both at once.

What do you find to be the case?

I don't know. Sometimes I think that I'm able to see two things at once, but I'm not sure, because I play with that kind of material so much that there are probably very rapid shifts of perception.

That would be something to strive for.

Maybe it's something we do all the time. Certainly we can watch a television program and read the weather report that's being scrolled along the bottom of the screen at the same time. So what we see is made up, perhaps, of lots of things. In seeing one thing, we probably see many.

I wonder, though, with something as tricky as the duck-rabbit image, if the same can happen.

I don't know. As well as I can understand from what I've read, it's somewhat uncertain. But it may be possible.

September 2, 1992, New York

Johns (left) and Robert Rauschenberg at Gemini, October 1980

Ellsworth Kelly

How did your work in printmaking begin?

My first lithograph was done in Paris in 1949 at the École des Beaux-Arts, when I was a student there. But it wasn't until fifteen years later, in 1964, that I began to do prints in series. I had completed a silkscreen for the portfolio *Ten Works × Ten Painters* that Sam Wagstaff had directed and had printed in New Haven in 1964; then Dale McConathy, an associate of Betty Parsons, suggested that I try to work with Tatyana Grosman, who had a reputation for making extraordinary prints. All the artists who made prints with her worked in an Abstract Expressionist style, which was not my way of working. My idea for making prints naturally developed from my painting, which presents large shapes of flat color. When I proposed making lithographs based on a series of drawings developed from previous painting ideas, Mrs. Grosman said that she didn't like to work this way, that I shouldn't have a preconceived idea, and that any project I printed with her had to be a collaboration. She felt that what I was doing wasn't lithography. So we decided not to collaborate. But still I wanted to make prints that had large areas of color.

Later that autumn, in 1964, I traveled to Paris for an exhibition of my paintings and sculpture at the Galerie Maeght. At that time, Aimé Maeght suggested I make a print in Levallois, outside of Paris, where he had a printing establishment. When I presented the same set of drawings to Maeght's master printer, Marcel Durassier, he said that large areas of pure color are very difficult to print well; they are a real challenge. But I worked there for six weeks at the end of that year, and produced a suite of twenty-seven prints.

How do you feel now about that initial foray into printmaking?

It was very gratifying, but my knowledge of printmaking was limited, and I wasn't critical enough. Durassier was the printer of Georges Braque, Joan Miró, and Alberto Giacometti, but he had little experience with large flats of color. Later, when I started to make prints at Gemini, I benefited very much from Ken Tyler's craft. Tyler realized that you had to roll the ink on the plate without overlapping, and that a very even layer of ink should be on the plate. I think obtaining a large area of unbroken color is one of the most difficult things I've had to do in making prints over the years.

What qualities were you striving for in the flat areas of color [Figure 9]?

It's like doing a painting. I struggled over the same problem of painting a large area that doesn't look fabricated or industrial. I want a full, deep, solid shape of color, with the marks and gestures left out. I was looking at a Rothko the other day; his technique is quite fabulous, the way he would layer the paint. His paintings have a great dry look to them. I envy that. With my painting, I try to paint an area so that when viewed from a distance of about 10 feet, the surface marks are unseen. I don't want the eye to concentrate on surface; I want you to read the shape as a solid mass. But I don't want the color to look like it's been airbrushed or sprayed. It has to have a subtle texture that gives the work life.

Has the choice of colors ever been a limitation for you in working with prints?

No. Oil colors are very different from printing inks. In working with oils, I repaint until I achieve the color that I want. With inks, I usually have a preconceived idea that the printer tries to match, and we pull trial proofs until the color satisfies.

How did the lithographs of plants [Figure 10] come about?

Durassier had seen me draw, and suggested I develop some prints from my drawings. I went to a conservatory in Paris, where I made studies from flowers and leaves. I later drew them onto transfer paper that Durassier transferred to a stone, so that my original drawings were not printed in reverse. He told me that Giacometti had used this

Kelly walking in front of his painting *Color for Large Wall* (1951) at Museum of Modern Art, New York, April 1981

method. Over Christmas of that year, I spent time at the Fondation Maeght in Saint-Paul-de-Vence, and came back to Paris with other drawings of plants. A dozen prints were made then, and later, during another visit to France in 1965, I continued the series so that it totaled twenty-eight prints.

Does a print usually follow a painting?

Yes, a print is a distillation of a painting idea. Whereas the painting is made up of a color panel hung on the wall, in the print the wall becomes the white paper. I believe a print makes the idea of the painting more visible.

I don't believe that my paintings can be commercially reproduced. A reproduction of a painting means little to me; you have to see the painting itself to experience the scale, the color, the three-dimensional presence of the work. However, with the print the form and color are present on a smaller scale, in two dimensions.

How did your association with Gemini begin?

In 1970 Frank Stella, who had been at Gemini, suggested that I also work there.

Has working with prints led you to new ideas in terms of surface treatment?

I've always wanted to do something that would have gesture. But I didn't want to have it look man-made, or as if it was *I* who made it, or to have that kind of expressionist gesture that, say, Robert Rauschenberg or Jasper Johns exhibits.

Starting in the mid-1980s, it seemed that printmaking became a vehicle for you to start to get at that gesture, when it hadn't become evident in the paintings.

The texture began with the "St. Martin" series [Figure 11, page 79]. I covered large aluminum plates with various brush marks. I wanted them to be anonymous, with chance markings. The curved forms were made from these plates.

This latest series of faces has a similar sense of incidental gesture or texture.

I tried to make it look as though each image was something that I hadn't done. I wanted to obliterate my own hand in some way, and also to have that allover surface.
 I've always wanted to get the personality out of the work.

Do you see the faces as a unique development in your work?

I don't think it's such a detour. Starting from the late forties to the early fifties in Paris, I've always liked the Surrealist approach to drawing. I have always searched for ways that art might compose itself. Early on I would use architectural motifs that were in some sense bizarre or unrecognizable. I didn't want to invent. At that time I was doing collage work [Figure 12, page 79] and reading about Dada and Surrealism, about how the artists worked: cutting up and rearranging a drawing with their eyes closed. By drawing with my eyes closed or with my left hand, I wasn't making a decision about composition.

In the case of the prints that have the images of Jack Shear and you, what was the source?

They began, about three or four years earlier, with snapshots that I enlarged using a Xerox until the faces lost a recognizable quality. I wasn't thinking of doing anything with them, just experimenting. The black-and-white prints came first; during the printing, the idea of putting the faces on a spectrum developed.

Your concept echoes a couple of precedents, including works by Andy Warhol, although yours are dematerialized people, and one might not realize that each is a face. The other thought that occurred to me, I guess because I was recently at the Museum of Fine Arts in Boston looking at the Monet series show, is that in your series the face is seen in a number of different lights or spectral shades.

Figure 9. Ellsworth Kelly, *Orange/Green*, 1970. 2-color lithograph, 41½″ × 30¼″. Published by Gemini G.E.L.

Figure 10. Ellsworth Kelly, *Ilanthus Leaves (Vernis du Japon I)*, 1964. Black lithograph, 28⅝″ × 41⅜″. Published by Maeght Editeur, Paris, France.

Kelly (left) with Jack Shear in Sidney Felsen's office at Gemini, June 1988

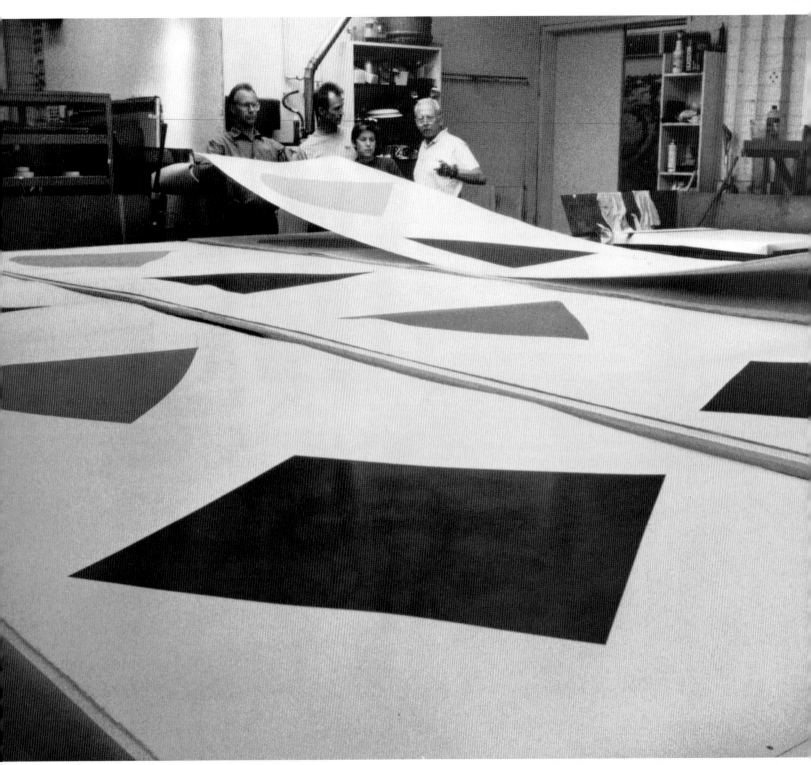

Kelly (right), assisted by Rob Hollister (left), Ken Farley, and Mari Andrews, during signing of *Purple/Red/Gray/Orange*, 1988

The Boston Museum has many Monets, and, when I was a student there, I studied the Rouen Cathedral paintings. I agree that my portraits are similar to those paintings in that they are frontal and squeeze the form to the edge of the print, and that there are many color variations.

It seems that these prints synthesize numerous of your practices.

Including the idea of making works in separate panels.

When I was in Paris in the early fifties, I felt that I was on to something quite different from the kind of geometric abstraction that had happened earlier and was still current in France. There was a whole school of geometric artists who had developed from the Constructivists; to avoid it I felt I had to turn about-face from this and do something else. That's when I felt that I wanted to break up the canvases. I began separating colors by using panels.

What strikes me about your series of faces is that, given your history as an abstract artist, there is a bit of risk involved in your doing them.

I felt that they were personal; I've done portrait drawings and photographs that I've never shown. I didn't feel they were central to the other work, but then, the longer I looked at them, the more I lost that feeling. They were just like playing, and they became more important because of their chance effects. Finally, I got used to them, and felt, yes, I could do it. But I knew that people might probably pick up on the fact that repeated faces on a spectrum are like Warhol, even though I had done a spectrum as early as 1952; Andy had said that he liked my early monochrome canvases.[1] But I think that we each come to the same thing from different avenues, which allows new things to happen. I wanted to enlarge the faces so that they became texture, almost indistinguishable.

Is the series of faces one of the rare times in your work when a print was not the direct sequel to a painting?

Yes, although I doubt if I would do a painting like that, but who knows?

Earlier, you said that you were interested in a surface that was, in effect, found, that you wanted to de-emphasize choice. I recall Johns saying that he liked the flags and targets as subject matter because no decision about the depiction of the subject had to be made. Is this a concern of your generation of American artists?

This was a reaction to the Abstract Expressionists and the School of Paris. When I arrived in Paris I became interested in pre-Renaissance art, especially Romanesque. I was attracted to the impersonal quality, and I wanted to make art that was anonymous.

What place does emotion have in your art?

I read somewhere that Willem de Kooning would fight the canvas; it would be a real gestural experience to apply the paint and to know where to stop. With a Jackson Pollock or a De Kooning—the best ones—they're like a frenzy. I got the feeling that for them the act of painting was a real outpouring of emotion. This is different from the way I feel.

Do you believe that one's work manifests one's personality in some sense?

I have always wanted my personality not to overshadow my work. Whereas in other artists' works, one finds the content within the painting, I've always felt that I've taken the content, the so-called literary content or ideas, out of the painting. The content is the shape and the color, and how each echoes shapes and colors in one's surrounding. I want to have my art pick up on the realities of shapes in space.

Figure 11. Ellsworth Kelly, *Baie Rouge*, 1984. 2-color lithograph, 51″ × 52″. Published by Gemini G.E.L.

Figure 12. Ellsworth Kelly, *Brush Strokes Cut into 35 Squares and Arranged by Chance*, 1951. Ink/collage, 4″ × 5⅝″. Collection of the artist.

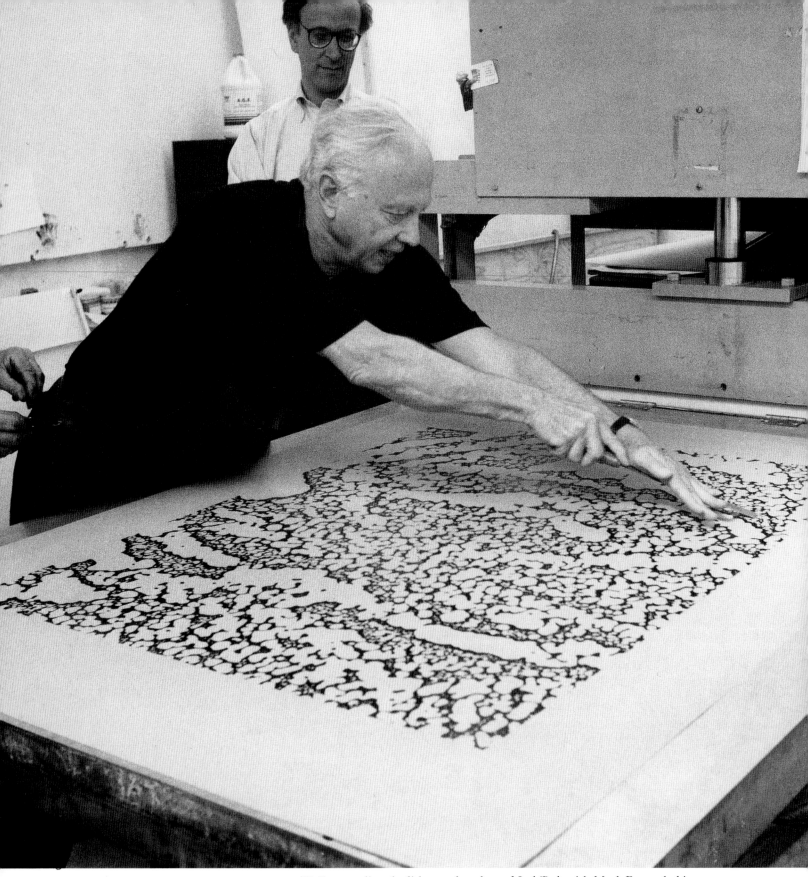

Kelly canceling the lithography plate of *Jack/Red*, with Mark Rosenthal in background, February 1990

Do you feel that the aspirations you have had as an artist during the last forty years still pertain, or have you started to form another kind of aspiration?

My work has always been about vision, the process of seeing. Each work of art is a fragment of a larger context. You don't read it as being on its own; the situation is open. With most other art, when you look at the art object you don't see other incidental things in the room, such as shadows that are, themselves, strong presences. You tend to read those out. I want the form and the color of my paintings to relate with the abstract qualities in the room, rather than to be seen for themselves alone.

As a student at the school of the Boston Museum of Fine Arts, I painted and drew from the nude, in the academic manner. Even though at the time I wasn't interested in painting academically, I believe it was an invaluable experience, for it taught me how to see. When I first went to Paris in 1948, I became intrigued with the idea of doing something that's not quite visible or that's read as an abstraction. I've always been interested in things that I see that don't make sense out of context, that lead you into something else.

June 1990, Los Angeles; January 1991, New York

Note
1. "I always liked Ellsworth's work, and that's why I always painted a blank canvas." Quoted in Barry Blinderman, "Modern 'Myths': An Interview with Andy Warhol," *Arts Magazine*, vol. 56, no. 2 (October 1981), p. 145.

Edward Kienholz and Nancy Reddin Kienholz

Regarding the newest work you've done at Gemini, entitled Bound Duck *[page 87], what was the source of the leather cap on the abstract sheet-metal figure?*

NRK: We found it in Berlin, where we live part of the year. The cap is part of a German pilot's uniform from World War I.

EK: Of course today one sees that kind of cap in America too, but more frequently associated with motorcycles than with war.

What do you like about life in Berlin?

NRK: We have lived in Berlin since 1973, so we have many good friends there; also, Ed loves being in an atmosphere in which he doesn't understand what is being said. He says it leaves his mind uncluttered and sets him free of overheard small talk. Berlin is a great town for artists; there are so many serious people there, it's very stimulating. And of course we do like the restaurants and the nightlife.

Does life in Berlin offer a lot of source material for you?

EK: Certainly to some extent, as most of our work turns out to be a reflection of where we are and what we are thinking and doing.

Do you feel an affinity with the German sensibility?

EK: Not particularly. Anyway, it is Berlin specifically that we enjoy, and much less Germany as a whole.

Where did you find the sheet-metal torsos for the Bound Duck *works?*

EK: We have them fabricated in Berlin. They are made like heating or air conditioning ducts, and are the main body of the figures.

NRK: Further, each body is topped by a half-hemispherical sheet-metal ball that was also made in Berlin.

And the arm?

NRK: It was cast in America. We have used the image of an arm holding a duck for a number of years. Like an ordinary chair, the arm indicates human presence.

Is it severed?

NRK: We never think of it that way.

How were the Gemini Bound Duck *pieces put together?*

EK: After the parts were fabricated in Europe and in California, they were assembled in Los Angeles. Nancy and I flew there last year with our assistants to apply the final fiberglass coating and sign the edition.

It seems as if there is often in your work, including the Bound Duck, *a sense of some crime having been committed or the memory of an unpleasant event.*

EK: Perhaps. Certainly if you hold a bird, impeding its wings, it is helpless and distressed. To us the arms and the bound ducks represent people with their human imperfections and hidden secrets. All of us have such aspects, and mostly we don't like to acknowledge or discuss them.

In your minds, does the Bound Duck *have anything to do with nature being trapped, hunted, or destroyed?*

EK: Not at all.

So there are no social issues involved here relating to your experiences living in the West?

NRK: No.

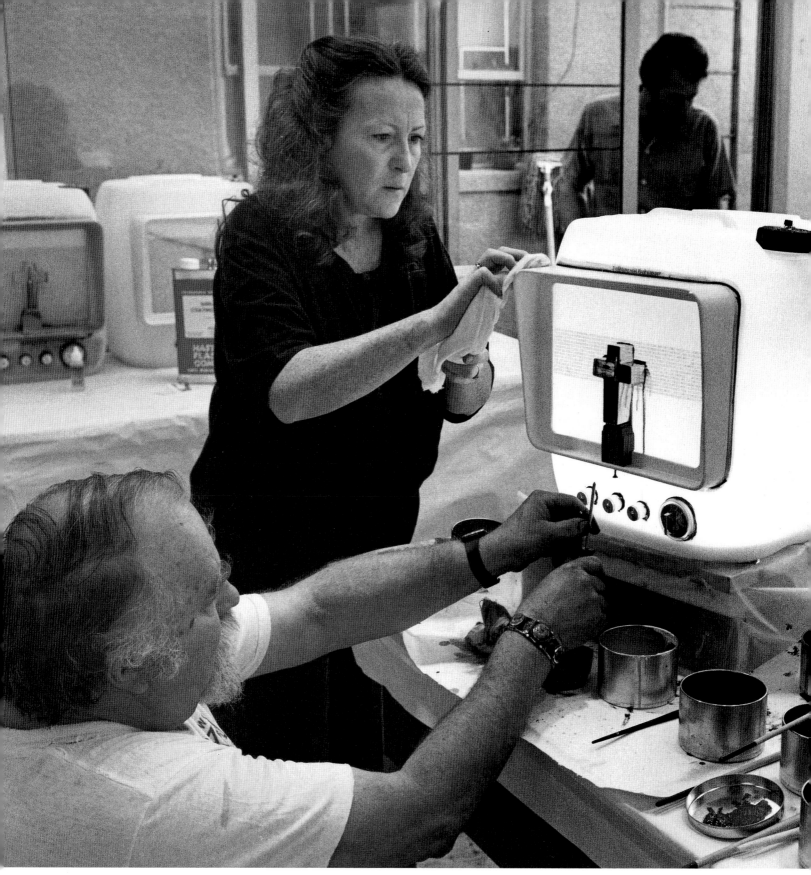

Edward and Nancy Reddin Kienholz putting the final touches on *Double Cross*, with Jeff Sanders in background, winter 1987

Edward Kienholz with *Bound Duck — Black*, November 1989

Facing page: Edward Kienholz and
Nancy Reddin Kienholz, *Bound Duck —
Black*, 1990 (checklist no. 54)

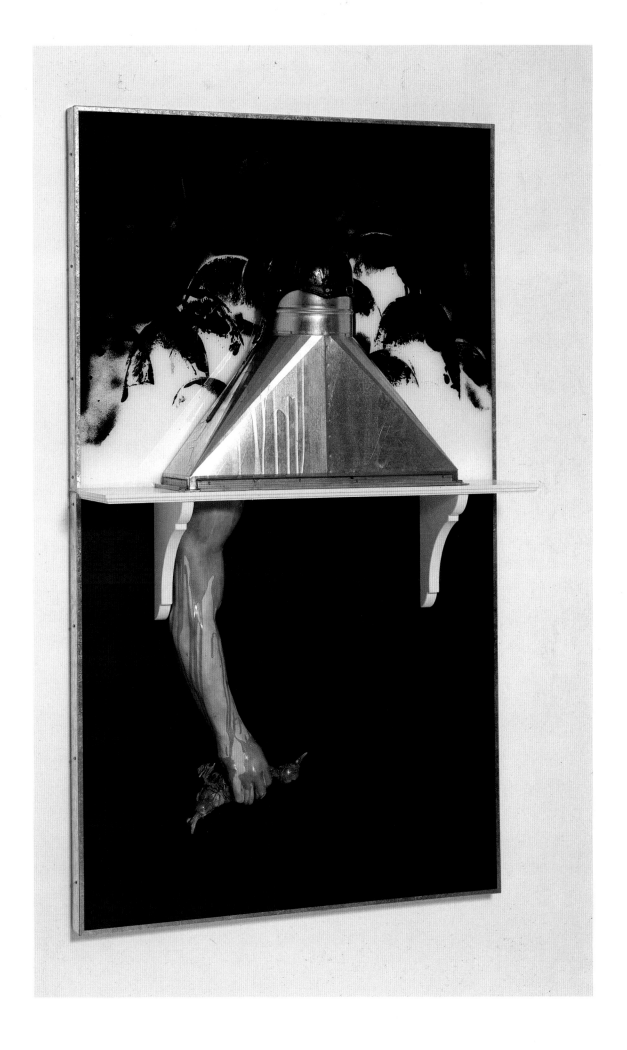

Are these images in any sense a "portrait" of an individual or a type of individual, and if so, how would you characterize that person?

NRK: No, they are not intended as actual portraits, only stereotypically.

Do you see art as having a practical social function, and if so, how would you characterize it?

EK: If art or anything else stimulates a person to think, I would call that beneficial.

Do you approach ideas for prints as a different arena from the rest of your work?

NRK: No, only the techniques vary.

Do you seek to suggest in these works, as you do elsewhere, a specific locale, such as Germany?

NRK: Not at all.

EK: I don't think of the work as being so specific. As I've been quoted before, I think of myself as an animal going through the woods (life), leaving a trail. The viewer then follows the spoor to a place where I, the artist, disappear. The viewer then has a number of possible directions or thought options to work out. I like this system of dual involvement.

What inspires your works?

NRK: Mostly we will be bothered by something, by some news event or experience. Usually we then make a work of art to deal with it, to help clear our minds, to sort things out. We're truly saddened by senseless events, especially the ones that show that people do not know or understand the value of life.

EK: The fact that many innocent people have been killed in the desert recently is especially disturbing just now.

September 19, 1991, Hope, Idaho

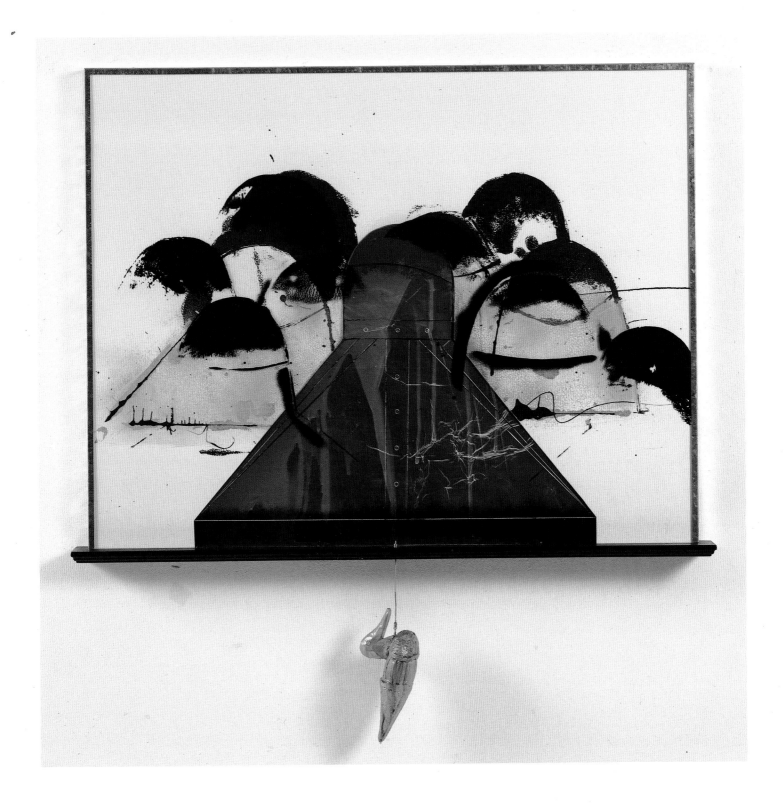

Roy Lichtenstein

When you first began to make prints, how did the technique relate to your other work?

This kind of working was very indirect, just as my painting became relatively indirect in the sixties. In printmaking, that a shape might be given (or drawn on a stone in black) and then later made whatever color you wanted, was sort of interesting, although at the beginning I used very few colors.

Before your new "Interior Series" at Gemini, has printmaking ever been a medium for you to experiment with ahead of painting?

This is the only time that's occurred. In general, a new idea would appear in a painting, and then be continued in a series of prints.

Has working at Gemini as opposed to other shops inspired any particular artistic thinking?

Each shop has its particular character. I think my initial interest was in going out to the West Coast in the middle of a New York winter, to live at the Marmont, to have a rented car, and that sort of thing.

Hollywood!

Of course. You lived in a bright, sunny way, and your phone wasn't ringing. That was great. I liked that experience a lot.

What is working at Gemini like?

I think you are more in control at Gemini, not that you can't be in control at other places. At Gemini, there are very good people, but there isn't that sort of master printer who presents ideas. However the work is going to be done, you initiate it, and you decide.

How did the "Interior Series" evolve?

I had planned to do them before I went to Los Angeles. It was an idea I kept having about the way rooms look in the yellow pages of the phone book. That's mostly where they come from, usually from ads for mirrors, upholstery, or something of that kind.

When I was in Italy, I noticed along the highway a sign about furniture that had the right appearance, and that spurred me into thinking about this imagery again.

When was that?

It was in the spring of 1989, when I was at the American Academy in Rome. That's when I did this valuable research in the yellow pages of the Rome telephone book.

Did you vary the compositions of the ads for the "Interior Series" a great deal?

I maintained the corner of the room situation and its perspective. I might add a mirror where there wasn't one, or substitute a different painting, or add a second painting. The little objects were usually different, but the basic concept was very much the same.

I actually projected the raw image from the advertisement and drew over it, which I usually don't do. I usually project my own drawing, not someone else's drawing. For these works, I projected the image on heavy tracing paper and drew on both sides a number of times.

And that's how you arrived at the compositions?

Yes. It's very hard to do because the originals are so brittle. I had to keep the composition somewhat the same but change it so it worked. And of course I wanted to restructure it, which was fun and which was the whole idea of the project; but this was harder to do than I had thought, because I kept wondering if I was reordering or copying. Finally, it became my drawing.

Lichtenstein working on his "Paintings" series at Gemini, March 1983. Part of an image from *Two Paintings* had been cut out by one of the printers and made into a mask.

It seems these works are in part about the practice of drawing.

The series is partly an architect's plan, and it's partly about how you learn to draw in commercial art school — the rigidity and unrealistic quality of the drawing. That's always been interesting to me — to show that an image is a mirror by putting streaks through it. Everything has its definite edge; you never really see nature this way.

Would you describe how the "Interior Series" was done?

The people at Gemini projected my initial collages (which were smaller) on a wooden board, to a size that I had determined earlier. They traced the lines in light blue pencil; I redrew them and then drew them again using black photographer's tape, which has the right thickness and meant the lines would be black.

When you say that you redrew them in black tape, you mean that you put the tape down over your own drawn lines?

Yes. But I tried to disregard my drawing to a certain extent and replace every line. That way, I could really see how the image might look in black and white, which makes it much more visible. Then I drew lines on either side of the tape, which was easy to do because I used the tape as a guide. Finally, I took the tape off and cut the edge of the line. Then the staff cut the wood material out, leaving the lines.

It's very hard to print these large works if there is the slightest depression in the wood, because even a microscopic depression makes a difference in the darkness of the image.

Of course, the Gemini people printed a proof, and I corrected that. This means they cut the wood again to make the changes. They could add to it, but that's difficult; it's easier to take some away.

What was your idea about color in these prints?

The color was supposed to be as strange as possible or as bound within the objects as I could make it. I wanted to isolate an object completely with the lines around it, and to give it its own color. The work was to appear to be all subject, so I had to decide how to delineate it: How should I draw a couch? Should I make the color local and silly? Or I used two greens or two yellows, one on a lamp base and one on a wall to set up some confusion in the middle. Because the drawing's so odd, the viewer doesn't immediately realize that the color is too. But if you think about the way it's done as compared with that in a traditional painting, it looks very silly or very odd.

Do you think your ideas behind this print series could be transformed into paintings?

Yes. I wouldn't reuse these images, but do something similar. I've actually begun to accumulate certain materials. I'll draw something, and then I might project it up to the size I think would be interesting to see on the wall. I'm thinking of doing fairly large paintings, 10 feet by 13 feet. I also hope to do these prints in a wallpaper.

Have you ever made wallpaper?

Yes, come to think of it. During the late sixties, Burt Stern had a store in New York called On First, and I did wallpaper for him. It was quite beautifully produced, on fabric, with a reflective, silvery part. It was an Art Deco repeat pattern.

I keep looking at the new prints, and wondering whether you intended to create a reflectiveness between the environment in which the print is installed and the imagery itself.

Well, that is partly why I thought of doing them as wallpaper. Sidney Felsen always takes pictures of everything at Gemini, and in one photograph my face was in front of one of these prints. It looks, in an odd way, as though I were really a part of the depicted space. And the space is so idiotic, yet for it to convince you that it has a reality is absurd. Then I thought if you had a room and could wallpaper one wall, that would make the room look bigger, but in this awkward way. This would set up a dialogue.

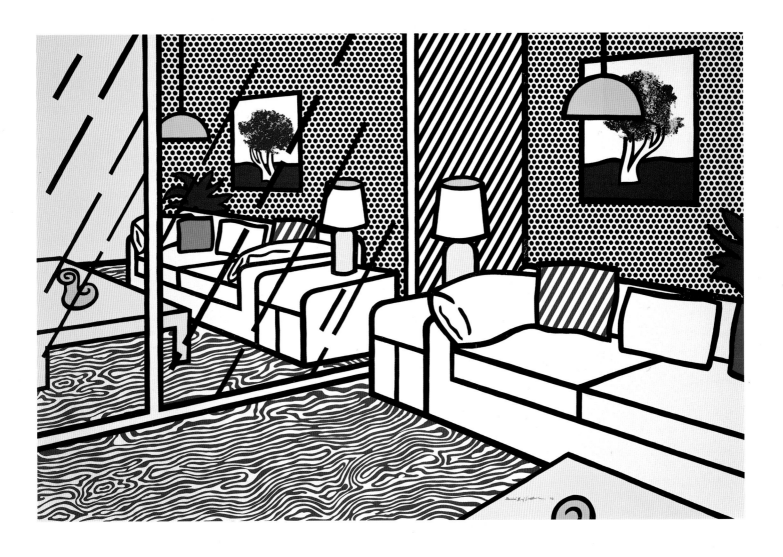

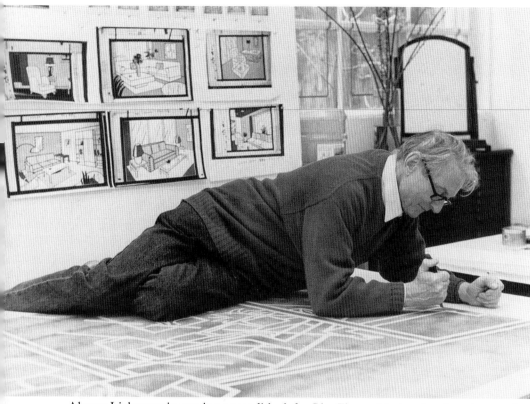

Above: Lichtenstein carving a woodblock for *Blue Floor*, with sketches for other works in his "Interior Series" on wall, February 1990; right: Lichtenstein (second from right) signing *Wallpaper with Blue Floor Interior*, La Paloma, March 1992

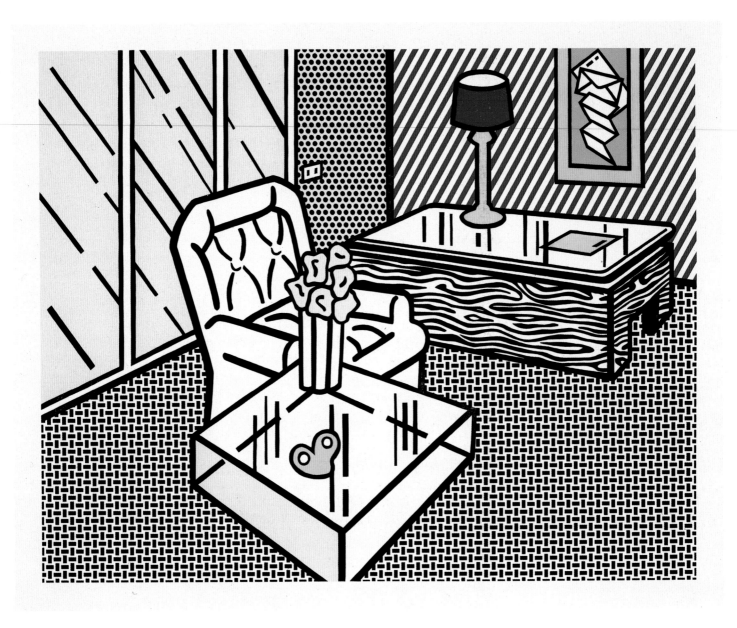

The dialogue would also stimulate a question as to whether one's living space is as nice as this one, and, if not, what one is missing. There is a kind of a "model home" quality about these images.

Each is devoid of anything personal. They are completely vacant. But they do have a few of my works or Andy Warhol's, or something like that.

You had painted some corners of rooms earlier [Figure 13], one with a lamp and mirror.

Yes. I did an "Office Furniture" series and an "Artist's Studio" group. They're the same idea, I suppose.

Besides the everyday aspect of these rooms, it seems as if there's also a play on a chic life style. Is that intended?

Yes — a little bit. Some of the rooms are a bit chic, but just as impersonal. In one [*The Den*], there is a Cubist painting for the office. And in one [*The Living Room*] is my ideal table-top sculpture.

But La Sortie *[page 107] is different, with a leg shown walking away.*

Oh, that's a Dagwood room, with Blondie. I thought that his chair and table were very recognizable things. I imagine people still know who Dagwood is these days!

How did you formulate this Dagwood image?

The room is from the comic strip; of course, I had done Blondie and Dagwood imagery earlier in a painting. Here, I thought that an image of just the furniture would have the same moronic look that these other rooms had but be a little different. It's a separate idea but somewhat related in that it, too, is an interior. And I thought it would be amusing that people would recognize it as Dagwood's room. And then I just got the idea of putting Blondie's leg in it, going out of the room.

Some of the plants were done with a sponge. I like that idea a lot. With a sponge you just give a squirt, and you get nature! I had to fool around for a long time to get the right sponge look. That was done with lithographic tusche.

You didn't necessarily think of these as the living rooms of people in New York rather than Florida; these are generic living rooms.

Yes, the kind for which you get a packaged living room set at a store, one that is advertised that way. And after you buy it, you stick all these namable things in your living room and turn on the TV.

For me, the images became a comment on our lives and on the amount of decorating that surrounds us.

They are. But, tempting as it is, I don't want to belabor the sociology. It is really the bad drawing that I'm trying to retain the character of, while restructuring it. And I'm trying to convey certain sensations or attitudes.

How would you characterize the series?

It has the "dumbness" I'm trying to get.

How much "dumbness" is actually in your work?

"Dumbness," as I see it, is a very inexact term, but it conveys a certain meaning to me. So long as my work is not "dumber" than I intend, I'm okay.

Has this "dumb" quality been in your work for long?

I have tried for it; even my line itself was supposed to look dumb. It did in the sixties, when the prevailing influences called for a calligraphic mark of varying shape, color, and texture. Almost nobody in the sixties would have put lines like mine in an image. They were thought of as too rigid and stupid. But now, I think, we are used to them.

It's acceptable, so now you have to find new ways of "out-dumbing" the opposition.

I'm trying.

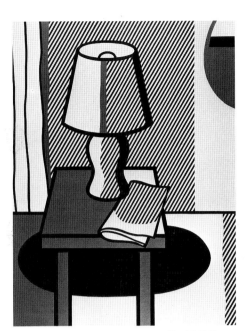

Figure 13. Roy Lichtenstein, *Still Life with Table Lamp*, 1976. Oil and magna on canvas, 74″ × 54″. © Roy Lichtenstein. Courtesy of Leo Castelli Gallery.

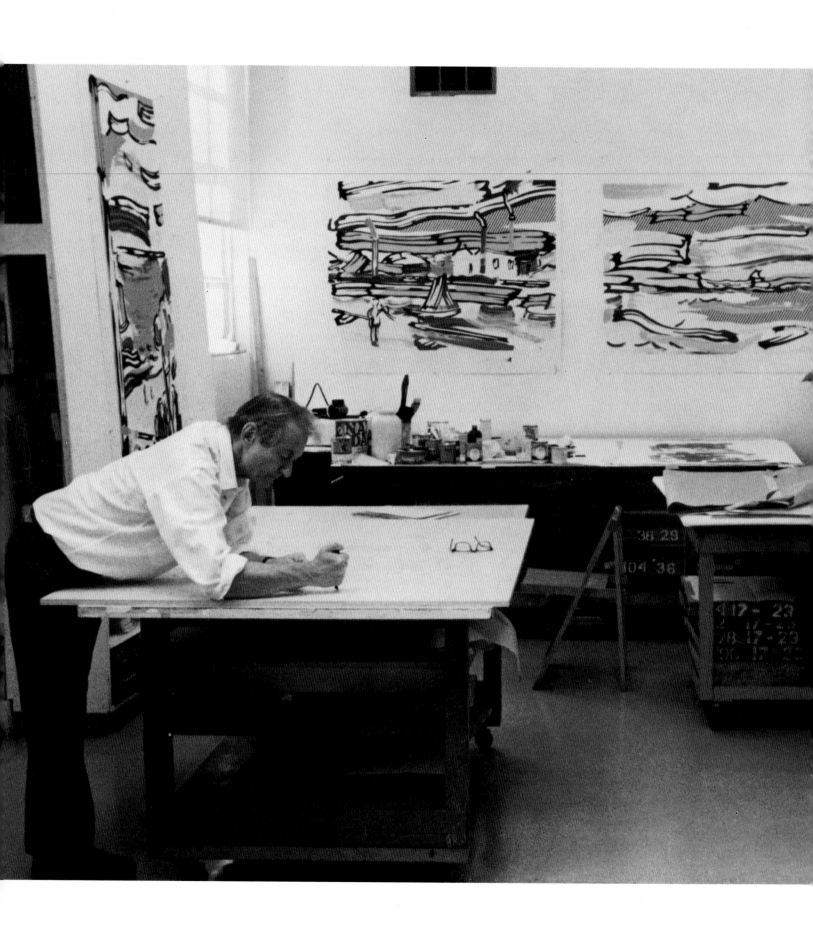

Left: Lichtenstein carving a woodblock for his "Landscapes" series at Gemini, 1985; above: Leo Castelli (left) and Lichtenstein with the artist's *Peace Through Chemistry* lithograph, Gemini, 1970 (photo by Malcolm Lubliner)

In one interview a number of years ago, you used the word "vulgarization" regarding your imagery, which in a certain way also seems appropriate to these images.

Of course, vulgarization has taken place almost steadily through the history of Western art. I want my work to look fake, copied, done by a printing press, impersonal, insensitive, and so on. This recent work is a kind of throwback, more like my early things than anything I've done recently, although I've been playing with earlier ideas in the "Reflection" paintings during the last few years.

While the term "Pop" has lost much of its meaning, maybe this idea of "vulgarization" holds as the hallmark of your own "Pop" style.

That may be.

During the twenties, there was a kind of utopian quality shared, for example, between the likes of Fernand Léger and Piet Mondrian. They seemed to be saying, "To hell with the individual, we're in an advanced new world."

But, even so, they were idealistic and perhaps sentimental: architects designing a city, good design for the masses. Now, that's all so remote and naive. No one believes that good design for the masses is going to work. There's really a marked difference between Pop and Léger or Bauhaus or Constructivism. Pop is meant to mimic more than to influence the environment. Perhaps it's tweaking those earlier ideals.

Do you feel cynical?

No. I don't feel cynical as a person at all. I can see humor and folly in certain ideas — in almost any philosophy, as a matter of fact.

I think it's the sentimentality attached to most philosophy that I object to. I have a philosophy, but I don't know that I can articulate it. It doesn't actually give hope to mankind's future or some such thing; it has nothing to do with that.

What does it have to do with?

We may never see things clearly or be truly enlightened because we have only the senses we developed while adapting to our terrestrial environment, senses that are sometimes extended with scientific devices. But we can raise the level of the abstraction of our thinking. We might postulate how matter and life were brought into being, but we always have to reexamine our assumptions (and maybe even this assumption).

But I still work every day and think I'm doing something. I don't think it is for any reason, except maybe enlightenment. You interact with your world or your work, and that interaction organizes your brain. There is a certain given in the brain, but a certain amount of it is created through interaction with an artwork. You become more sensitive (or perhaps less sensitive) to certain things. That's the purpose, really. You create an organized complexity that makes your life interesting...and then you die! And that's all there is. And you try to be good to people and to do as many good things as possible. You don't have to do that, but action changes you.

Why do you like working in woodcut?

Ah! Right from the ridiculous to the sublime! Because it's more difficult. I try to make the line perfect in a painting, but I can't, and that has a certain interest. The same is true in wood: you can't easily cut wood to make it come out perfectly, which gives me something to struggle against. The wood has a certain power that is evident to me, so now I try to make that the basis of all of these prints.

I didn't realize that so many of your prints have been woodcuts.

Yes, starting with the Indian woodcuts that I did at Tyler Graphics. That project made me think about German Expressionist woodcuts, which led to the prints I did at Gemini [Figure 14]. After that, I did some paintings that *look* like Expressionist

Figure 14. Roy Lichtenstein, *Head*, 1980. 7-color woodcut with embossing, 40″ × 33¾″. Published by Gemini G.E.L.

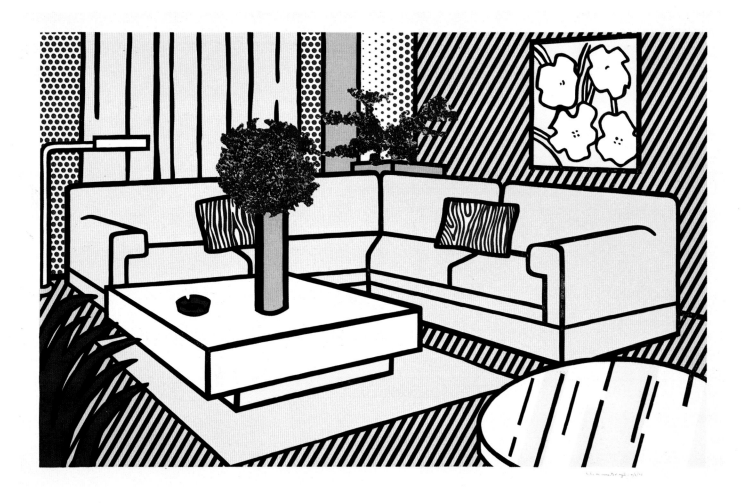

Lichtenstein at work on the "Interior Series" in 1990: at left, sponging Cel-Vinyl onto Mylar to create plant imagery for *Yellow Vase;* above, working with black tape on a woodblock for *Blue Floor*

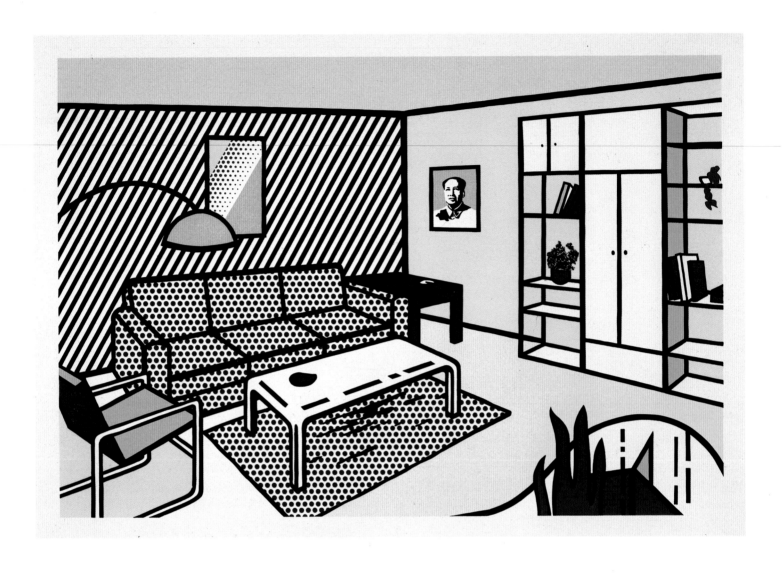

woodcuts, and since then I've used woodcuts for the basic lines and some of the colors in most of my prints. It depends. But it's very hard to get the right amount of ink to make those light, bright colors that I need, so they end up being silkscreened. I also use lithography with most woodcuts.

How do you relate the woodcut look to other aspects of your work?

At first, woodcuts were interesting to me because I wasn't using brushstrokes yet. Then I thought of using cartoon brushstrokes to make objects, and after that I started combining real brushstrokes with cartoon brushstrokes. That was in the "Landscapes" series I did. I still enjoy seeing that kind of real paint smear next to a fake brushstroke. It points up the artificiality of the fake brushstrokes. There's a long history in painting since Titian showing clearly that the subject matter of all painting is composed of brushstrokes. Besides being self-referential, they give a painting a bravura and virtu- oso look.

I was interested when you started exploring the German subjects because for years I had thought of your work firmly in relation to the French, as a kind of Cubist reordering of experience.

I still have my early influence of Cubist Picasso, which I've been running away from all my life. I think that's the biggest influence of the twentieth century. It wasn't until I "did" a Picasso that I felt liberated from its presence, but I think some things of mine are still very influenced by Cubism anyway. My early works of separate objects on blank grounds were really an attempt to get away from Cubism. Using German Expressionist brushstrokes was another. Of course, some German Expressionism is influenced by Cubism.

I also regard you as the sustainer of a great tradition started by Léger. I thought of this again when I saw your painting at the Equitable Center in New York, with its Everyman quality of imagery, its boldness, and, of course, its mural scale.

Léger is in that. I mean, he had to be.

Do you enjoy working at that scale?

Very much. I love how public it is, and I have to feel surrounded by color.

Do you find yourself trying for a level of perfectionism in working with prints that you don't have in your paintings, or vice versa?

I think it's about the same. I'm a little bit meticulous, although there are certain irreg- ularities that I like and want. But I do keep refining, probably much more than anyone can perceive.

In a way, a process like the one you used to produce these prints gives you a chance to be more precise, because you can whip something off and drop something back in.

Yes. That's something that I like a lot—the ease with which I can change a work, and then have somebody else to do the rest to complete it.

In a sense, you employ a collage aesthetic.

That's right. It *is* like collaging, which I do a lot in my paintings. I start something and keep adding to it—putting pieces of paper down temporarily and looking at the image. Because to do all those graduated dots and dotted areas and diagonal areas and then take them all off and redo the painting is punishing work (although not at all impossible). It's just much easier to try it out first in collage to get everything I want.

September 1990, Southampton, New York

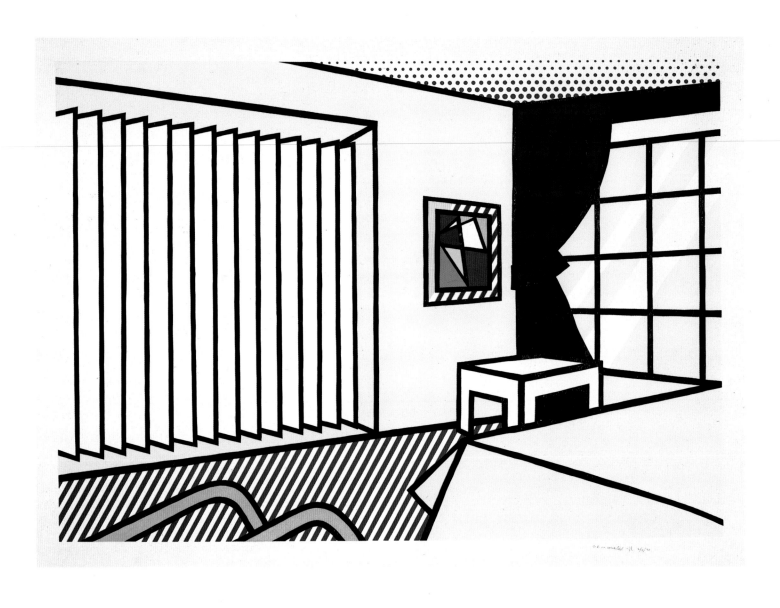

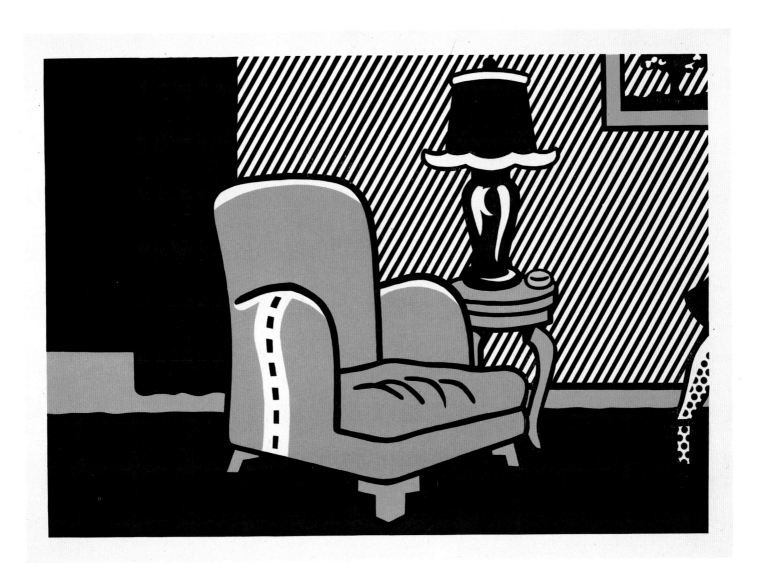

Malcolm Morley

During Gemini's twenty-fifth anniversary celebration, Malcolm Morley produced one print at the workshop, *Erotic Fruitos* (page 111). Although Morley was gracious enough to consent to a brief interview, he generally prefers not to talk about his work. "All that I might say," he remarked, "is contained within the works themselves." With respect for this view, we have chosen simply to reproduce the print, allowing it to offer its own commentary.

Above: Morley on Melrose Avenue in front of Gemini, with rainbow in background, October 1987; right: the artist painting onto copperplate for *Rite of Passage*, 1988

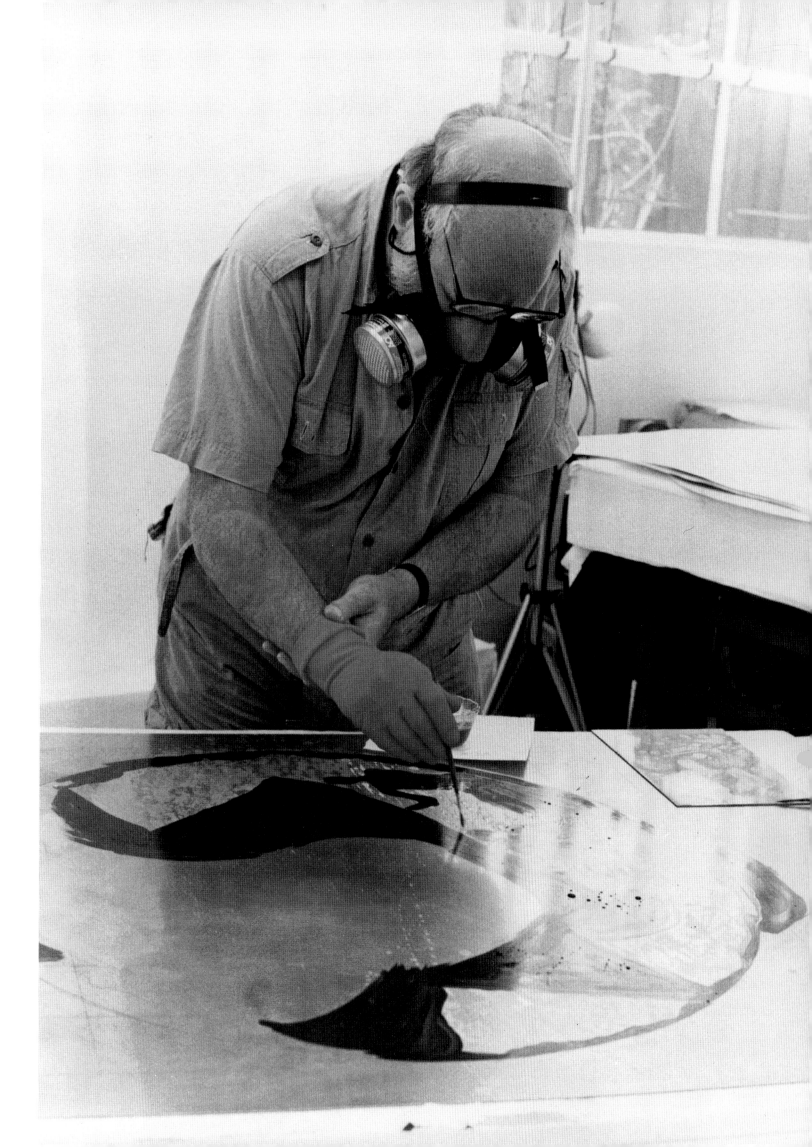

Morley at the Gemini workshop, 1987

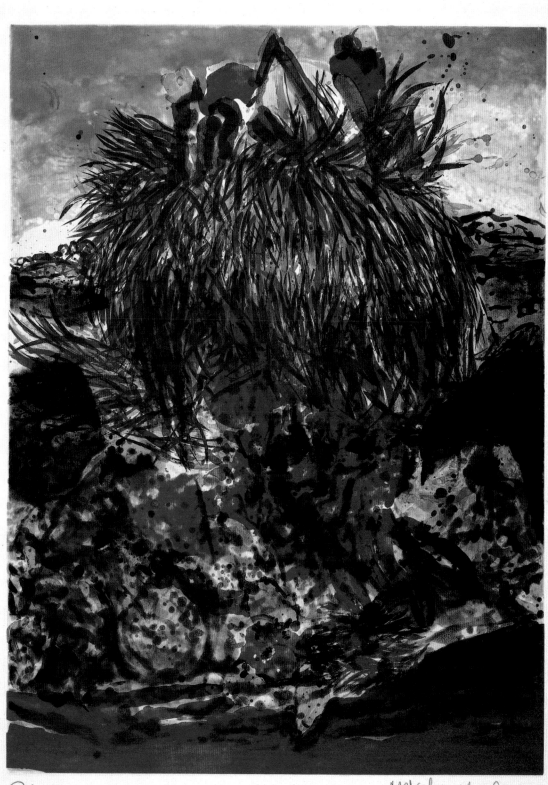

RTP. Malcolm Morley

Claes
Oldenburg

I went in January of 1968 and stayed about three months. I started to work in two directions. One was lithography, which became the *Notes* portfolio; the other was the *Airflow* multiple. The portfolio was about colossal monuments in the context of Los Angeles and also about different approaches to the print medium. It was finished during that period and published the same year.

The plan for the *Airflow* had originally been more ambitious: to make a whole portfolio with different sections of the car—three-dimensional objects like the tail-lights, parts of the motor, and lithographs of the inside of its doors—to make a sort of anatomy of the car. But I overestimated my capacity in the time I had.

It would have been a monstrous job.

Yes. The studies for those projects were given to the Walker Art Center in Minneapolis. They have a complete record of the unrealized part of the *Airflow* project. However, the *Profile Airflow* was done, larger than most multiples. It was begun in 1968, but wasn't actually issued until the end of 1969. It was a lengthy project.

What was the atmosphere at Gemini at that time?

Gemini gave you the feeling that they could do anything you wanted. If you wanted to make an *Airflow* multiple that would cost a million dollars, that was okay. It was like that. And Los Angeles was a sort of paradise of technology; you had the feeling that all you had to do was look something up in the yellow pages, drive for three hours, and there would be some guy who would make whatever you wanted.

Gemini was a focal spot, too, for people coming through Los Angeles, which at that time was a fairly unknown place for New York artists. Los Angeles had been even more unknown when I first went in 1963. There was a well-established school of Los Angeles artists, who looked with disapproval on outsiders; they were the important ones on the scene, and you immediately had to deal with that and prove yourself. I always felt a little overshadowed by them because they could do things like surf and ride motorcycles, and they all seemed to smoke cigars. . . .

Was it a collision of East Coast–West Coast artists and life styles?

They had their own life styles and were very proud of it. Anyway, I managed to make peace with them, though I always felt like very much of an outsider. I always wore what seemed to be conservative clothes in that context. I looked very pale; I read the *New York Times;* I stayed at the Chateau Marmont, which is where all the foreigners—New Yorkers—stayed. I did eventually start smoking cigars and get a tan, but I never quite adopted the dress code.

But you seem to have gotten on well there?

It was an antidote to New York. The first time I went there, it was to get away from New York, to replace New York with something as much its opposite as possible. I went from the Lower East Side of New York to Venice, California. Both places had something in common in those days. A lot of people from the Lower East Side were living in Venice, older people with little shops just like they had had on the Lower East Side. When they came out of the stores, instead of looking at Avenue B, they looked at the Pacific. So that was a total change: the color, the vegetation, the life style, the technological paradise. It was, and has remained for me, an alternative to New York.

Was the idea of the multiple new for you when you went to California?

No, I had done several. Multiples were pretty far advanced in my thinking by the time I went out there. I conceived of them as an alternative to printmaking, or at least as a parallel. If someone asked me to make a print, I asked if I could make a multiple instead. I felt a little bit like I was on even terms with other artists in doing a multiple, whereas making a lithograph, at that time anyway, still seemed to be a special craft

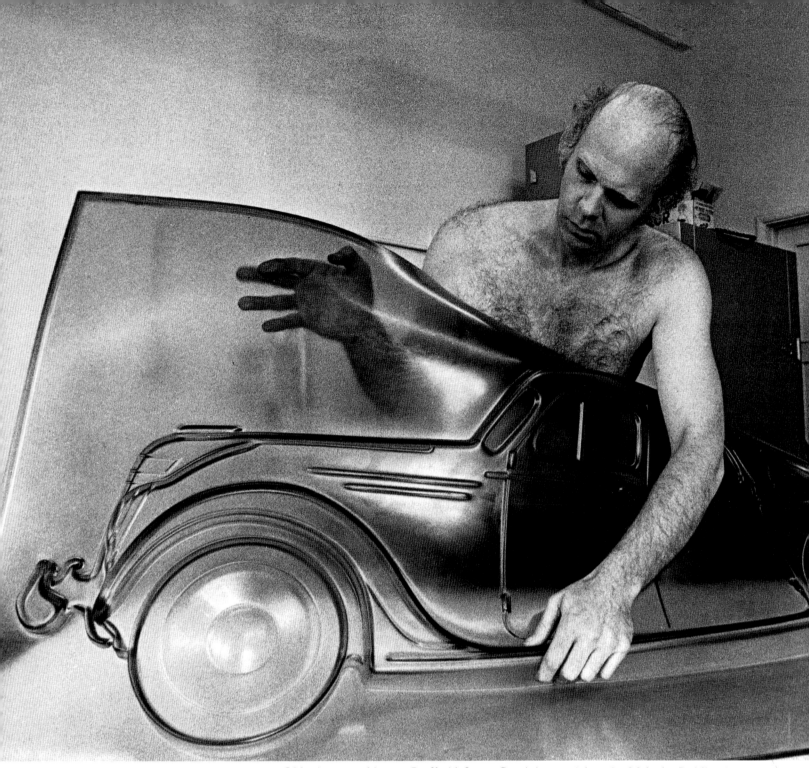

Oldenburg working on *Profile Airflow* at Gemini, 1968 (photo by Malcolm Lubliner)

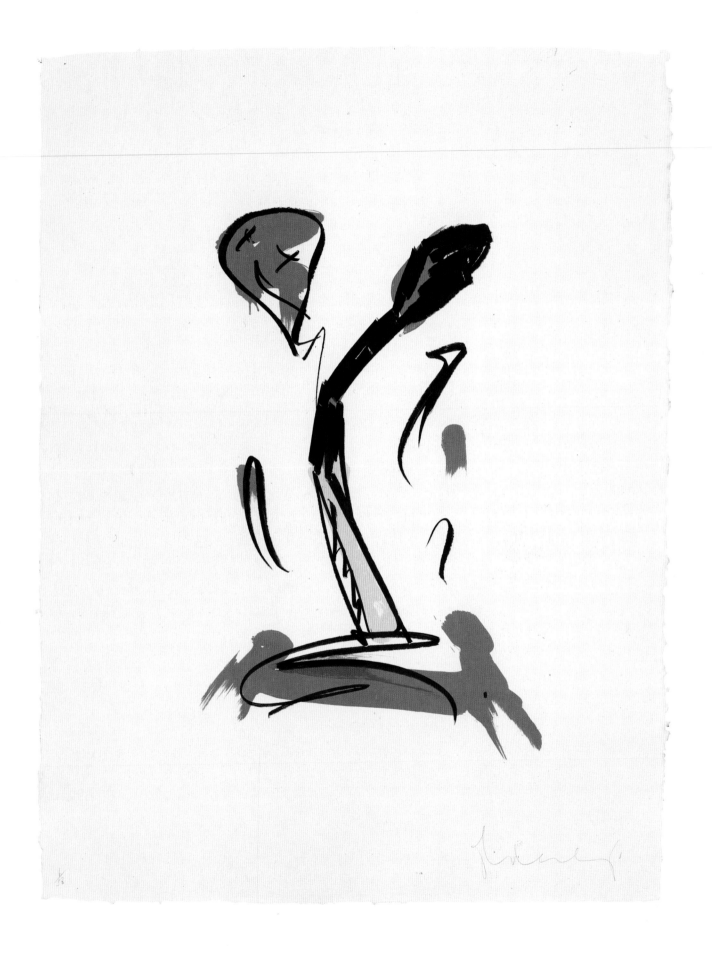

you had to learn. It seems less that way now. But at that time, still in the days of the Tamarind Workshop, there was a kind of ethic about preparing prints. And when I came into contact with a very skillful lithographer such as Jasper Johns, for example, I could see that one had to do quite a bit to reach that level, to get into the medium part of it. I started to explore lithography, but the multiple was a way of doing something in an edition that I found more inventive for my own purposes.

I was fascinated by mass production. That phenomenon seemed to be a part of the modern object, which existed not only in one item but in many, many items in the supermarket. Whenever I made a multiple, I always made an object that existed in reality in many examples, for instance, the baked potato, tea bag, or even a car.

The multiple was also a matter of scale. I enjoyed the scale-model aspect about it, the idea of something that seemed to be the same size as the original but always was either a little bit larger or a little bit smaller. I always tried to have the multiples photographed together, to see more than one at a time. I liked to imagine them in different situations, scattered around after they had been sold. I enjoyed the fact that they could occupy the same sort of space in a room that actual objects would occupy. Usually they were treated that way; if you went to someone's house and saw them, maybe a baked potato would be next to a flowerpot or a lamp. I was always comparing the artwork to something in the so-called real world. This was another way to do it.

Did the idea of the Sneaker Lace *[pages 116–120] start in Los Angeles?*

Yes, it was a drawing for a sculpture, and appeared in the first volume of the *Notes* [Figure 15]. It was stripped down to resemble a palm tree, an association that enabled me to increase and define the scale.

What are your associations with the Sneaker Lace? *Is it kid-oriented? I recall you once saying in your publication* Store Days, *"I am for the art of kids' smells."*

A sneaker lace was simply a motif for a sculpture, and actually it's associated with more than kids. Everybody wears sneakers.

In pornographic magazines I saw in 1963 in Los Angeles, models frequently wore sneakers with black stockings. On the other hand, the secretary walking to work in New York will wear the same combination for purely practical reasons.

Sneakers have all kinds of different associations, including having status and being cool. They're a pretty loaded item at this point, and different kinds of sneakers are constantly being developed. My laces, however, come from what used to be called "hightops," first used for sports like basketball.

In the 1980s Coosje van Bruggen, my collaborator, had the idea that the *Sneaker Lace* would make a good subject for a monument to Wallace Stevens. It had less to do with the sneaker as a sneaker than with its delicacy of form and resemblance to a skeleton.

The Sneaker Lace *does seem like a skeleton.*

Especially the sculptural version, which holds itself up by the laces. It's doing something that it really could do only if it were a spinal column.

So it has a kind of human dimension?

Yes. It's also like a discarded object: sneakers that have been ripped up and thrown out, like the objects in my *Haunted House* exhibition, an object you might find in a suburban backyard. So it has that corroded, entropic look to it, at least this Gemini version, as it finally turned out.

When I read your description of the Sneaker Lace, *with the mention of the tongue, I thought of your self-portrait with your tongue sticking out [Figure 16].*

A tongue is a curious word for something that is in a shoe. I've also done a tongue cloud. The tongue occurs often in my work.

Figure 15. Claes Oldenburg, *Notes (Gym Shoes)*, 1968. 6-color lithograph, 22^{11}/$_{16}$″ × 15³/₄″. Published by Gemini G.E.L.

Figure 16. Claes Oldenburg, *Symbolic Self-Portrait with Equals*, 1969. Pencil, crayon, spray enamel, watercolor, collage, 11″ × 7¹⁵/₁₆″. Collection of Moderna Museet, Stockholm.

Claes Oldenburg

Sneaker Lace in Landscape with Palm Trees, 1990 (checklist no. 86) *Sneaker Lace in Landscape—Line State,* 1990 (checklist no. 84)

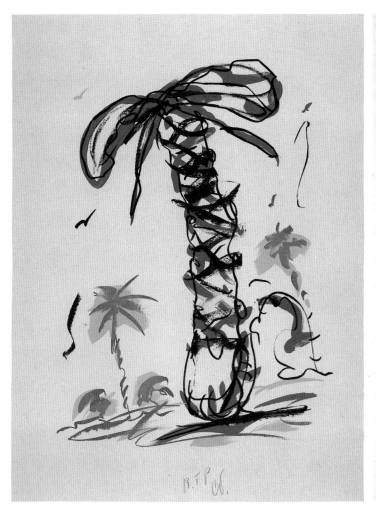 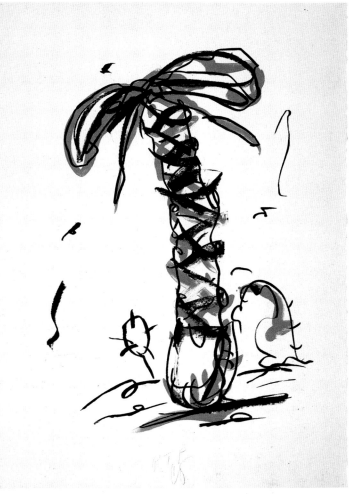

Facing page: Oldenburg (right), Ken
Farley (left), and Mark Mahaffey pulling
a proof for one of the *Sneaker Lace*
lithographs, August 1990

Claes Oldenburg
Study for Sneaker Lace — Black, 1990 (checklist no. 87) *Sneaker Lace in Landscape — Grey,* 1990 (checklist no. 83)

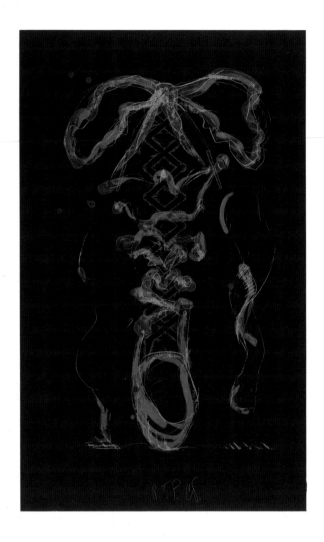

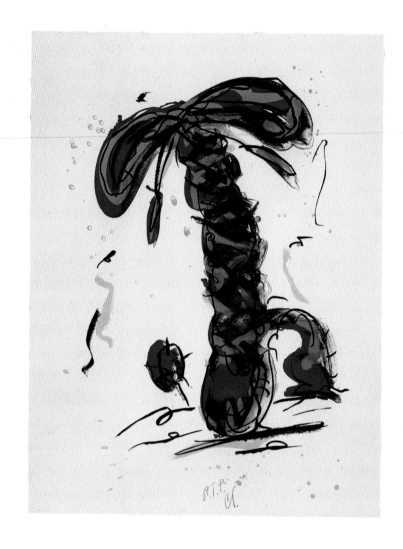

Facing page: Claes Oldenburg, *Sneaker Lace,* 1990 (checklist no. 81)

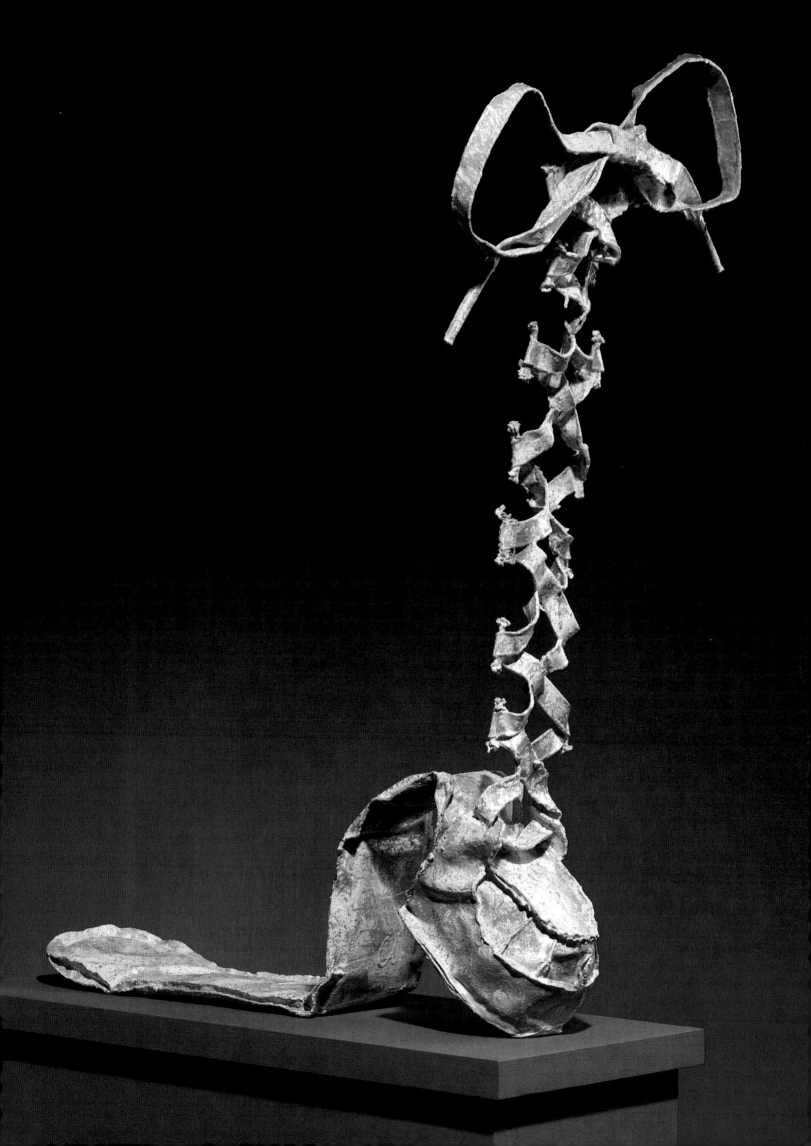

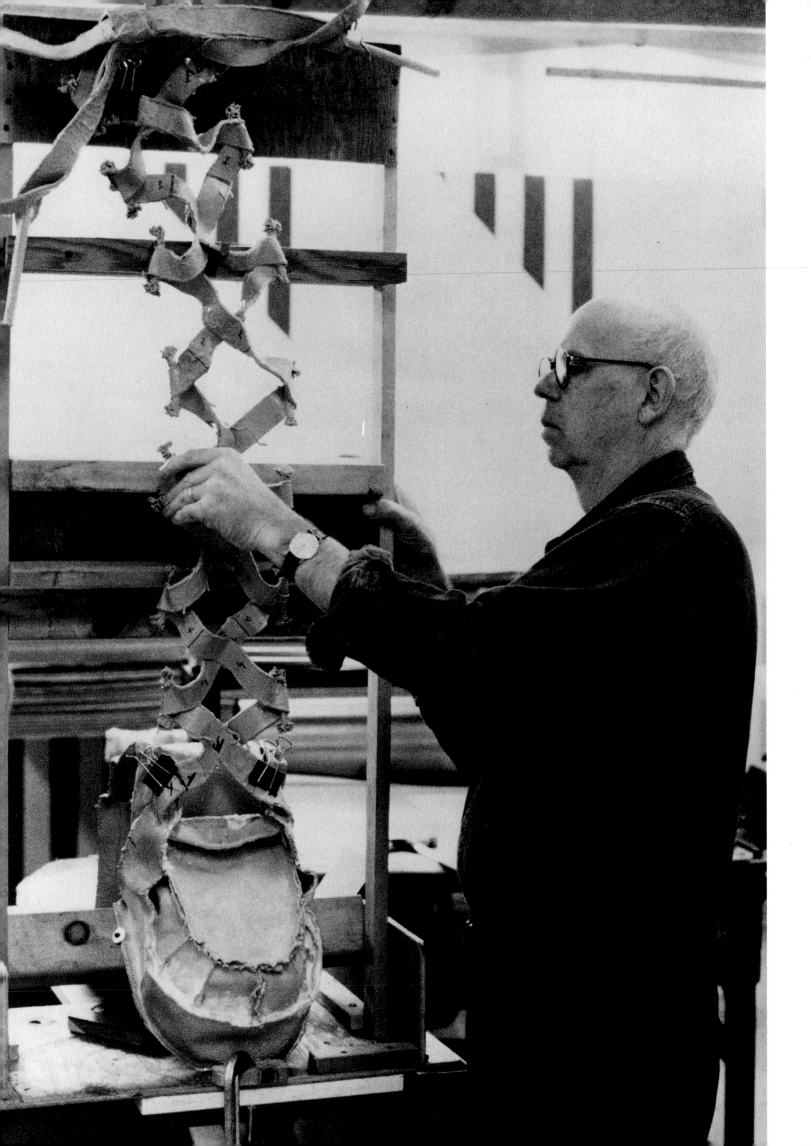

Figure 17. Claes Oldenburg, *Rotten Apple Core*, 1987. Canvas, polyurethane foam, polyurethane resin, steel, latex paint, 65″ × 48″ × 48″. Private collection, Berlin.

Mick Jagger copied you?

At least we're on the same wavelength.

Doesn't the apple-core subject [page 123] go back to a sculpture that was also in the Haunted House *[Figure 17]?*

Yes.

Conceived as a monument for New York?

No. I didn't think of it that way at all. I've been asked in the past to do an apple for New York, but I've never done it. This had no particular relation to the insignia of the city. It was just an apple.

It's interesting that the apple is not whole but eaten.

Yes. It's been acted upon, as were my baked potato, banana, fudge sundae, and omelet; all were being eaten. There is a whole series in which the sculpture was done by an unseen set of teeth. I'm thinking of eating as being a sculptural activity like carving. It's like when you are eating an apple: you examine it and you say, "My God, that's rather nice."

There are two ways to make sculpture: the additive and the subtractive methods. This—eating—is the subtractive way. When you look at that eaten apple, you also experience the feeling of the whole sphere, even though it has been bitten away.

I came across the line of yours, also in Store Days—*"I am for the brown sad art of rotting apples"—a statement that preceded the apple by a long shot.*

That was written in 1961.

And in the same publication you also said that you were "for the worms art inside the apple."

Meaning they have their part as well. I was always very fond of apples. I don't know why I didn't start them before the *Haunted House.* They are also suitable to a technique of sewing and stiffening canvas. When you sew, you have to have a geometrical pattern. You can make a geometrical pattern for the apple, and then in crushing the cloth create the organic look of it. You can do the same thing with a banana, but with some fruits it is more difficult. With the apple you have a geometrical form to begin with, and then you reduce it to a rotten, or emaciated, effect.

When you started the Apple Core *lithograph, was it with the idea of showing the seasons of this object?*

No, that was Coosje's suggestion. I started to do different colored versions of the apple drawing, but seemed to need some reason for doing so. Then Coosje suggested one for each season: a green apple, a yellow apple, a nice red apple, and a white and black apple. They each have quite a different effect.

The series as a whole does take on a certain analogy to the human condition.

Maybe it does, but the prints weren't really conceived of that way. I didn't want to call the series "Four Seasons," because that's too traditional a subject. Yet there they are, and maybe they should hang together.

Have you always very carefully avoided anything traditional?

Actually, I enjoy making connections with tradition. I like to establish relationships between time periods. I like to make a reference to another time. Had I lived then, I would have done an object in a different way. Sometimes that can take the form of a traditional reference, as, for instance, in the bicycle-saddle multiple [Figure 18]. It is a bicycle seat but rendered in the technique of cemetery sculpture of the late nineteenth century. There's a picturesque cemetery in Philadelphia with wonderful sculptures in which a smooth, shiny form emerges from a rough rock; it was a cliché of the time, I

Oldenburg refining his canvas-and-resin model for *Sneaker Lace,* August 1989

guess derived from Michelangelo, in which the flesh comes out of the stone. The bicycle saddle does that because it is a smooth thing that is not flesh, although it is polished by flesh. It comes out of the rock, which is sort of an irrational combination.

I find your Profiterole *[pages 124–126] a wonderful image and object. Did it exist first as a multiple?*

Yes. I'm still painting these objects, because they're so difficult to paint.

Thinking of the apple that has been bitten into, or sculpted, the Profiterole *seems to ask for the same thing.*

Yes. It asks to be destroyed. But I haven't done one in stages of consumption yet. The bread would crumble, and the ice cream has the capacity to melt. Then you have that chocolate sauce too. So you have a melting as well as a crumbling, and that could get quite messy about the final stage.

Do you conceive the Profiterole *at all in anthropomorphic terms?*

I think of it more as being architectural, perhaps because of the association with Frank Gehry, who suggested that I do a multiple to benefit the Hereditary Disease Foundation. Actually, I was thinking of the Tower of Babel as painted by Pieter Brueghel in relation to the *Profiterole*. In this case, the multiple was an attempt to achieve a feeling of large scale.

The Profiterole, *along with so many of your other images, suggests that you are the twentieth-century master artist of food.*

Food is a basic subject for sure.

I have always been concerned with why people make art. I feel that food and sex are two basic impulses for making art. I suppose religion is another. For the average person, the experience of eating seems related to aesthetics. It's probably the aesthetics of their life to eat, drink, and relate to things through their senses. Food is made to look good and appetizing; food is a kind of a subart, and sex is the same. It's hard to imagine art without some kind of sexual charge, at least for me.

Would you tell me about the Thrown Ink Bottle *[page 129]?*

It is based on a legend about Martin Luther. At one point he was translating the Bible from Latin into German in a castle in Wartburg, Germany, but he was constantly distracted by a fly. He got the notion that the fly was really the devil trying to keep him from working, and he became so angry that he threw a bottle of ink at it. He didn't hit the fly; instead, the ink made a big mark on the wall, which became a sort of relic that people would visit long after Luther died. Even after the spot was painted over during the renovation of the castle, people would still claim to see the spot.

This story became intertwined in Coosje's and my project "The European Desktop," which also dealt with a text of Leonardo da Vinci and the text of a letter by Coosje, which she wrote as if to Frédéric Chopin. The piece combined the quill and the exploding ink bottle; the blotter and the reversals of the blotter; and a collapsed postal scale, European style. All the objects were rather old-fashioned, not supermarket objects.

Did you, in any sense, see the quill and ink as being your own implements of creation, just as they were for Luther?

There was a coexistence of writing and drawing in the *Thrown Ink Bottle*. And the feather was also related to the text of Da Vinci, which was one of his premonitions about inventing the flying machine. Then there was the fly. There were these ideas about flying things, and then the ink bottle was exploding, which I suppose is also like being thrown. But it was also exploding by itself.

The images reflected the very disrupting year that 1990 was for Europe, with boundaries cracking open and falling, with things that had stood for a long time sud-

Figure 18. Claes Oldenburg, *Sculpture in the Form of a Bicycle Saddle*, 1976. Glazed cast ceramic, mahogany, sand, 14″ × 8¹/₂″ × 8¹/₂″. Published by Petersburg Press, London; photo courtesy of the artist.

Claes Oldenburg, four *Apple Core* lithographs, 1990
Top left: *Apple Core — Spring* (checklist no. 72)
Bottom left: *Apple Core — Autumn* (checklist no. 70)

Top right: *Apple Core — Summer* (checklist no. 73)
Bottom right: *Apple Core — Winter* (checklist no. 74)

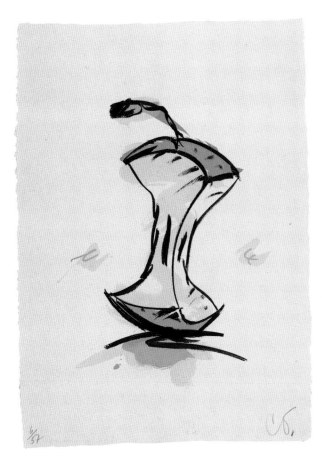

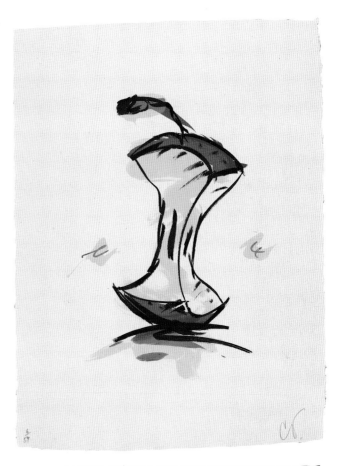

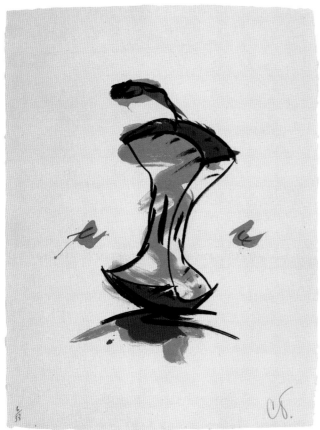

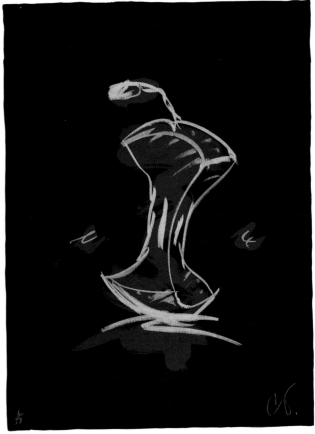

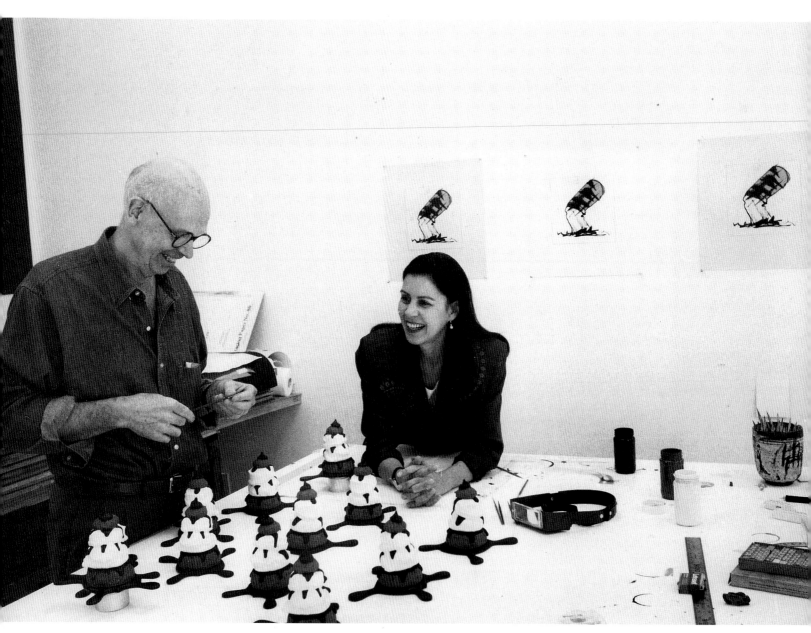

Oldenburg working on his *Profiterole* sculpture edition with his wife, Coosje van Bruggen, August 1990; proofs of *Butt for Gantt* appear on the wall

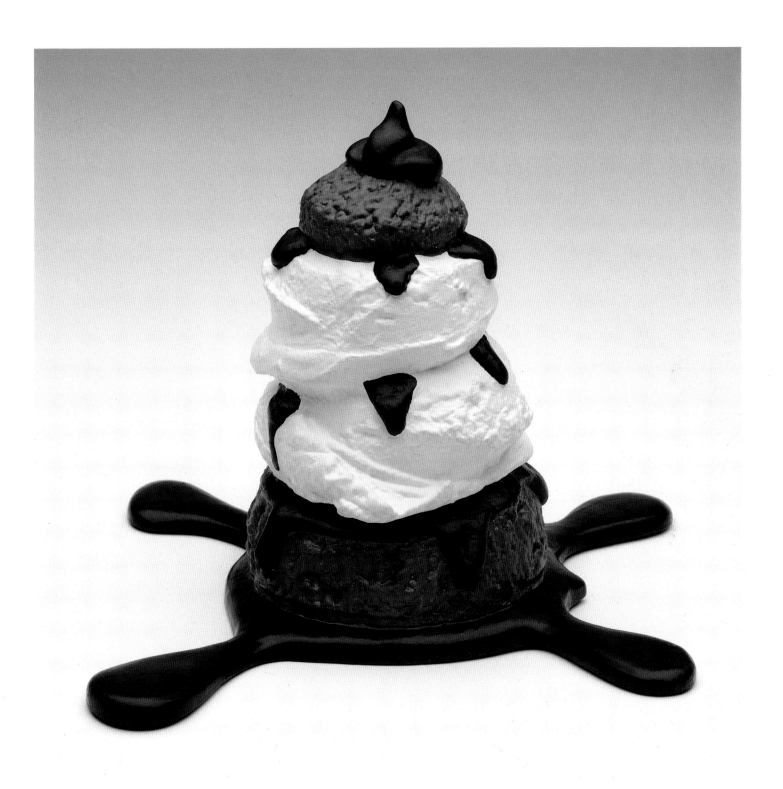

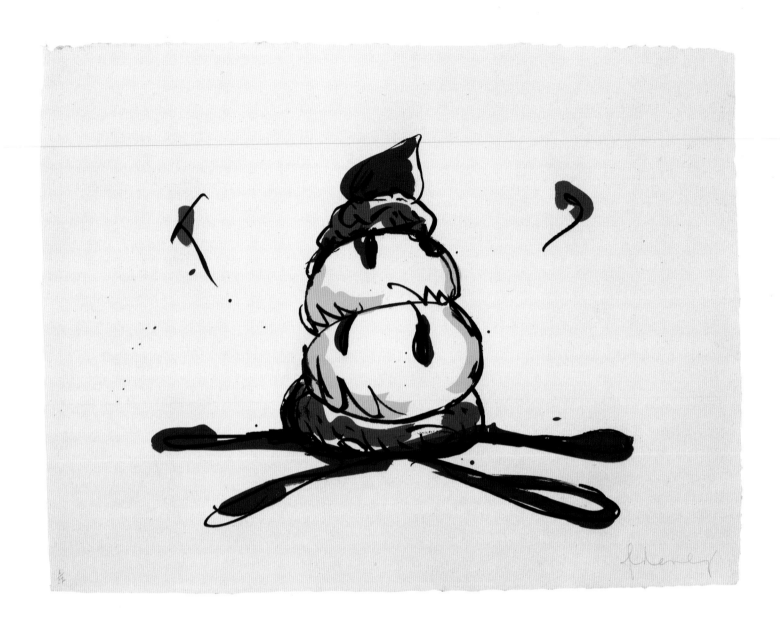

denly disappearing. "The European Desktop" had a feeling of collapse and change, from one thing into its opposite, and the desktop was literally breaking up, as though it had been hit by an earthquake.

In all of the energetic activity in your work, there is some presence that is veiled.

Do you mean that the agents are usually invisible? The hand or the tooth, or whatever, is not seen. It's only the effect of something that has happened. It's an object world, but it reflects the human beings and other forces doing things to objects.

At one point you said, "I like to see things either at the beginning or the end."

More dramatic things occur at the beginning and the end, but I like the feeling of process, too, of time going by and things happening in time, movement. Change is very important to me.

Can you tell me something about what you look for in a subject?

Over a period of time some subject asserts itself, and I am certain about it before I completely know why. There are always clear reasons as well as obscure ones that I discover later. I am sometimes seized with the desire just to replicate an object that I am fond of. It is probably a little bit like building model airplanes, which I used to do. But in the course of reconstruction the object changes through the action of imagination and material. So, even if I re-create an apple, for example, out of affection, that apple doesn't end up looking or functioning like God's version.

Is it fair to say that an object rarely possesses specific personal or emotional associations for you?

No, there's always a reason when I make something; it's not a random choice, though the reason may not be apparent. It may have to do with a recollection or with the form having a resemblance to something important to me; perhaps it is a mask for something sexual. Certainly, one is partial to certain objects. Objects can contain all kinds of feelings. I think of objects as containers and also as things that summarize experiences. As with Marcel Proust's *madeleine*, a taste reminds you of something else. So the objects usually have a personal significance. It is not necessary to know that, however, to appreciate them.

Do you also search out objects that might make some comment about society or the world?

Yes, sure. Sometimes it's very specific, like the *London Knees* and the Chicago *Fire Plug*. It's usually an object I consider to be a summation of something, or an important icon, like the hamburger or the *Sneaker Lace*.

Are the formal qualities equally important?

Absolutely. That's another condition, of course. I wouldn't take an object that was too anecdotal or that I couldn't reduce to geometry or to sculpture. It has to be possible to put in another lens and see the thing as pure sculpture.

How do you see your work changing?

I don't think of my work as being linear. I think of it more as a sea of possibilities in which all of these objects are washing around; there comes a moment when one seems more important than another, has its moment, and gets done.

In the last few years there has been more emphasis on social issues in my work. There have also been a couple of sculptures that have suggested a specific political context, like the *Blasted Pencil (That Still Writes)*. This has come about a lot through Coosje's involvement with social issues. There have also been changes in techniques and changes in the use of color; a change from making large-scale projects exclusively to making installations again in gallery shows; and a return to performance, such as "Il Corso del Coltello" ["The Course of the Knife"] in Venice in 1985, which was an expansion of resources and new materials.

Do you have any secret dreams you'd love to realize?

I have a category of things I know can't be done due to limitations of time and money, which hasn't prevented me from drawing them.

Coosje and I have yet to make a feasible proposal for New York. I think that imaginary monuments are more appropriate for New York than real ones because of the city's scale. A real monument in the city has little effect, but if you imagine something on the scale of the skyscraper, then it fits in with New York.

Perhaps you could put it on top of a skyscraper or in the water around New York. That's also possible. But anyway, to me, New York has always been in the realm of the imaginary. Perhaps it's just too gritty now; you watch too many awful things on the news, and it sort of brings you down to the neighborhoods and so on. But the New York of the twenties or the thirties, when there was a great deal of fantasy and optimism about the city, New York was the city I was thinking about in these colossal proposals, even if they are parodies of grand projects.

Your work has a great deal of optimism.

Of course. How else could I get up in the morning?

January 1991, New York

Ken Price

I am interested in your peripatetic life: you've come back to Los Angeles only recently?

We moved from Los Angeles to Taos in 1970, and lived there about eleven or twelve years. Then we went to southeastern Massachusetts. We wanted to get out of Taos for a variety of reasons, and had visited a friend in Massachusetts who lived right on the Atlantic Ocean. It was really beautiful, so we moved there, and stayed for about eight years. Altogether we were gone from L.A. about twenty years.

How did you feel as an artist living in the East, in contrast to the West? Did you feel like a fish out of water in terms of your approach to art?

I suppose so, in some ways. I was in two of the worst categories you can be in in the East, one of which is a California artist, and the other is a clay artist. So that was not a good thing. Here I can say this.

How would you define craft?

A craftsman knows what he's going to make and an artist doesn't know what he's going to make, or what the finished product is going to look like. The craftsman makes something essentially for use; that was the original definition of craft. It's an object that a person put experience and understanding into, but essentially that object was made to please somebody else. The maker would adjust the piece according to the wishes of the person he was making it for but could not expect to find the object in a museum afterwards.

How do you see yourself?

I don't know. All those generalities are whatever you want to make of them. I don't consider myself a part of any kind of school, group, or movement. Although I'm generally included with other clay people, it doesn't mean I necessarily have anything in common with them except the material. I have my own purposes, and they have theirs. It's like De Kooning once said, when asked about action painting: "I'm not sure what I'm doing but I know I'm not the others." I always thought that quote applied to me because I'm often being thrown into this group. It's not that I'm against the other people, but I don't have the same agenda. It's confusing, though, because I like pottery, and make it, too, as well as sculpture.

Ceramics had a shot at the big time about ten years ago, about the same time photography did. The reason it didn't gain in stature is because there wasn't enough good work.

There is never more than a handful of wonderful painters either.
Did you ever feel a commonality with other California artists during the 1960s?

Oh yes, very much so. It was an attitude about a certain level of resolution—resolving something totally in the visual area, rather than in the conceptual. But it's hard to remember what I had in common with a bunch of guys thirty years ago.

What was life like then?

We didn't grow up as an art school but as individuals. Then we discovered each other later: Billy Bengston, Ed Moses, John Altoon, Craig Kauffman, Bob Irwin, Larry Bell, and Ed Ruscha.

There wasn't a big art economy, or any potential of selling work, or any museum or gallery support. It was a bunch of people who had to make art, art that didn't have any market. There was a comradery in those days because it was like defending the fort.

Everybody had better get a gun and start shooting.

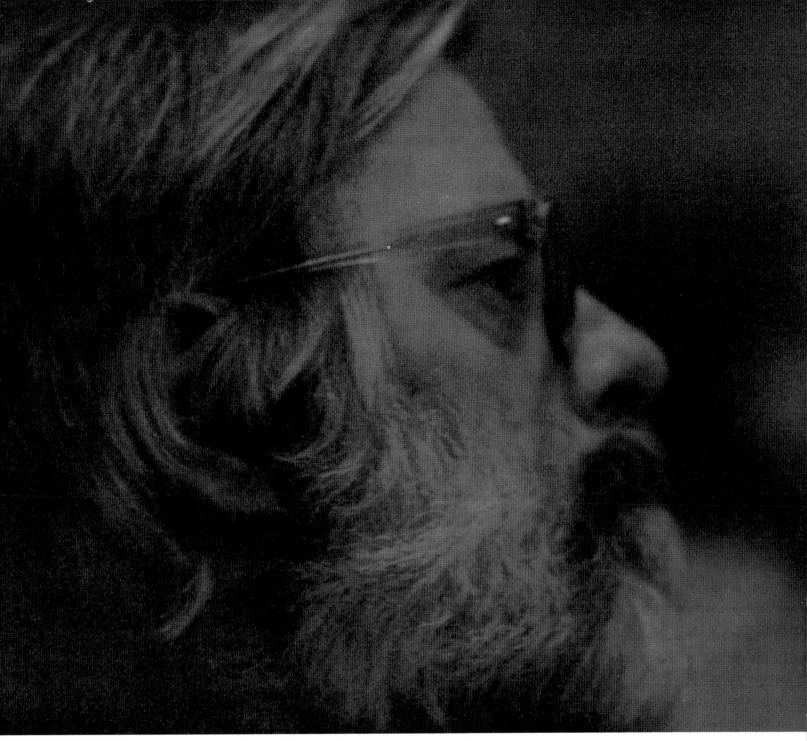

Price at a jazz concert, August 1989

But after we each had some success, gained recognition and sales, there was a lot of squabbling in the fort.

There was a lot of vitality here from the late 1950s through the mid-1960s. By the late 1960s, a decadent phase set in. You didn't have to have money because a Bohemian life style existed, and plenty of money was around. But nothing was happening; this was the city where something was just about to become a reality, always on the threshold of making it. You'd look around and say, oh yes, all the factors are in place. It would go on and on.

When did you begin to make cups?

I discovered ceramics at Santa Monica College (later called Santa Monica City College).

I met Bengston, who was already making pottery. He was a surfer, and in those days surfing was esoteric enough so that if anybody was a surfer you would grab the guy, collar him, to see what he was up to. He was making ceramics and was very advanced compared to me.

Is working with the one form, the cup, like being a musician who just plays the blues?

I just like the cup. I think it's a real kind of primal idiom. I suppose it connects to liking Japanese cups, too, but I've always made cups mostly for American drinks, or drugs of one sort or another, like coffee, tea, tequila, and so forth. Yes, it's very limiting, but once you agree to all the tight limitations, then you have total freedom. I keep the size tight, too, because I like the scale in relation to the hand. When the cups get larger, the scale suggests a cartoon, and it feels like a parody of the real object. It's too self-important. But, anyway, I like the idiom and the weight. The size of all sculpture is seen in relation to the human body. But there's not much that is scaled to the intimate, hold-in-your-hand size. When you use a cup, it's right in your hand, and you actually put it to your mouth and drink warm liquid from it. That is very primal, physical, and sensual, and is representative of sensual life. That's what the cups are about.

Have you pondered the symbolic or allusive meanings a lot?

Not a lot. No, but it's there. It's that primal connection. Everybody knows what a cup is for.

So it's as if, at a certain point in your career, you chose to be a blues player?

Something like that, yes. Although nobody knows what their style is going to be. I like the work to suggest possibilities, ones where there is the possibility of discovery for me. That's why it's nice to stay within a small idiom.

Do drawings ever play a role in relation to these works?

Yes, definitely.

Is every cup preceded by a drawing?

No, not every one, but a lot of them are. All of the decorations on each cup usually are. The thing about a drawing is that it can only take you so far, but I like to draw and that's a good excuse. I draw all the time anyway, so a lot of times I just put the drawing on the cup if I think it's going to work.

So, at times, what you're doing isn't so much about the cup form as a cup is a surface on which a drawing can appear?

Sometimes.

Who were your most important influences?

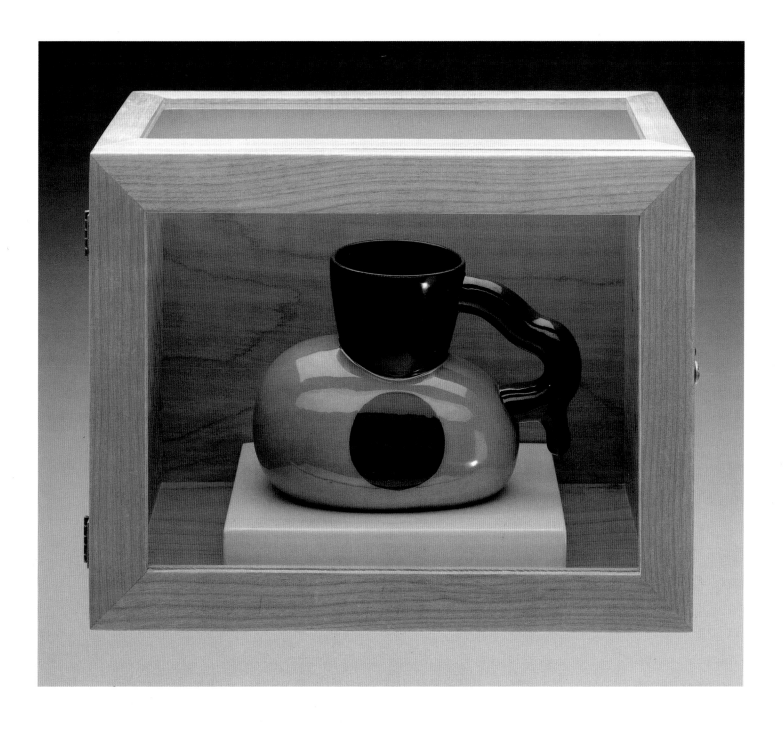

Figure 19. Meret Oppenheim, *Object (Le Déjeuner en fourrure)*, 1936. Fur-covered cup, saucer, and spoon; cup, 4³/8" (10.9 cm) diameter; saucer, 9³/8" (23.7 cm) diameter; spoon, 8" (20.2 cm) long; overall height 2⁷/8" (7.3 cm). Collection, The Museum of Modern Art, New York. Purchase.

Figure 20. Pablo Picasso, *Absinthe Glass*, 1914. Painted bronze, 8³/4" high. Philadelphia Museum of Art: A. E. Gallatin Collection. Photographed by Graydon Wood.

Figure 21. Ken Price, *Untitled*, 1991. Glazed ceramic, 3" × 3¹/2" × 2³/4". Courtesy of James Corcoran Gallery, Los Angeles.

So many people. As a teacher, Voulkos was my big influence when I was studying ceramics. Part of the "influence" was that there just was nobody home; the field was wide open to do just about anything. That's one of the reasons why I did so many different things.

Another influence was Japanese pottery. It's the ultimate achievement in the history of pottery, especially the Momoyama period. That work—the pottery, the tea ceremony vessels, and so forth—influenced my sense of scale and my sense of what I want from a piece of pottery. It set a standard of, I don't dare use the word anymore, quality.

Does the Meret Oppenheim fur-lined cup [Figure 19] stand as the ne plus ultra *of cups?*

Yes, but it's part of the whole idiom of Surrealist objects that I like: for instance, the female fig leaf by Duchamp, and the absinthe glass by Picasso [Figure 20]. As much as my work comes out of craft, I'm much more interested in Surrealist objects.

The thing about craftsmen vis-à-vis artists—the craftsmen don't understand what the difference is. They think art is some kind of a scam. They are much better craftsmen than I am, certainly. I'm not interested in making a line of wares for sale, or in finding the perfect vessel and then repeating it ad infinitum. There is no market for any kind of functional stuff that's handmade anymore. Cups of the future will be surfaces for advertising.

Are Mexican sources still of great interest to you?

I still love them. The work isn't coming up out of Mexico anymore, so I don't have contact with it much, except old pieces. However, Southern California is permeated with Mexican culture still, and I like that.

It sort of gives your work a kind of indigenous quality.

If there is a tradition in California, that would be it. This was a part of Mexico, and the real tradition reflects that. Southern California was full of Mexican pottery when I grew up, not just in restaurants, but in everybody's homes. The stuff that came to the border was not specifically made for the tourist trade; it was just the regular functional craft and folk art, which was coming to the end of a great tradition.

The reason it came to an end was the lead poisoning. The wares poisoned the makers and the users; it really had to stop. The guys making them went blind.

How did you approach the multiple for Gemini?

I started with the molds, and worked on the objects out of the molds, after they were cast, rather than the other way around. So when we arrived at a conclusion, it was already a multiple.

Did you give any thought to adding the cityscape imagery in your latest cups [Figure 21], shown at the Corcoran Gallery, to the Gemini ones?

No. That's like apples and oranges, although I don't think of it so much in terms of categories. Those at the Corcoran are traditionally decorated pottery. In other words, when you put up a blank of a bowl, or a cup, it carries its history with it. If you don't understand how it was used and what it was for, you're in danger of making some real kitsch-y stuff. You say, oh, well, this Hopi, Anasazi, or Chinese piece looks great, and you incorporate some aspect. That's like making Spanish Colonial television sets. The point is that the Corcoran cups relate to a history of vessels that carried a lot of cultural information. But it's not as if mine are going into some burial site, too, nor will they be dug up, with people saying, "Look, this is what Los Angeles looked like in those days."

Henry Takemoto in his Los Angeles studio, working on Ken Price's *Mildred*, 1991

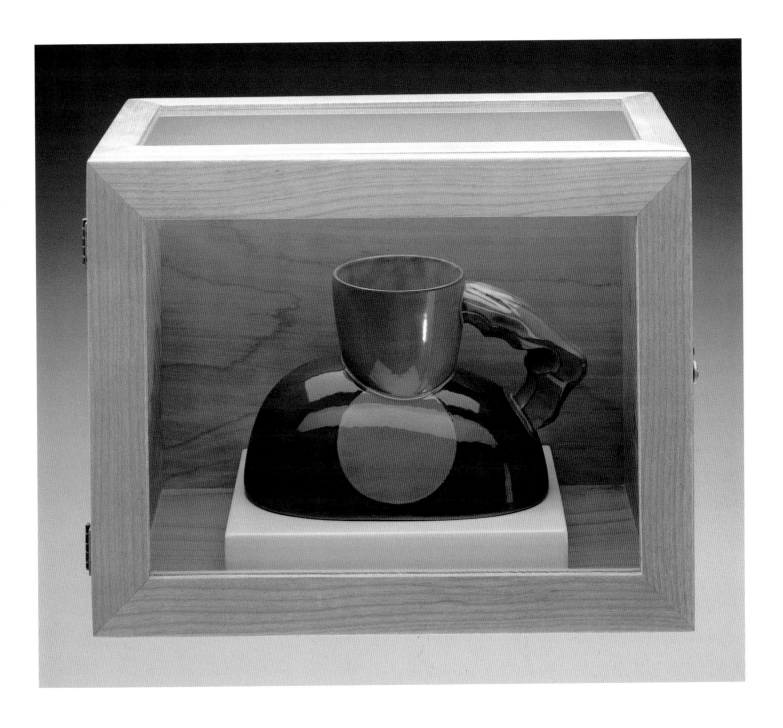

As for the Gemini cups, the surface decoration and form are supposed to be one thing, wedded into a logical whole. I want them to have a little magic, too, if they can. A little something.

How would you talk about content in your work?

I think it's in the visual idiom and can't be translated into words that easily.

Do you think it's legitimate to become Freudian about the cup and say it's a female symbol?

I wouldn't argue with that. It has a strong female aspect, that's for sure.

Is it fair to compare the painted scenes of empty rooms, in the Corcoran pieces, to the interiors of the Gemini cups? Both have a similar kind of pregnant mystery and sensuality, or "magic," to use a term you used earlier. Does that sound incredibly imaginative?

When you frame the exterior with a window looking out, it really solidifies what's out there and makes it more metaphysical. With my other printed scenes of bands of cities all around a cup, they won't be as metaphysical. The sculpture I make involves the void also. I've been working the void for a long time; that's very female too. I agree that the inside plays a big factor in those pieces, but I don't know how to analyze it any more than just to recognize it.

Is colored sculpture a major area of your ambition?

Yes, but color that is not just applied as an afterthought. The quality that is constant in my work is the relationship of the form to the color, and the surface to the form to the color or glaze.

It seems that at certain times in your career, more than at others, you have been especially interested in revealing spontaneous gestures. Is that true?

Sometimes you're courting something there — the alchemy of the glaze, and everything which is part of this magical aspect. You can court that kind of richness, but beyond that, ceramics is too much of a lab technician's kind of work.

Is this the first time you have made a multiple?

I've done a lot of prints, but never any multiple objects. I've been trying to make these for a while; we've made three different versions that were all failures for one reason or another.

What made the others failures?

I tried to make functional cups, and that was ridiculous, because I realized nobody's going to use them.

You keep fighting that battle.

I do off and on. You have to deal with the culture the way it is. There are a lot of guys who do their wares in Japan and write their manifestoes in English.

June 28, 1991, Los Angeles

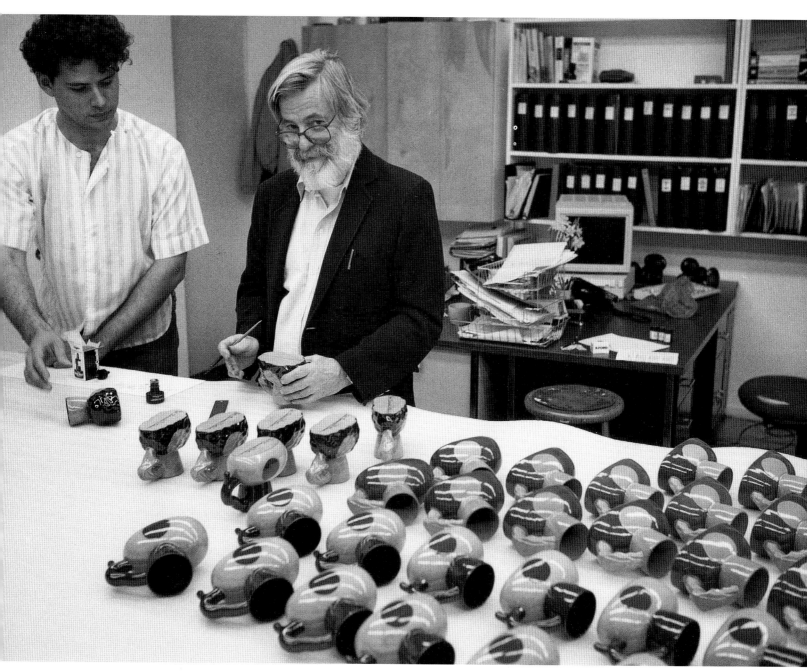

Price (right) signing his earthenware cups at Gemini, assisted by Octavio Molina, February 1992

Robert Rauschenberg

Do you like visiting Los Angeles?

I love Los Angeles. I once said publicly that one of the reasons I like Los Angeles is that it is a thousand miles wide and a quarter of an inch deep. I find Los Angeles both innocent and stimulating. It still has that kind of Western feeling, a controversial rawness. The city certainly works with my renegade feelings about what art is, both of what it's not supposed to be and what it could be.

How did you begin to work with Gemini? Was Booster *[Figure 22, page 150] the first piece you did for Gemini?*

Yes. I remember being in Los Angeles at the Grinsteins', without an idea in my head. Stanley said, "Well, tell us about your idea for a Gemini project." My idea came from nowhere. I said, "I'm going to do a self-portrait." That was the beginning.

What's the atmosphere like at Gemini?

They're quite laid back at Gemini because they have to work with so many different points of view. That's what is so nice. Roy Lichtenstein can come in, and then Jasper Johns, and the whole situation, architecturally, physically, chemically — and the pacing of the work — will relate directly to that particular person.

I was here only one time when Jasper was working, and he was in real trouble because he only had two more days. It was quite marvelous, because it was one of the first times in years that we had been in a situation in which we needed each other. But I wasn't volunteering. He was hanging up proofs and said, "Which one of these do you like?"

As for working at Gemini, I arrive without knowing what I'm going to do. The tolerance level of all the printers, even though they've changed over the years, is always great. You'd drive them crazy if you came with a preprogrammed attitude.

You obviously enjoy collaboration.

When I first started working at Gemini, they had just finished a Man Ray project. I thought they hadn't sufficiently engaged him in the process. My attitude was that the artist should be as involved as possible and that the work should be unique, as opposed to being a high-quality reproduction. That's where the collaboration comes in.

The reason I enjoy collaboration is that very early in my career I figured out that two distinct expertises are much better than one. I don't get involved too much with the chemicals in the shop, but rather with the processes. In the case of this latest group of lithographs for Gemini, instead of putting on tusche or washes, I'm applying photo emulsion which becomes the ground for the photographs I've taken. The images are then burned directly into the plate.

So when you came to Los Angeles to do this group of work, you arrived with these photographs?

No. I had passed through Washington, D.C., and taken a couple of photographs that appear in this series, but the rest were all done here in Los Angeles.

What is the title of this group?

I'm thinking of calling the series "Illegal Tender L.A."

What does that mean?

I don't know, but I like it. I like the "Tender" part and the "Illegal" part. I know what "legal tender" means, but I don't know what these two words — "Illegal Tender" — mean together. I think they just describe an attitude.

I love titling. Now I have to give titles to each of the ten lithographs in this suite. That's something that happens at the right moment; it's nothing that I ever force. Once the titling process starts, I have to make sure that I can write fast in order to remember, but I love that. I've always considered that in painting, prints, and theater, the title is the last brushstroke.

Rauschenberg painting onto plates for his "Illegal Tender L.A." series, 1991

Rauschenberg (at left in each photo) with
Gemini's Sidney B. Felsen (top center),
Stanley Grinstein, and Elyse Grinstein,
autumn 1986

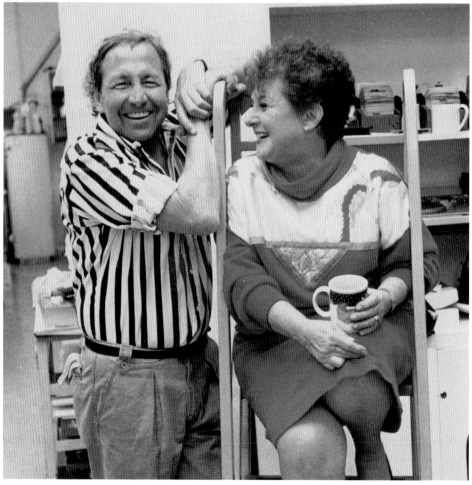

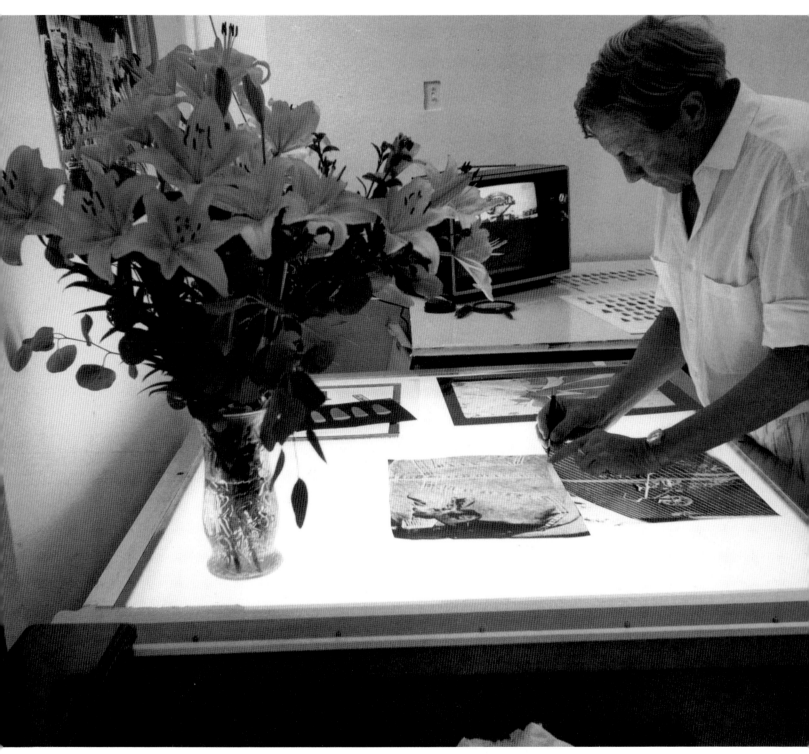

Rauschenberg working on his "Illegal Tender L.A." series, September 1992

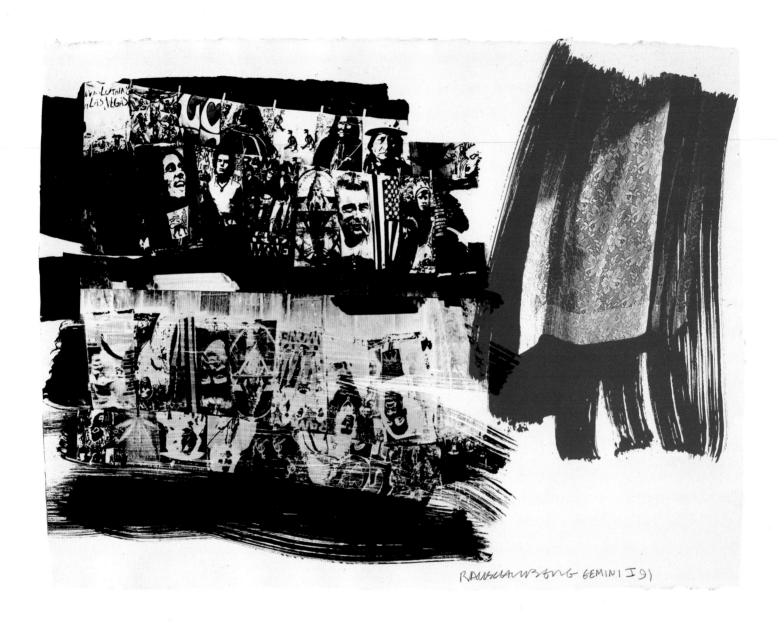

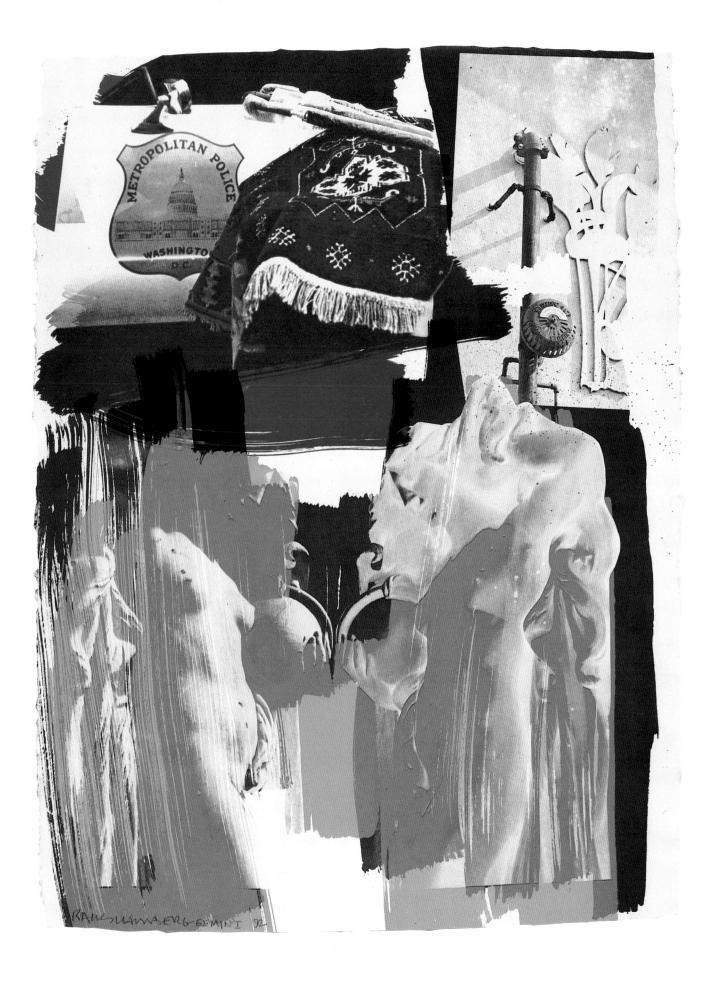

Have you ever done a triptych before, as you've done here [facing page] in lithograph form?

I did the *Trilogy* from the "Bellini" series in 1987.

How did you decide to do a triptych here?

The paper was too small otherwise.

I did various photographs, in Venice, Italy, of a kid swinging, and I liked the image. I wanted to bring all three of the variations into a single work, so that's how a triptych came about.

How do you see your activity in prints vis-à-vis the rest of your work?

I use the activity as a kind of refresher. I've consistently been impatient, restless, and curious, and I've satisfied this weakness by changing mediums often. As soon as I can do something, that is the end of the series. There must be thousands of other things that I haven't thought of, or haven't occurred to anybody, that need to be done. And I'm getting of an age that I have to start thinking, "Can I get all of it done?"

Turning to the chairs . . .

It's *Shares*, as in financing—*Borealis Shares* [pages 154–155]. They are titled that way because these objects always look more beautiful when there are two people on them instead of just one. So the word is "shares," meant both ways.

How did you come upon the term "borealis"?

I was already working on another series before coming to Gemini, involved with rainbow corrosions. While on my way to Sweden, I saw my first borealis. I thought that word should be the title for these corrosions. Since then there have been more variations.

The rainbow corrosion still interests me. In fact, I have a new approach to it, which is either to draw or print in a resist so that the metal carries the image instead of the opposite way around, where the paint is the image on the surface.

What are the chairs made of?

The chairs are brass with aluminum, and they are covered with Lexan. That's used for bulletproof glass and storm shutters for hurricanes, but is surprisingly comfortable to sit on. If somebody shot you from behind, or even from underneath, you'd be perfectly safe.

How are the images applied to the chairs?

They are silkscreened.

Do you relate these kinds of surfaces to your earlier work?

I like my artwork to absorb generously anything that's going on around it. Since I got involved with working with the reflective metals, that's one of the things I've enjoyed. And I always had used mirrors and built light bulbs into my pieces, so that there was never only an artwork inside.

Someone writing about your work used the term "swarms of images." That seems like such a nice expression for describing the way the images sort of run around these chairs. But when you put the images together, here and in "Illegal Tender," are you thinking about the poetic combinations along with the formal implications?

I have to, in addition to considering the spatial qualities, and the color at the same time. I think an artist has to be schizophrenic, and it helps if you are a Libra too, because then you are already off balance.

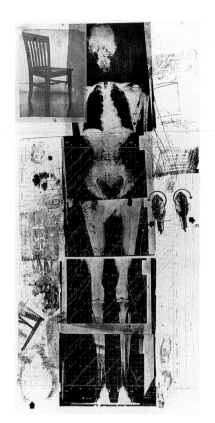

Figure 22. Robert Rauschenberg, *Booster*, 1967. 4-color lithograph/screenprint, 72" × 35½". Published by Gemini G.E.L.

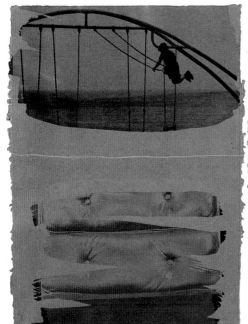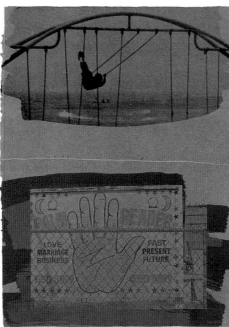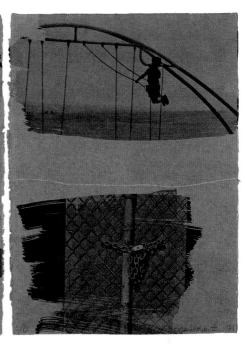

Trying to find balance all the time?

I never watch what I'm doing because I feel that if I know, then I must have seen it somewhere. I don't want to do anything obvious. If I work from plans and thinking, the work usually doesn't have that kind of spontaneity. I guess I just have to go fishing again. I used to have some of my best ideas while I was fishing right out in front of the house. My mind starts drifting, and all of a sudden I'm working in a whole other consciousness level.

You've been using the image of the chair for some thirty-five years.

It's a very common object. I'm particularly attracted to elements in life that for the most part are taken for granted so successfully that no one sees them or understands them anymore. For instance, you'd take a telephone a lot more seriously if you had an emergency. I am looking for those elements to photograph now.

Given the context of all the chairs over the years, Borealis Shares *seems to be the most baroque chair of all, almost thronelike.*

I did think it was important that, given the context of people being a part of the art, the chairs look as good as possible. And, hopefully, we've done a good framing job.

I see. You've framed the person sitting there. But the back of the chair is at least as exciting as the front.

If you get tired of sitting, you can stand. I didn't want it to be simply a piece of furniture. Even though it is an object, with a utilitarian purpose, its other side is like a painting on the wall.

How do you feel about furniture?

I like scale, but I hate furniture. I live very austerely — quite grandly, but austerely.
 The chairs that I do incorporate in my work are classically ordinary. Maybe that's the revenge of the chairs. I just bought the contents of a restaurant that was going out of business. The chairs that I typically use in my work were all over the room. I have about twenty-six left, and I want to use them all in one sculpture.

Is this the first time you've ever made an artwork that is used, for example, for sitting?

No. I did some furniture during the "Cardbird" series for Gemini, in 1970–72. I made boxes that were fastened together but mobile. You could stack some as a table, others as a chair or a bed.
 At my old Fulton Fish Market base, I slept on fish boxes.

Did you actually sleep on them?

Yep.

That's why you hate furniture now?

I don't know, but I very rarely see a piece of furniture that I think is interestingly designed.

It seems that you've always made objects covered with images.

I got the other side of life taken care of very quickly, thanks to Josef Albers's austerity, by doing the all whites and the all blacks in the early 1950s. Actually, it wasn't his austerity, it was my stubbornness and respect for every color in the world. Albers always said that art is a swindle, that red is there to make green look brighter. But I couldn't choose between the colors without feeling as though I was misusing them; it

Robert Rauschenberg, *Borealis Shares II*, 1990 (checklist no. 105): front view

Back view

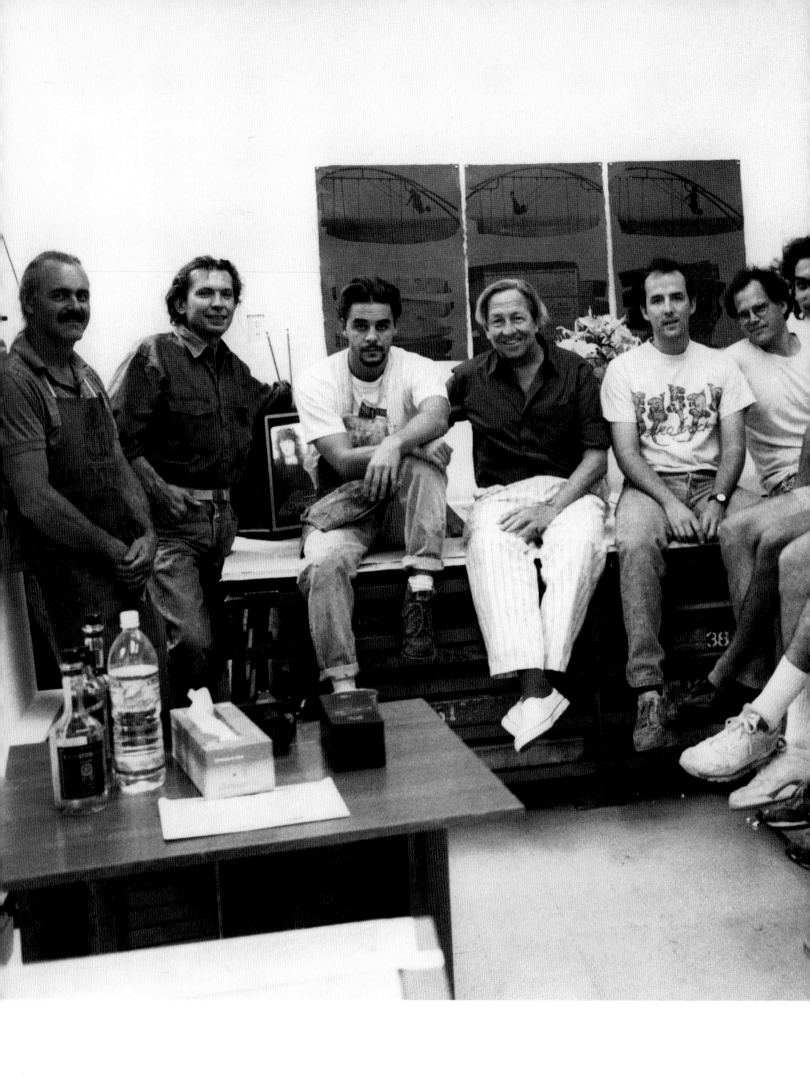

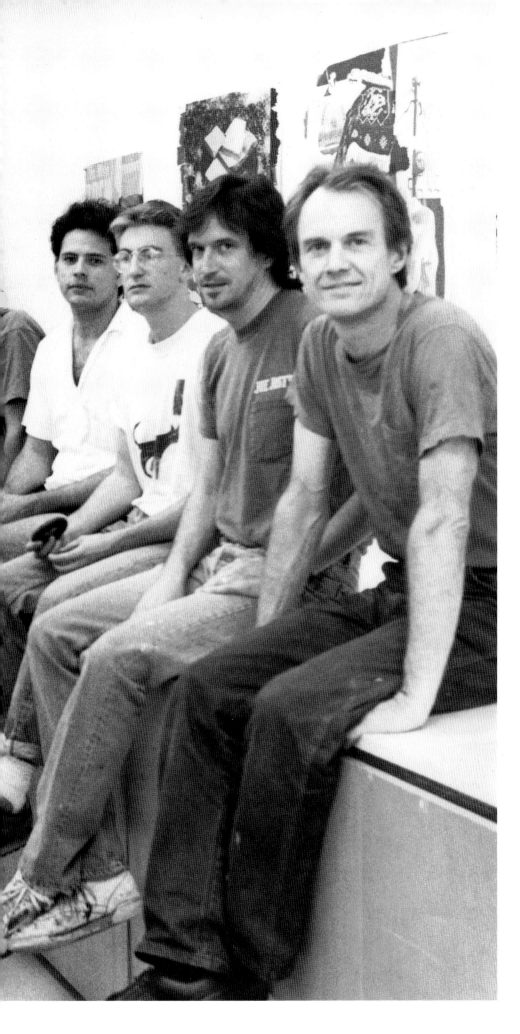

After a proofing session for the "Illegal Tender L.A." series in September 1991, Rauschenberg sits for a group portrait with Gemini staff members and collaborators; left to right: James Reid, Darryl Pottorf, Carmen Schilaci, Rauschenberg, Mark Mahaffey, Kyle Militzer, Larry Mantello, Octavio Molina, Mark Schultz, Stan Baden, and Ken Farley

was not fair to make a contract with one color at the expense of another. So I was just frozen into wanting to exercise all colors equally. It wasn't until several years later that I even dared to do the all reds, and once I did those, other colors, like oranges and yellows, started "leaning" on them. Then I finally just broke loose.

It's always been fascinating to think of you working in the 1950s contemporaneously with the Abstract Expressionists.

I don't think they knew who I was or where I was in my art. There were two schools then, Hans Hofmann and Willem de Kooning. It was one of the few times that I found living in the shadows to be an advantage. By the time anybody realized that maybe I *was* serious, it was too late for anybody to do anything about it.

September 22, 1991, Los Angeles

Gregory Peck (top, 1990) and Dennis Hopper (bottom, 1988) visiting Rauschenberg at Gemini

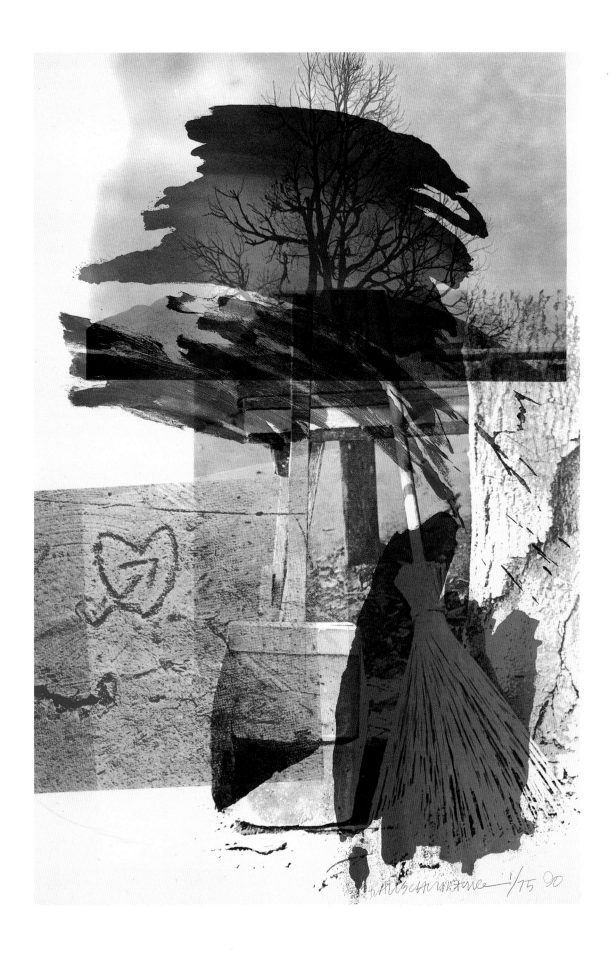

Richard Serra

Would you describe your history as a printmaker?

I made my first series of prints in 1972 at Gemini. I've only done seven series altogether: six with Gemini and one recently in Paris.

I have a resistance to printmaking. One of the problems I've found with printmaking, as opposed to drawing, is that it's mechanical; a quality is invariably lost between the direct expression of the drawing and the print. Oftentimes the spontaneity of the line is lost, or the ink will mottle or blot a form that was unintended. To understand the medium, I think you have to draw specifically for it, draw for the potential of the mechanical process, draw for the overprintings, or redraw your drawing to fit the needs of the roller or the ink or the etching plate or the press; this means that you should take into consideration how the manufacturing process is going to transform the work.

Having said this, I would say that a few people are quite good at printmaking. They take knowledge from other venues and apply it to the print mediums. In this regard, the best active printmakers are Jasper Johns, Robert Rauschenberg, and Roy Lichtenstein; they are masters at utilizing methods and processes borrowed from commercial techniques, whether they be layout, collage, transparency effects, graphic design, whatever.

But aren't you similarly one step removed from the construction of your sculptures?

No. The transformation from drawing to print is far different in kind from the realization of a sculptural idea. The mechanics of the process that I employ in printmaking create a far greater separation between the initial drawing and the print than exists between a sculptural model and the finalized work. The materials of the model and of the resultant sculpture are virtually the same.

Are the large Paintstik screenprints you've recently done at Gemini actually printed?

They're created by pulling Paintstik through silkscreens. In a sense, this is a more direct process than lithography, in which ink is blotted out through the pressure of the press.

Are these works as close as you have come to making prints that are like drawings?

The way they differ is that, in drawings, the density of the relation of the particle of Paintstik to the whole is much more compacted and I can control it.

One aspect of the silkscreen process is that the Paintstik particle is more fragmented than it is with drawing. There's more of a fluctuation within the surface. People who often look at prints like the fact that there is a tonal variation and gradation within the depth of the field of the silkscreen.

Do your Paintstik prints relate to a specific group of drawings?

The screens came out of a drawing series I did in 1989—"Weights and Measures"— that was shown at Leo Castelli in New York and another group that was shown in Germany. In the first group the shapes were larger and more irregular; in the subsequent group it was mostly squares that were juxtaposed. The problem was in determining how to represent two juxtaposed shapes and not place the emphasis on the Gestalt or the composition. I instead wanted to emphasize the weight and the differentiation in weight of each shape. In all the drawings, the focus is on the center and on the tension that arises where the two elements happen to touch or approach one another, which means that the focus is on the center crack, or split. If there is any historical lineage in these works, it is from Paul Cézanne or Barnett Newman, not from panel painting.

Serra at Gemini, 1982

#1

#2

#3

#4

#5

#6

#7

#8

Serra at Gemini, September 1980

Richard Serra, *Double Black*, 1990 (checklist no. 130)

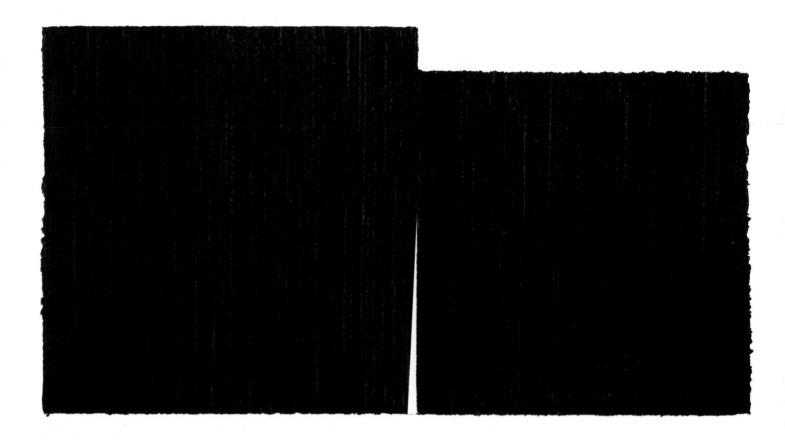

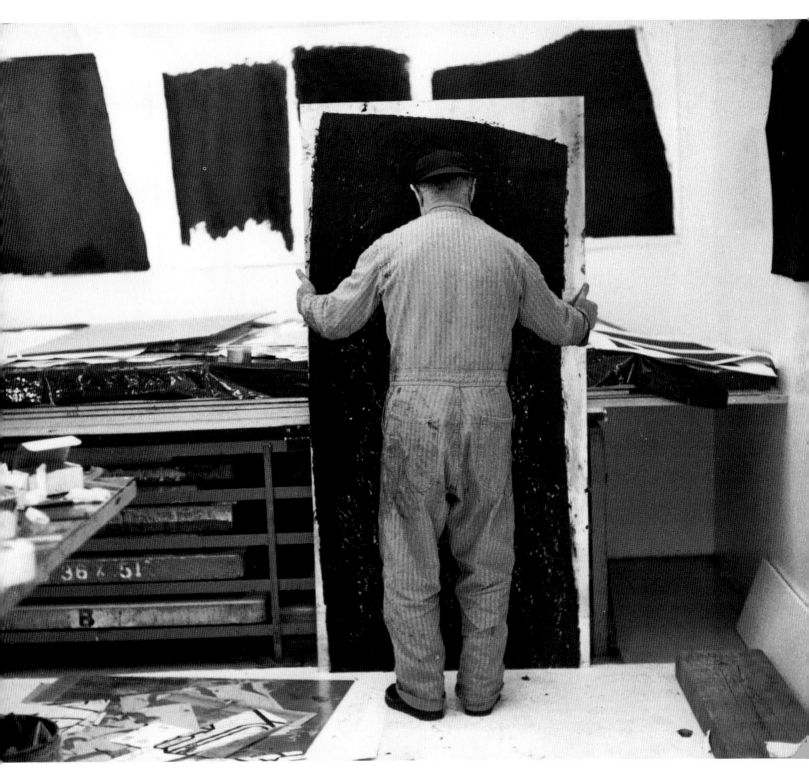

Serra at work on his etchings and Paintstik compositions, November 1990

Serra using litho rubbing ink on a copperplate for *Vesturey III*, 1991

Facing page: Richard Serra, *Spike*, 1990
(checklist no. 133)

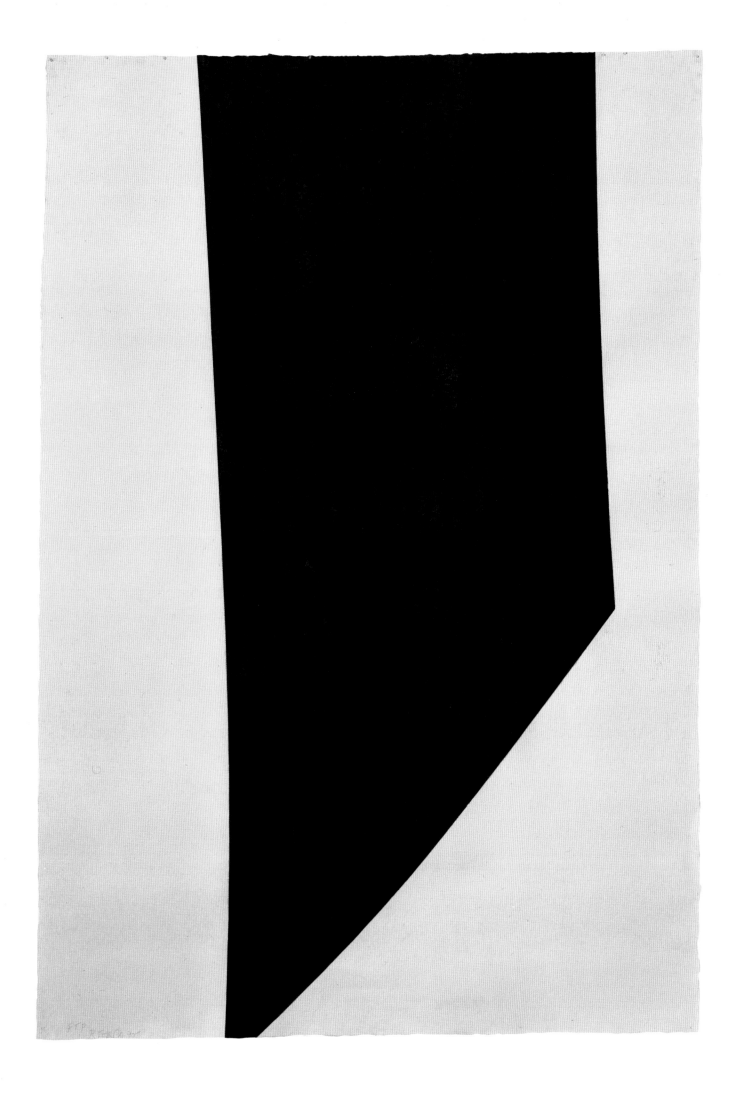

When did you first juxtapose a pair of two-dimensional shapes?

The first example is the 1987 drawing that is owned by the Philadelphia Museum of Art [Figure 23]. This drawing remains idiosyncratic. It is the first drawing in which I particularized the weight of two distinct shapes. It is an illustration of the problem, however, in that the two forms are contained within the same sheet of paper and are not literally juxtaposed.

How do you distinguish your silkscreens from your wall drawings?

The silkscreens can and do approximate my large paper drawings in size. The biggest sheets of paper are 9 feet square; when the two panels are juxtaposed, the silkscreen may expand to 16 feet. Nonetheless, each silkscreen is autonomous in relation to its installation site, whereas my canvas drawings deal with the site of their installation. They relate solely to the context in which they are made. One of my most successful wall drawings was done in the big second-floor gallery of the Kunsthalle Basel [Figure 24]. It consisted of one canvas about 60 feet long and 10 feet high, stretching from the ceiling halfway down the wall, and a second canvas of the same size, mounted lower down on the opposite wall. The work made the whole room seem to roll; you felt as though you were standing on a ship with the ballast leaning to one side, which is not unlike the sensation created by the piece I recently completed for the Carnegie International. Last year I did a large-scale drawing in Paris where two corners of the gallery space were diagonally connected by the installation of the drawing. Everybody who went into the room stood in the diagonal space formed between the two corners. When my bigger canvas drawings are successful, they create a context that differentiates itself from the architectural space.

How are your large drawings and prints generally exhibited?

The large paper drawings have always been exhibited in frames, and the canvas drawings, which are at least four to five times larger, have always been shown tacked to the wall. Now, however, Gemini has figured out a way of attaching the large silkscreens directly to the wall.

And you prefer that?

The frame is problematic. However, I don't know if attaching the prints directly to the wall solves the problem. Context is not the issue here.

When you work with the pairs of sheets, in the silkscreens, how do you determine what the space between should be?

The space makes one shape lean against the other. If you think of a trapezoid, with the smaller edge on the bottom and the vertical edge on the left, then the mass of the shape is going to move from left to right, toward the top. In juxtaposing another shape, you can either reinforce that directionality or work to counterbalance it.

What challenge did the silkscreens offer you that was different from that offered by the drawings?

The silkscreens allowed me to expand the scale to almost that of the large paper drawings that I was making at the time; also, with silkscreening the feedback is continuous, which keeps me involved in the process, not unlike what happens with drawing.

Could you explain how the silkscreens were produced?

I had Gemini put ink and Paintstik on large squares of paper, which I would then tear down to different sizes and shapes, and I would experiment with various juxtapositions.

Figure 23. Richard Serra, *Untitled*, 1987. Paintstik on two sheets of paper, 80″ × 116″. Philadelphia Museum of Art: Purchased: The Alice Newton Osborn Fund and the Adele Haas Turner and Beatrice Pastorius Turner Memorial Fund. Photographed by Graydon Wood.

Figure 24. Richard Serra, *Equal Size, Unequal Weight*, 1988. Paintstik on linen; two parts, each 9′6″ × 60′. Installation at Kunsthalle Basel, 1988.

Richard Serra, intaglio works in the
"Afangar Islandic Series," 1991

Hreppholar II (checklist no. 119)

Hreppholar III (checklist no. 120)

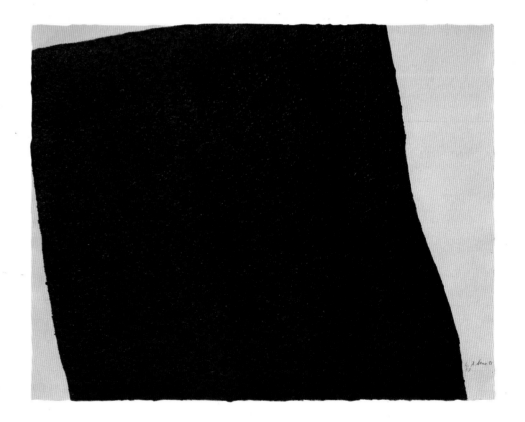

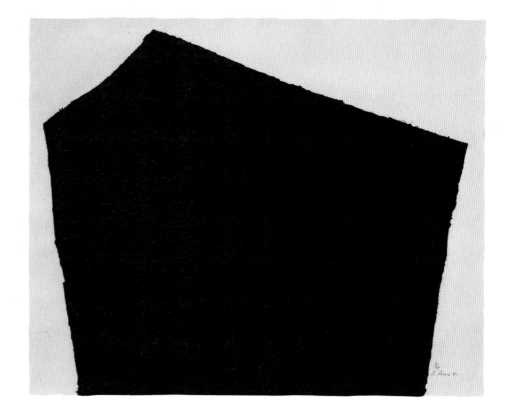

Hreppholar VI (checklist no. 123)

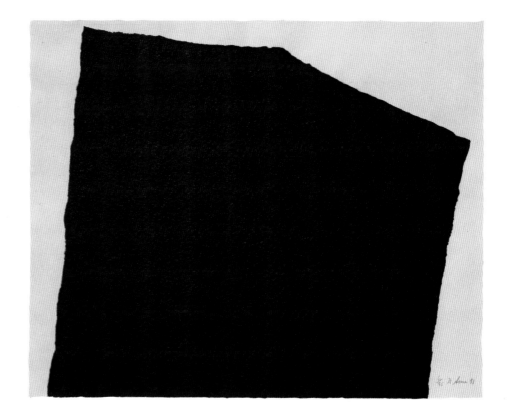

Hreppholar VIII (checklist no. 125)

How did you decide on the number of layers of Paintstik?

The number of passes of Paintstik that are made through the screen accounts for the density of the surface. It takes various amounts of Paintstik particles to give weight to different shapes.

Because of the process, is each version of a print with the same title unique?

If you are asking if each is different, then yes, if you eyeball them, each one is different. But generically they're the same.

I have never seen screenprinting on this scale before.

I haven't either.

How do the etchings that you made at Gemini relate to your recent sculptural work in Iceland [Figure 25]?

Work comes out of work. I have been preoccupied with the work in Iceland for over a year now. To draw from a sculpture after its completion is a way of informing myself about the work, trying to bring the piece closer to me, trying to have another look at what I am up to, trying to see it afresh. You only see a work with fresh eyes once, you never see it like that again. To retain that moment, to conclude the work, to distill it into another language, is the essence of my notebook drawings.

How did you make the etchings from drawings? Were the drawings done on the site in Iceland?

Yes, right after the Iceland piece went up. I made hundreds of drawings. I sent Gemini eighty-one transfer paper drawings from Iceland. None of them worked out; but they got me into the process. Last summer, I started to draw directly on copperplates; I condensed the gesture of my notebook drawings, and tried to bring back or retain or enlarge what I had seen. The process has been ongoing. I rethought and reworked the drawings again and again before the etchings were concluded. I'm finding that these etchings are more spontaneous and less encumbered by the mechanism of the process. Actually, I'm enjoying the printmaking more.

 In trying to understand the nature of etching, I used the rubbing ink crayon in various ways. I've melted down crayons and re-formed them into large marking tools. I started working on very small plates, 4 by 6 inches, and I worked some sixty of them. Of these sixty, ten are now finished. These small plates enabled me to discover the potential of the medium, to engage myself with its possibilities. I think these etchings are unorthodox, because they were produced by biting very, very deep into thick plates, and some of the prints take over a pound of ink per sheet.

 In the process of experimenting, I ended up enlarging the scale from 4 by 6 inches to close to 3 by 4 feet; three etchings measure 3 by 6 feet.

The notebook drawings and small etchings seem to be almost a detour for you.

I draw constantly, all the time. I have hundreds of notebooks. They're an index to how I think, how I inform myself about the peculiarities of my work and my subjective responses to work, and how I want my work to move along. I don't know of any other device that keeps me intimately in touch with my work; neither photographs nor language do it for me.

 The etchings are probably more conventional, more, for lack of a better word, introspective or subjective than the silkscreens. But I think that the etchings have more potential than the silkscreens for satisfying my own purposes and my own interests, and for understanding how my own subject matter has evolved. I'm learning more from them.

January 2, 1991, New York

Figure 25. Richard Serra, *Afangar*, 1990. Nine pairs of basalt stones on two contour elevations; nine stones approx. 300 × 60 × 60 cm; nine stones approx. 400 × 60 × 60 cm. Videy Island, Iceland. Photographed by Dirk Reinartz/ D-Buxtehude.

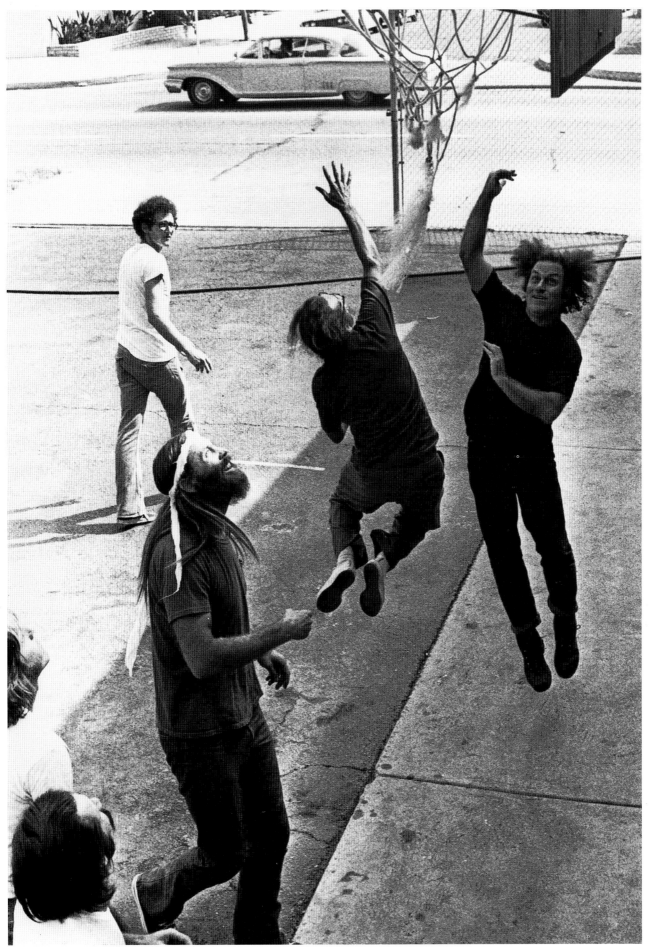

Serra (far right) in a 1973 basketball game at Gemini with (from left)
Jim Webb, Jeff Wasserman, George Page, Ron Olds, and Frank Stella
(photo by Daniel Freeman)

Saul
Steinberg

Does working in the print medium induce you to approach art differently?

No. If anything it gives me paralysis. It makes me think that I have to perform a work of art, and that's the end of it.

I don't think it makes sense to talk about this in a catalogue, but I'm agreeing to participate, to contribute. "If you don't want to do it," I could say to myself, "why the hell are you on the Ginza at midnight? You come here for some action. What are you doing here—are you a voyeur? By any chance you want to see what's going on?"

I'm much more productive, much more at ease, when I do things in a modest way, all by myself.

Is it true that you were recommended to Gemini by Jasper Johns?

I don't know; it's possible.

I know that I am one of the few artists who keeps discovering images, whose mind is working all the time, and who performs a form of autobiography—very complex, not a two-dimensional or one-idea affair. I would say the one-idea artist makes the autobiography of a fish.

I do wish I had been more stoic and more craftsmanlike, in order to be able to work together with the printers, with the fellows who lift lithographic stones, not to mention the acid people and the other difficult and dramatic professions. And signing and numbering, all the Zen fuss about packaging. These things are beautiful, and I'm sorry that I haven't been able to reach that state. The truth is, I probably get intimidated by the contrast between my modest contribution and the giant effort done around me. I feel uneasy; I feel guilty about it, and in no time I escape.

The work you did recently at Gemini, Legs, *is an etching. Have you done many etchings?*

I've done quite a few, and I ruined them. I'm spontaneous and completely free when I am alone, and I do something without any sense of responsibility. When I'm irresponsible, I am good. But as soon as responsibility comes in, I feel that I have to perform like a hero, like a real artist, and that of course paralyzes me.

Regarding Legs, *it seems so much of your work is about movement. Has that ever been a conscious fascination?*

No, I haven't noticed that part. I am much more simple. I don't think of people going somewhere, but I think of legs. That is important to me, legs and feet and shoes, and women's legs becoming more and more the protagonist. In fact, I've developed now what I call "monopodes": people made of one leg and one foot, and the nose maybe representing the head. Certainly the leg and the transformation of the woman through the millennia has become the protagonist. That has become the most symbolic part of women's liberation. The leg becomes longer and longer, the exploration going upward and downward. The shoe—a few years ago we had this fantastic platform shoe, and the boots that women wore, implying everything: the marching armies, the sadism, the sex kinkiness, and so on. And going upwards, exploring parts of the body that had been taboo even six months ago. Suddenly they are uncovered. So the leg now goes all the way to the armpit, I would say. What remains is the head. Even that is simplified, reduced to a mouth, or to an eye, or to a hairdo.

What I see in these two walking girls [in *Legs*] is that they are on the way to losing one leg and becoming monopodes. The two legs make them walk, but one is only a repetition of the other. They have a function if they walk, or better if they run or skate; but it's always one leg that is most important, the leg that holds the whole architecture of a lady—the pedestal of a monument. Where is the body then, the torso? It's on its way out. Certainly the arms were gone, according to the best modifications done by the vandals on sculptures. Everything that was useless disappears. In fact, there's a mean political symbol here. Women have been reduced now to a torso and a

Steinberg in Los Angeles, March 1992, with Gregory Evans in background

leg. Certainly the arms for defense and gesticulating or for carrying things are gone. The torso, yes, it's important, but it has become basically a miniskirt that starts right below the neck as it's pictured in that drawing. While it's not a profound political statement, one can embroider.

The term "caricature" seems weak in describing what you do. Is there a better term?

I don't know. "Caricature" doesn't suit me. I think it's applied to portraits mostly. "Satire" is too generic and too tired. I don't think there is a need to find the label for me. Let's say it's "sui generis." That's simpler. No, I don't feel that I need a label. Anyway, I'm in a precarious territory because I'm not in the middle, in the center of things. I'm in the peripheral part, and that suits me. I like to be almost on the outside. Being in the center, while alive, is fairly deadly. It's not a comfortable position. It's the opposite of work. It's what I call being your own widow, and that's not worth considering.

Speaking of being on the outside, it strikes me that your work is always about public situations.

It's political. There is no question I am a political artist, political in the old Greek sense of philosophical—about time, about people, about being around. In the end, as I told you in the first two minutes, it's autobiographical. I'm full of good and bad things, the way things are supposed to be—a mirror of some sort. And that's why I'm not settled yet.

Another way that one might be autobiographical is to belabor one's inner thoughts, but that isn't the kind of autobiography you're speaking of.

It doesn't have to be specific or direct or explained. What I do is very much like a symptom, and all the doctors around can try to figure out what it is. They become archaeologists or detectives. I think that in the process of trying to figure out what it is, they improve their minds. It is one of the most important functions of art and literature and poetry: Give them a riddle. Give them a headache!

I think we've said enough. We don't want to make an autobiography here. The more we say, the more we get in trouble.

October 23, 1992, New York

The Harvey Gantt Series

The 1990 campaign for a U.S. Senate seat from North Carolina, between incumbent Jesse Helms and challenger Harvey Gantt, was played out in the context of a bitter censorship controversy involving the National Endowment for the Arts in Washington, D.C. Led by Helms, political conservatives had applied pressure to inhibit the freedom of expression of artists who received National Endowment grants. On various other occasions, Gemini and one or more artists produced works to raise funds for mutually valued causes, as indicated in the Checklist at the end of the book. In this case, eight artists created prints at Gemini to support the challenge mounted by Gantt.

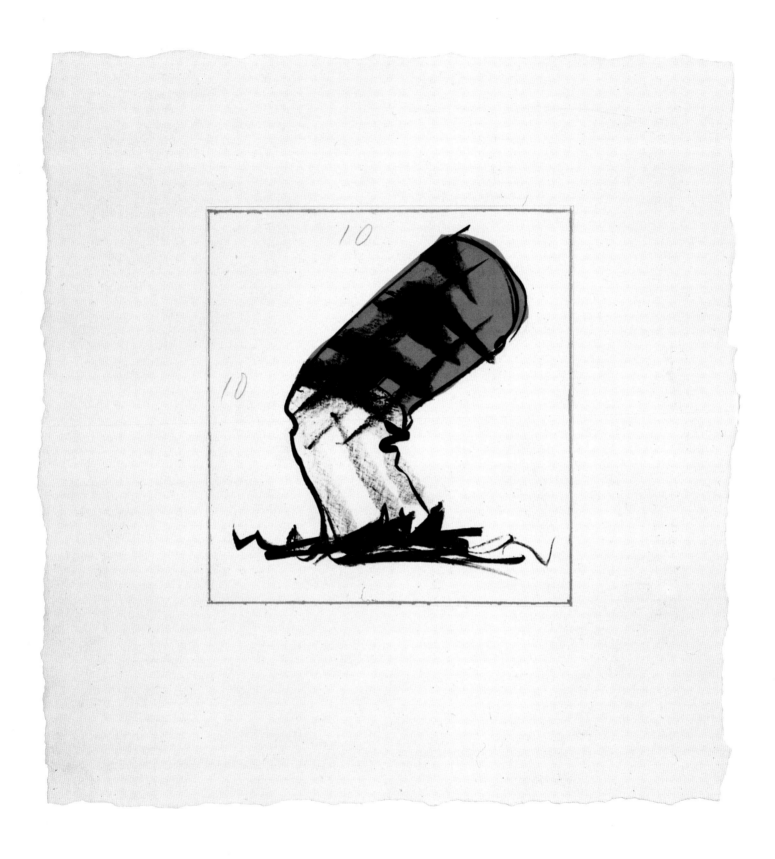

Robert Rauschenberg, *Spackle*, 1990 (checklist no. 109)

Checklist

Works Produced During Gemini's Twenty-fifth
Anniversary Celebration

The following list of works is arranged in alphabetical order, first by the last name of the artist, then by the title of the series (if any), and finally by the title of the work. If the section devoted to a particular artist contains both works within series and works that do not form part of a series, the former are listed first. If a work was created to benefit a cause — for example, Earth Day or the Harvey Gantt Senate campaign — the cause is identified at the end of the entry.

Measurements are listed with height first, followed by width; for three-dimensional objects, depth is the final dimension given. Measurements for prints refer to the size of the sheet. In the line for edition size, the first figure indicates the number of prints or sculptures in the published edition. *AP* refers to artist's proofs, *AC* to artist's copies. The abbreviation *TBD* (to be determined) indicates that the edition size or number of proofs was not finalized when this book went to press. The number of "other proofs" includes trial proofs, color trial proofs, working proofs, progressive proofs, printer's proofs, special proofs, black elements, cancellation proofs, and Gemini impressions. The Gemini I.D. and Catalogue Raisonné numbers relate to the workshop's own records of its publications. "Editioning" refers to the printing or production process used to create the complete edition.

John Baldessari

Born 1931, National City, CA
Resides Santa Monica, CA

A French Horn Player, a Square Blue Moon and Other Subjects
(nos. 1–8)

1 *Accordionist (with Crowd)*, 1992
24-color lithograph/screenprint on Arches 88 white
Size: 48″ × 40″ (121.92 × 101.6 cm)
Edition size: 35–50 projected
Gemini I.D. no. JBA91-1270
Project management: James Reid
Proofing and editioning: Stan Baden, James Reid, Carmen Schilaci, Claudio
 Stickar

2 *French Horn Player (with Three Contexts — One Uncoded)*, 1992
13-color lithograph/screenprint on Arches 88 white
Size: 60″ × 22″ (152.4 × 55.88 cm)
Edition size: 35–50 projected
Gemini I.D. no. JBA91-1268
Project management: James Reid
Proofing and editioning: Stan Baden, Mark Mahaffey, James Reid, Carmen
 Schilaci, Claudio Stickar

3 *Jump (with Volcano)*, 1992
9-color lithograph/screenprint on Arches 88 white
Size: 48″ × 24″ (121.92 × 60.96 cm)
Edition size: 35–50 projected
Gemini I.D. no. JBA91-1267
Project management: James Reid
Proofing and editioning: Stan Baden, James Reid, Carmen Schilaci, Claudio
 Stickar

4 *Keys (with Intrusion)*, 1992
8-color lithograph/screenprint on Arches 88 white
Size: 29″ × 48″ (73.66 × 121.92 cm)
Edition size: 35–50 projected
Gemini I.D. no. JBA91-1269
Project management: James Reid
Proofing and editioning: Stan Baden, James Reid, Carmen Schilaci, Claudio
 Stickar

5 *Money (with Space Between)*, 1992
20-color lithograph/screenprint on Arches 88 white
Size: 2 panels, each 48″ × 22″ (121.92 × 55.88 cm); 4″ between panels
Edition size: 35–50 projected
Gemini I.D. no. JBA91-1265
Project management: James Reid
Proofing and editioning: Stan Baden, James Reid, Carmen Schilaci, Mark
 Schultz, Claudio Stickar

6 *One and Three Persons (with Two Contexts — One Chaotic)*, 1992
10-color lithograph/screenprint on Arches 88 white
Size: 48″ × 37³/₈″ (121.92 × 94.93 cm)
Edition size: 35–50 projected
Gemini I.D. no. JBA91-1266
Project management: James Reid
Proofing and editioning: Stan Baden, James Reid, Carmen Schilaci, Mark
 Schultz, Claudio Stickar

7 *Two Bowlers (with Questioning Person)*, 1992
18-color lithograph/screenprint on Arches 88 white
Size: 2 panels, each 48″ × 36¹/₂″ (121.92 cm × 92.71 cm); 4¹/₂″ between panels
Edition size: 35–50 projected
Gemini I.D. no. JBA91-1271
Project management: James Reid
Proofing and editioning: Stan Baden, Mark Mahaffey, James Reid, Carmen
 Schilaci, Claudio Stickar

8 *Two Sunsets (One with Square Blue Moon)*, 1992
5-color lithograph/screenprint on Arches 88 white
Size: 48″ × 32″ (121.92 cm × 81.28 cm)
Edition size: 35–50 projected
Gemini I.D. no. JBA91-1272
Project management: James Reid
Proofing and editioning: Stan Baden, James Reid, Carmen Schilaci, Claudio
 Stickar

9 *Man with Snake (Blue and Yellow)*, 1990
3-color lithograph on Arches 88 white
Size: 18″ × 13⁷/₈″ (45.72 × 35.22 cm)
Edition size: 170, 22 AP, 8 other proofs
Gemini I.D. no. JBA90-1246; Catalogue Raisonné no. 1455
Project management: Kyle Militzer, James Reid
Proofing and editioning: Kyle Militzer, Octavio Molina, Carmen Schilaci
Published for the Harvey Gantt Campaign

Jonathan Borofsky

Born 1942, Boston, MA
Resides Ogunquit, ME

10 *Berlin Dream Stamp (Negative Version)*, 1991
Photograph with perforation on Kodak Polycontrast R.C.
Size: 13″ × 9¹/₄″ (33.02 × 23.49 cm)
Edition size: 50, 10 AP, 3 other proofs
Gemini I.D. no. JB85-9005A; Catalogue Raisonné no. 1476
Project management: Ken Farley
Proofing and editioning: Ken Farley, Photo Impact

11 *Beyond Good and Bad, It's Amazing to Be Alive*, 1990
5-color lithograph/screenprint on Archivart 4-ply museum board
Size: 33¹/₂″ × 71″ (85.09 × 108.34 cm)
Edition size: 60, 10 AP, 14 other proofs
Gemini I.D. no. JB90-1238; Catalogue Raisonné no. 1462
Project management: James Reid
Proofing and editioning: Stan Baden, Jim Baughman, Christy Becker, Gary
 Chavez, Heather Kurlander, Kyle Militzer, James Reid, Cecil Schmidt,
 Mark Schultz, Claudio Stickar

12 *Big Five from the Number 3253776*, 1991
1-color woodcut/relief on Meirat Velasquez rough standard white
Size: 78″ × 59³/₄″ (199.12 × 151.76 cm)
Edition size: 25, 8 AP, 7 other proofs
Gemini I.D. no. JB89-1217; Catalogue Raisonné no. 1469
Project management: Mark Mahaffey, James Reid
Proofing and editioning: Ken Farley, Steve Glassman, Mark Mahaffey, Carlos
 Moreno, James Reid, Mark Schultz, Phil Silverman, Claudio Stickar, Robin
 Taylor

13 *Bronze Casting with Numbers*, 1991
Cast bronze with patina; unique hand-painting by the artist
Size: 5″ × 9″ × 8″ (12.7 × 22.86 × 20.32 cm)
Edition size: 25
Gemini I.D. no. JB90-175; Catalogue Raisonné no. 1468
Project management: James Reid
Proofing and editioning: Peter Carlson, Frank Grasso

14 *Cross Head*, 1991
5-color etching/screenprint on Rives BFK white
Size: 52″ × 39¹/₂″ (132.08 × 100.33 cm)
Edition size: 32, 8 AP, 7 other proofs
Gemini I.D. no. JB89-3151; Catalogue Raisonné no. 1472
Project management: James Reid
Proofing and editioning: Stan Baden, Ken Farley, Mark Mahaffey, Kyle
 Militzer

15 *Deer Dream*, 1991
4-color screenprint on Arches Cover buff
Size: 54″ × 40¹/₈″ (137.16 × 101.91 cm)
Edition size: 33, 8 AP, 6 other proofs
Gemini I.D. no. JB89-1200; Catalogue Raisonné no. 1475
Project management: James Reid
Proofing and editioning: Stan Baden, Jim Baughman, Ken Farley, Kyle
 Militzer, James Reid, Carmen Schilaci, Mark Schultz, Claudio Stickar

16 *Face*, 1991
1-color etching on Meirat Velasquez rough standard white
Size: 31½" × 24" (80.01 × 60.96 cm)
Edition size: 30, 8 AP, 7 other proofs
Gemini I.D. no. JB89-3154; Catalogue Raisonné no. 1470
Project management: James Reid
Proofing and editioning: Ken Farley, Mark Mahaffey, Claudio Stickar

17 *Flower Head*, 1991
5-color etching on Meirat Velasquez rough standard white
Size: 31½" × 24" (80.01 × 60.96 cm)
Edition size: 37, 8 AP, 15 other proofs
Gemini I.D. no. JB89-3156; Catalogue Raisonné no. 1480
Project management: James Reid
Proofing and editioning: Ken Farley, Mark Mahaffey, Kyle Militzer, Carlos
 Moreno, Mark Schultz

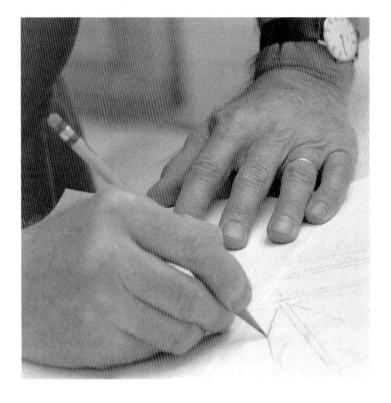

18 *Goldfish Dream*, 1991
5-color lithograph/screenprint on Arches Cover buff
Size: 54" × 31½" (137.16 × 80.01 cm)
Edition size: 35, 10 AP, 13 other proofs
Gemini I.D. no. JB89-1201; Catalogue Raisonné no. 1473
Project management: James Reid
Proofing and editioning: Stan Baden, Jim Baughman, Ken Farley, Mark
 Mahaffey, Kyle Militzer, James Reid, Carmen Schilaci, Mark Schultz,
 Claudio Stickar

19 *Hammering Man*, 1990
Collage/screenprint with La Paloma handmade paper
Size: 12′ × 5′9″ × 3″ (365.76 × 175.26 × 7.62 cm)
18 unique works, 1 prototype; each displays a number from 3302537 through
 3302555
Gemini I.D. no. JB90-2173; Catalogue Raisonné no. 1465
Project management: Ron McPherson
Proofing and editioning: Julie Bach, John Fitzgerald, Edan McPherson, Ron
 McPherson

20 *Heart Light*, 1991
Aluminum and resin sculpture with electronic sound and light
Size: 96" × 41" × 35" (243.84 × 104.14 × 88.9 cm)
Edition size: 18, 4 AC, 3 other copies
Gemini I.D. no. JB90-2171; Catalogue Raisonné no. 1479
Project management: Tom Buechele, John Lilly, Octavio Molina
Proofing and editioning: John Lilly and Practical Devices, Inc. (Thomas
 Homsher and Michael Zarembsky)

21 *I Dreamed I Was Taller Than Picasso*, 1991
5-color lithograph/screenprint on Arches Cover buff
Size: 54" × 35" (137.16 × 88.9 cm)
Edition size: 35, 10 AP, 12 other proofs
Gemini I.D. no. JB89-1199; Catalogue Raisonné no. 1474
Project management: James Reid
Proofing and editioning: Stan Baden, Jim Baughman, Ken Farley, Kyle
 Militzer, James Reid, Carmen Schilaci, Mark Schultz, Claudio Stickar

22 *Man with a Briefcase*, 1990
Woodcut/collage with La Paloma handmade paper
Size: 92" × 39" (233.68 × 99.06 cm)
53 unique works; each displays a number from 3274676 through 3274727
Gemini I.D. no. JB90-170; Catalogue Raisonné no. 1461
Project management: Ron McPherson
Proofing and editioning: Julie Bach, Annoush Bargamian, Jimi Bentley,
 Cindee Bessman, John Fitzgerald, Eric Garding, Ken Herrand, Phil
 Jerrome, Joe Lewandowski, Mary McGilvray, Edan McPherson, Ron
 McPherson, Quin Roberts, Brenda Wentzel

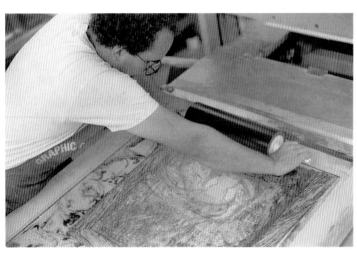

Gemini staff member Claudio Stickar in the lithography shop, November 1992

23 *Man with a Briefcase (A)*, 1991
Woodcut/collage with La Paloma handmade paper
Size: 92″ × 39″ (233.68 × 99.06 cm)
Edition size: 35, 6 AP, 6 other proofs
Gemini I.D. no. JB90-1252; Catalogue Raisonné no. 1482
Project management: Ron McPherson
Proofing and editioning: Julie Bach, John Fitzgerald, Ken Herrand, Ron
 McPherson, Quin Roberts

24 *Man with a Briefcase (B)*, 1991
Woodcut/collage with La Paloma handmade paper
Size: 92″ × 39″ (233.68 × 99.06 cm)
Edition size: 12, 4 AP, 3 other proofs
Gemini I.D. no. JB90-1253; Catalogue Raisonné no. 1483
Project management: Ron McPherson
Proofing and editioning: Julie Bach, John Fitzgerald, Ken Herrand, Ron
 McPherson, Quin Roberts

25 *Man with a Briefcase (C)*, 1991
Woodcut/collage with La Paloma handmade paper
Size: 92″ × 39″ (233.68 × 99.06 cm)
Edition size: 12, 4 AP, 2 other proofs
Gemini I.D. no. JB90-1254; Catalogue Raisonné no. 1484
Project management: Ron McPherson
Proofing and editioning: Julie Bach, John Fitzgerald, Ken Herrand, Ron
 McPherson, Quin Roberts

26 *Numbers in Space*, 1991
1-color screenprint (printed on both sides) on 4-ply museum board
Size: 7 panels, each 20″ × 16″ (50.8 × 40.64 cm)
20 unique prints; each displays two numbers from 3320765 through 3320804
Gemini I.D. no. JB91-177; Catalogue Raisonné no. 1481
Project management: James Reid
Proofing and editioning: Stan Baden, Kyle Militzer, Carmen Schilaci, Mark
 Schultz

27 *Picasso Dream Fractured*, 1991
5-color lithograph/screenprint on Arches Cover buff
Size: 5 segments, unframed; overall 55⅝″ × 38⁹/₁₆″ (136.19 × 97.94 cm)
Edition size: 35, 10 AP, 10 other proofs
Gemini I.D. no. JB89-1198; Catalogue Raisonné no. 1463
Project management: James Reid
Proofing and editioning: Susan Cornish, Ken Farley, James Reid, Mark
 Schultz, Claudio Stickar

28 *Self Portrait—Bronze Head*, 1991
Bronze with patina, cast from woodcarving done by the artist at age 8
Size: 3″ × 1″ × 1″ (7.62 × 2.54 × 2.54 cm)
Edition size: 62
Gemini I.D. no. JB90-2166; Catalogue Raisonné no. 1466
Project management: James Reid
Proofing and editioning: Frank Grasso, Dwight Hackett (Art Foundry, Santa
 Fe, New Mexico)

29 *Self Portrait—Bronze Head (State)*, 1991
Bronze with unique hand-painting by the artist, cast from woodcarving done
 by the artist at age 8
Size: 3″ × 1″ × 1″ (7.62 × 2.54 × 2.54 cm)
Edition size: 38
Gemini I.D. no. JB90-2166A; Catalogue Raisonné no. 1467
Project management: James Reid
Proofing and editioning: Frank Grasso, Dwight Hackett (Art Foundry, Santa
 Fe, New Mexico)

30 *Self Portrait with Gold Dot*, 1991
Lithograph/screenprint/gold leaf with hand-painting by the artist on Arches 88
 white
Size: 38″ × 31½″ (96.52 × 80.01 cm)
Edition size: 35, 10 AP, 13 other proofs
Gemini I.D. no. JB90-1256; Catalogue Raisonné no. 1471
Project management: James Reid
Proofing and editioning: Stan Baden, Jim Baughman, Susan Cornish, Ken
 Farley, James Reid

31 *3124727* (through *3124757*), 1991
1-color screenprint on Arches Cover white
Size: 21″ × 70″ (53.34 × 177.8 cm)
31 unique prints, each displaying a different number
Gemini master I.D. no. JB89-178 (with separate I.D. no. for each print);
 Catalogue Raisonné no. 1477
Project management: James Reid
Proofing and editioning: Stan Baden, Mary Kenneally, Mark Mahaffey, James
 Reid, Carmen Schilaci, Mark Schultz, Claudio Stickar

32 *Turtle*, 1991
11-color lithograph/screenprint with embossment and gold leaf on Rives BFK
 white
Size: 59″ × 44″ (149.8 × 111.76 cm)
Edition size: 35, 8 AP, 11 other proofs
Gemini I.D. no. JB90-1237; Catalogue Raisonné no. 1478
Project management: James Reid
Proofing and editioning: Stan Baden, Jim Baughman, Ken Farley, Mark
 Mahaffey, James Reid, Carmen Schilaci, Mark Schultz, Claudio Stickar

33 *White Horse*, 1991
Lithograph/screenprint/gold leaf with hand-painting by the artist on Arches 88
 white
Size: 38″ × 31 1/2″ (96.52 × 80.01 cm)
Edition size: 35, 10 AP, 9 other proofs
Gemini I.D. no. JB90-1255; Catalogue Raisonné no. 1464
Project management: James Reid
Proofing and editioning: Stan Baden, Jim Baughman, Gary Chavez, Susan
 Cornish, Heather Kurlander, Kyle Militzer, James Reid

Richard Diebenkorn
Born 1922, Portland, OR
Resides Healdsburg, CA

34 *Untitled*, 1990
2-color lithograph on Rives BFK white
Size: 13″ × 15 3/4″ (33.02 × 40.01 cm)
Edition size: 250, 50 AP, 13 other proofs
Gemini I.D. no. RiDi90-1243; Catalogue Raisonné no. 1452
Project management: James Reid
Proofing and editioning: Jim Baughman, Ken Farley, James Reid, Mark
 Schultz, Claudio Stickar
Published for the Harvey Gantt Campaign

35 *Untitled*, 1991
1-color lithograph on Arches Cover white
Size: 16″ × 14″ (40.65 × 35.56 cm)
Edition size: 75, 12 AP, 10 other proofs
Gemini I.D. no. RiDi90-1262; Catalogue Raisonné no. 1508
Project management: James Reid
Proofing and editioning: Jim Baughman, Michael Cascadden, James Reid,
 Claudio Stickar

36 *Untitled*, 1991
1-color lithograph on Arches Cover white
Size: 17 3/4″ × 15″ (45.09 × 38.1 cm)
Edition size: 75, 20 AP, 10 other proofs
Gemini I.D. no. RiDi90-1263; Catalogue Raisonné no. 1509
Project management: James Reid
Proofing and editioning: Jim Baughman, Michael Cascadden, James Reid,
 Claudio Stickar

Mark di Suvero
Born 1933, Shanghai, China
Resides Long Island City, NY, and Petaluma, CA

37 *Santana Wind*, 1990
1-color etching on Rives BFK white
Size: 19 1/2″ × 22″ (49.53 × 55.88 cm)
Edition size: 30, 8 AP, 7 other proofs
Gemini I.D. no. MdS89-3150; Catalogue Raisonné no. 1497
Project management: James Reid
Proofing and editioning: Ken Farley, Kyle Militzer

Jasper Johns
Born 1930, Augusta, GA
Resides New York City

38 *Untitled*, 1990
3-color lithograph on Arches 88 white
Size: 10 1/2″ × 8″ (25.4 × 20.32 cm)
Edition size: 250, 50 AP, 9 other proofs
Gemini I.D. no. JJ90-1247; Catalogue Raisonné no. 1456
Project management: James Reid
Proofing and editioning: Jim Baughman, Bill Goldston, James Reid
Published for the Harvey Gantt Campaign

39 *Untitled*, 1992
8-color lithograph on Twinrocker paper
Size: approx. 38″ × 31″ (96.52 × 78.74 cm)
Edition size: 70 projected, 14 AP, 7 other proofs
Gemini I.D. no. JJ92-1304
Project management: Bill Goldston, James Reid
Proofing and editioning: Bill Goldston, Carmen Schilaci, Claudio Stickar

40 *Untitled*, 1992
8-color lithograph on Twinrocker paper
Size: approx. 38″ × 31″ (96.52 × 78.74 cm)
Edition size: 70 projected, 14 AP, 7 other proofs
Gemini I.D. no. JJ92-1305
Project management: Bill Goldston, James Reid
Proofing and editioning: Stan Baden, Bill Goldston, James Reid

Ellsworth Kelly
Born 1923, Newburgh, NY
Resides Spencertown, NY

41 *Blue/Yellow/Red*, 1990
3-color lithograph on Rives BFK white
Size: 37″ × 36″ (93.98 × 91.44 cm)
Edition size: 80, 25 AP, 33 other proofs
Gemini I.D. no. EK90-1257; Catalogue Raisonné no. 1524
Project management: James Reid
Proofing and editioning: Stan Baden, Jim Baughman, Michael Cascadden,
 Carmen Schilaci
Published for Mémoire de Liberté (human rights)

42 *EK*, 1990
1-color lithograph on Arches 88 white
Size: 47″ × 38″ (119.38 × 96.52 cm)
Edition size: 50, 10 AP, 11 other proofs
Gemini I.D. no. EK88-1185; Catalogue Raisonné no. 1425
Project management: James Reid
Proofing and editioning: Ken Farley, Diana Kingsley, Mark Mahaffey, Ryu
 Okabayashi, James Reid, Claudio Stickar

43 *EK/Green*, 1990
2-color lithograph on Arches 88 white
Size: 47″ × 36 3/4″ (119.38 × 93.35 cm)
Edition size: 50, 10 AP, 12 other proofs
Gemini I.D. no. EK88-1189; Catalogue Raisonné no. 1429
Project management: James Reid
Proofing and editioning: Stan Baden, Mary Kenneally, Mark Mahaffey, James
 Reid, Claudio Stickar

44 *EK/Spectrum I*, 1990
12-color lithograph on Arches 88 white
Size: 25⅝" × 94" (65.1 × 238.76 cm)
Edition size: 50, 12 AP, 16 other proofs
Gemini I.D. no. EK88-1194; Catalogue Raisonné no. 1434
Project management: James Reid
Proofing and editioning: Jim Baughman, Ken Farley, Mark Mahaffey, James
 Reid, Mark Schultz, Claudio Stickar, Robin Taylor

45 *EK/Spectrum II*, 1990
6-color lithograph on Arches 88 white
Size: 25⅝" × 94" (65.1 × 238.76 cm)
Edition size: 50, 12 AP, 15 other proofs
Gemini I.D. no. EK88-1193; Catalogue Raisonné no. 1433
Project management: James Reid
Proofing and editioning: Michael Cascadden, Ken Farley, Mark Mahaffey,
 James Reid, Claudio Stickar, Robin Taylor

46 *EK/Spectrum III*, 1990
6-color lithograph on Arches 88 white
Size: 14¾" × 40" (37.47 × 101.6 cm)
Edition size: 50, 10 AP, 11 other proofs
Gemini I.D. no. EK88-1197; Catalogue Raisonné no. 1436
Project management: James Reid
Proofing and editioning: James Reid, Carmen Schilaci

47 *Jack I*, 1990
1-color lithograph on Arches 88 white
Size: 47" × 37½" (119.38 × 95.25 cm)
Edition size: 35, 8 AP, 16 other proofs
Gemini I.D. no. EK88-1186; Catalogue Raisonné no. 1426
Project management: James Reid
Proofing and editioning: Mary Kenneally, Diana Kingsley, Mark Mahaffey,
 Ryu Okabayashi, James Reid, Claudio Stickar

48 *Jack II*, 1990
1-color lithograph on Arches 88 white
Size: 47" × 38" (119.38 × 96.52 cm)
Edition size: 35, 8 AP, 11 other proofs
Gemini I.D. no. EK88-1187; Catalogue Raisonné no. 1427
Project management: James Reid
Proofing and editioning: Ken Farley, Diana Kingsley, Mark Mahaffey, Ryu
 Okabayashi, James Reid

49 *Jack III*, 1990
1-color lithograph on Arches 88 white
Size: 47" × 39" (119.38 × 99.06 cm)
Edition size: 35, 8 AP, 13 other proofs
Gemini I.D. no. EK88-1188; Catalogue Raisonné no. 1428
Project management: James Reid
Proofing and editioning: Diana Kingsley, Mark Mahaffey, Ryu Okabayashi,
 James Reid, Phil Silverman, Claudio Stickar

50 *Jack/Blue*, 1990
2-color lithograph on Arches 88 white
Size: 47" × 36¼" (119.38 × 93.35 cm)
Edition size: 35, 8 AP, 13 other proofs
Gemini I.D. no. EK88-1190; Catalogue Raisonné no. 1430
Project management: James Reid
Proofing and editioning: Ken Farley, Mark Mahaffey, James Reid, Phil
 Silverman, Claudio Stickar

51 *Jack/Gray*, 1990
2-color lithograph on Arches 88 white
Size: 47" × 38" (119.38 × 96.52 cm)
Edition size: 35, 8 AP, 11 other proofs
Gemini I.D. no. EK88-1191; Catalogue Raisonné no. 1431
Project management: James Reid
Proofing and editioning: Ken Farley, Mark Mahaffey, Kyle Militzer, James
 Reid, Carmen Schilaci, Claudio Stickar

52 *Jack/Red*, 1990
2-color lithograph on Arches 88 white
Size: 47" × 37½" (119.38 × 95.25 cm)
Edition size: 35, 8 AP, 13 other proofs
Gemini I.D. no. EK88-1192; Catalogue Raisonné no. 1432
Project management: James Reid
Proofing and editioning: Ken Farley, Mark Mahaffey, James Reid, Phil
 Silverman, Claudio Stickar

53 *Jack/Spectrum*, 1990
6-color lithograph on Arches 88 white
Size: 25⅛" × 92½" (63.83 × 234.95 cm)
Edition size: 35, 8 AP, 13 other proofs
Gemini I.D. no. EK88-1195; Catalogue Raisonné no. 1435
Project management: James Reid
Proofing and editioning: Michael Cascadden, Ken Farley, Mark Mahaffey,
 James Reid, Mark Schultz, Claudio Stickar, Robin Taylor

Edward Kienholz
Born 1927, Fairfield, WA
Resides Hope, ID, and Berlin, Germany

Nancy Reddin Kienholz
Born 1943, Los Angeles, CA
Resides Hope, ID, and Berlin, Germany

54 *Bound Duck — Black*, 1990
Wall sculpture with screenprinting, acrylic, cast aluminum object, galvanized
 steel air duct, leather helmet, formica, and resin hand-applied by the artists
Size: 67" × 39" × 10" (170.18 × 99.06 × 25.4 cm)
Edition size: 25, 10 AC, 7 other copies
Gemini I.D. no. EdK89-2153; Catalogue Raisonné no. 1486
Project management: Noah Kienholz, James Reid, Claudio Stickar
Proofing and editioning: Stan Baden, Mardee Carter, Frank Grasso, Mary
 Kenneally, Edward Kienholz, Nancy Reddin Kienholz, Noah Kienholz,
 Mark Mahaffey, Kyle Militzer, Carlos Moreno, James Reid, Phil Silverman,
 Claudio Stickar

55 *Bound Duck — White*, 1990
Wall sculpture with screenprinting, acrylic, cast aluminum object, galvanized
 steel air duct, leather helmet, formica, and resin hand-applied by the artists
Size: 67" × 39" × 10" (170.18 × 99.06 × 25.4 cm)
Edition size: 25, 10 AC, 7 other copies
Gemini I.D. no. EdK89-2154; Catalogue Raisonné no. 1487
Project management: Noah Kienholz, James Reid, Claudio Stickar
Proofing and editioning: Stan Baden, Mardee Carter, Frank Grasso, Mary
 Kenneally, Edward Kienholz, Nancy Reddin Kienholz, Noah Kienholz,
 Mark Mahaffey, Kyle Militzer, Carlos Moreno, James Reid, Phil Silverman,
 Claudio Stickar

56 *One Duck Hung Low*, 1990
Wall sculpture with screenprinting, lithography, acrylic, cast aluminum
 object, embossed aluminum sheet, and resin hand-applied by the artists
Size: 42" × 41" × 3" (106.68 × 104.14 × 7.62 cm)
Edition size: 50, 10 AC, 10 other copies
Gemini I.D. no. EdK89-2155; Catalogue Raisonné no. 1485
Project management: Noah Kienholz, James Reid, Claudio Stickar
Proofing and editioning: Stan Baden, Mardee Carter, Frank Grasso, Mary
 Kenneally, Edward Kienholz, Nancy Reddin Kienholz, Noah Kienholz,
 Mark Mahaffey, Kyle Militzer, Carlos Moreno, James Reid, Carmen
 Schilaci, Phil Silverman, Claudio Stickar

Roy Lichtenstein
Born 1923, New York, NY
Resides New York, NY

Interior Series (nos. 57–64)

57 *Bedroom*, 1991
10-color woodcut/screenprint on PTI 4-ply museum board
Size: 56³/4″ × 78¹/2″ (144.1 × 199.3 cm)
Edition size: 60, 14 AP, 14 other proofs
Gemini I.D. no. RL90-1220; Catalogue Raisonné no. 1499
Project management: Mark Mahaffey, James Reid
Proofing and editioning: Stan Baden, Jim Baughman, Christy Becker, Ken Farley, Scott Griffith, Karoline McKay, Mark Mahaffey, Kyle Militzer, Carlos Moreno, Margaret Parr, James Reid, Carmen Schilaci, Cecil Schmidt, Mark Schultz, Claudio Stickar

58 *Blue Floor*, 1991
12-color lithograph/woodcut/screenprint on PTI 4-ply museum board
Size: 57³/4″ × 83¹/2″ (146.6 × 212.09 cm)
Edition size: 60, 14 AP, 14 other proofs
Gemini I.D. no. RL90-1227; Catalogue Raisonné no. 1506
Project management: Mark Mahaffey, James Reid
Proofing and editioning: Stan Baden, Jim Baughman, Christy Becker, Michael Cascadden, Gary Chavez, Ken Farley, Scott Griffith, Heather Kurlander, Mark Mahaffey, Kyle Militzer, Carlos Moreno, Margaret Parr, James Reid, Carmen Schilaci, Mark Schultz, Phil Silverman, Claudio Stickar

59 *The Den*, 1991
7-color woodcut/screenprint on PTI 4-ply museum board
Size: 57¹/2″ × 71⁵/8″ (146.05 × 181.94 cm)
Edition size: 60, 14 AP, 12 other proofs
Gemini I.D. no. RL90-1222; Catalogue Raisonné no. 1501
Project management: Mark Mahaffey, James Reid
Proofing and editioning: Stan Baden, Jim Baughman, Christy Becker, Michael Cascadden, Ken Farley, Steve Glassman, Diedre Keaveny, Heather Kurlander, Mark Mahaffey, Kyle Militzer, Carlos Moreno, James Reid, Carmen Schilaci, Phil Silverman, Claudio Stickar, Robin Taylor

60 *The Living Room*, 1991
11-color woodcut/screenprint on PTI 4-ply museum board
Size: 58″ × 72″ (147.32 × 182.88 cm)
Edition size: 60, 14 AP, 14 other proofs
Gemini I.D. no. RL90-1223; Catalogue Raisonné no. 1502
Project management: Mark Mahaffey, James Reid
Proofing and editioning: Stan Baden, Jim Baughman, Christy Becker, Michael Cascadden, Ken Farley, Steve Glassman, Mark Mahaffey, Kyle Militzer, Carlos Moreno, Margaret Parr, James Reid, Carmen Schilaci, Mark Schultz, Phil Silverman, Claudio Stickar

61 *Modern Room*, 1991
12-color lithograph/woodcut/screenprint on PTI 4-ply museum board
Size: 56″ × 80³/4″ (142.24 × 205.1 cm)
Edition size: 60, 14 AP, 14 other proofs
Gemini I.D. no. RL90-1225; Catalogue Raisonné no. 1504
Project management: Mark Mahaffey, James Reid
Proofing and editioning: Stan Baden, Jim Baughman, Christy Becker, Ken Farley, Steve Glassman, Diedre Keaveny, Heather Kurlander, Karoline McKay, Mark Mahaffey, Kyle Militzer, Carlos Moreno, Margaret Parr, James Reid, Carmen Schilaci, Mark Schultz, Claudio Stickar, Robin Taylor

62 *Red Lamps*, 1991
11-color woodcut/screenprint/lithograph on PTI 4-ply museum board
Size: 57¹/4″ × 78³/4″ (145.42 × 200.03 cm)
Edition size: 60, 14 AP, 9 other proofs
Gemini I.D. no. RL90-1224; Catalogue Raisonné no. 1503
Project management: Mark Mahaffey, James Reid
Proofing and editioning: Stan Baden, Jim Baughman, Christy Becker, Michael Cascadden, Ken Farley, Scott Griffith, Diedre Keaveny, Heather Kurlander, Mark Mahaffey, Kyle Militzer, James Reid, Mark Schultz, Claudio Stickar

63 *La Sortie*, 1991
6-color woodcut on PTI 4-ply museum board
Size: 58¹/2″ × 81″ (148.59 × 205.74 cm)
Edition size: 60, 14 AP, 12 other proofs
Gemini I.D. no. RL90-1221; Catalogue Raisonné no. 1500
Project management: Mark Mahaffey, James Reid
Proofing and editioning: Stan Baden, Jim Baughman, Ken Farley, Karoline McKay, Mark Mahaffey, Kyle Militzer, Carlos Moreno, Margaret Parr, James Reid, Carmen Schilaci, Phil Silverman

64 *Yellow Vase*, 1991
11-color lithograph/woodcut/screenprint on PTI 4-ply museum board
Size: 55¹/2″ × 84¹/2″ (140.97 × 214.63 cm)
Edition size: 60, 14 AP, 14 other proofs
Gemini I.D. no. RL90-1226; Catalogue Raisonné no. 1505
Project management: Mark Mahaffey, James Reid
Proofing and editioning: Stan Baden, Jim Baughman, Christy Becker, Michael Cascadden, Susan Cornish, Ken Farley, Steve Glassman, Scott Griffith, Mark Mahaffey, Kyle Militzer, Carlos Moreno, James Reid, Carmen Schilaci, Cecil Schmidt, Mark Schultz, Phil Silverman, Claudio Stickar

65 *Mirror*, 1990
2-color screenprint on 4-ply rag board
Size: 10″ × 7³/8″ (25.4 × 18.75 cm)
Edition size: 250, 50 AP, 34 other proofs
Gemini I.D. no. RL90-1241; Catalogue Raisonné no. 1450
Project management: James Reid
Proofing and editioning: Aiko Baden, Kenneth Baden, Stan Baden, Michael Cascadden, James Reid
Published for the Harvey Gantt Campaign

66 *Reflections on Soda Fountain*, 1991
10-color screenprint on Rives BFK white
Size: 36³/4″ × 38¹/2″ (93.34 × 97.79 cm)
Edition size: 85, 30 AP, 8 other proofs
Gemini I.D. no. RL90-5190; Catalogue Raisonné no. 1498
Project management: Stan Baden, James Reid
Proofing and editioning: Aiko Baden, Kenneth Baden, Stan Baden, Christy Becker, Dave Johnson, Diedre Keaveny, Heather Kurlander, Kyle Militzer
Published to benefit the Jewish Fund for Justice

67 *Wallpaper with Blue Floor Interior*, 1991
9-color screenprint; 36 printings on PTI waterleaf
Size: 5 panels; overall 8′6″ × 12′8¹/2″ (259.08 × 387.35 cm)
Edition size: 300, 50 AP, 13 other proofs
Gemini I.D. no. RL90-5196; Catalogue Raisonné no. 1558
Project management: Ron McPherson
Proofing and editioning: Julie Bach, John Fitzgerald, Eric Garding, David Gregory, Ken Herrand, Joe Lewandowski, Edan McPherson, Ron McPherson

68 *Yellow Brushstroke*, 1990
Bronze casting with patina/enamel
Size: 11¹/2″ × 13″ × 4³/4″ (29.21 × 33.02 × 12.06 cm)
Edition size: indefinite
Gemini I.D. no. RL89-2157; Catalogue Raisonné no. 1507
Project management: James Reid
Proofing and editioning: Michael Cascadden, Dwight Hackett (Art Foundry, Santa Fe, New Mexico)
Published for the Frederick R. Weisman Foundation to honor people in the arts

Malcolm Morley
Born 1931, London, England
Resides Brookhaven, NY

69 *Erotic Fruitos*, 1992
7-color etching on Rives BFK white
Size: 47³/4″ × 35¹/2″ (121.28 × 90.17 cm)
Edition size: TBD
Gemini I.D. no. MM89-3149
Project management: Ken Farley
Proofing and editioning: Ken Farley, Mark Mahaffey, Kyle Militzer, Phil
 Silverman, Claudio Stickar

Claes Oldenburg
Born 1929, Stockholm, Sweden
Resides New York, NY

70 *Apple Core — Autumn*, 1990
4-color lithograph on Koller HMP off-white
Size: 41″ × 31¹/4″ (104.14 × 79.38 cm)
Edition size: 58, 12 AP, 8 other proofs
Gemini I.D. no. CO89-1209; Catalogue Raisonné no. 1440
Project management: Ken Farley, Mark Mahaffey, James Reid
Proofing and editioning: Ken Farley, Kyle Militzer, Claudio Stickar

71 *Apple Core — First State*, 1990
2-color lithograph on Lawrence Barker green
Size: 40″ × 29¹/4″ (101.6 × 74.3 cm)
Edition size: 24, 8 AP, 9 other proofs
Gemini I.D. no. CO89-1205A; Catalogue Raisonné no. 1445
Project management: Ken Farley, Mark Mahaffey, James Reid
Proofing and editioning: Ken Farley, Carmen Schilaci, Phil Silverman,
 Claudio Stickar

72 *Apple Core — Spring*, 1990
4-color lithograph on Lawrence Barker green
Size: 40″ × 29¹/4″ (101.6 × 74.3 cm)
Edition size: 57, 12 AP, 10 other proofs
Gemini I.D. no. CO89-1211; Catalogue Raisonné no. 1438
Project management: Ken Farley, Mark Mahaffey, James Reid
Proofing and editioning: Ken Farley, Carmen Schilaci

73 *Apple Core — Summer*, 1990
4-color lithograph on Koller HMP off-white
Size: 41″ × 31¹/4″ (104.14 × 79.38 cm)
Edition size: 54, 10 AP, 8 other proofs
Gemini I.D. no. CO89-1205; Catalogue Raisonné no. 1439
Project management: Ken Farley, Mark Mahaffey, James Reid
Proofing and editioning: Jim Baughman, Ken Farley, Mark Mahaffey, Phil
 Silverman, Claudio Stickar

74 *Apple Core — Winter*, 1990
3-color lithograph on Arches Cover black
Size: 40″ × 30″ (101.6 × 76.2 cm)
Edition size: 59, 12 AP, 13 other proofs
Gemini I.D. no. CO89-1210; Catalogue Raisonné no. 1441
Project management: Mark Mahaffey, James Reid, Claudio Stickar
Proofing and editioning: Ken Farley, Carmen Schilaci, Claudio Stickar

75 *Butt for Gantt*, 1990
3-color lithograph with embossing on Arches 88 white
Size: 19″ × 18″ (48.25 × 45.72 cm)
Edition size: 250, 50 AP, 19 other proofs
Gemini I.D. no. CO90-1242; Catalogue Raisonné no. 1451
Project management: James Reid
Proofing and editioning: Jim Baughman, Sun Mi Choe, James Reid, Carmen
 Schilaci, Claudio Stickar
Published for the Harvey Gantt Campaign

76 *Extinguished Match*, 1990
4-color lithograph on Koller HMP white
Size: 40³/4″ × 30³/4″ (103.51 × 78.11 cm)
Edition size: 58, 12 AP, 10 other proofs
Gemini I.D. no. CO89-1207; Catalogue Raisonné no. 1442
Project management: Ken Farley, Mark Mahaffey, James Reid
Proofing and editioning: Mark Mahaffey, Kyle Militzer, James Reid, Carmen
 Schilaci, Claudio Stickar, Robin Taylor

77 *Extinguished Match — First State*, 1990
1-color lithograph on Twinrocker grey
Size: 40³/4″ × 31″ (103.51 × 78.74 cm)
Edition size: 24, 8 AP, 10 other proofs
Gemini I.D. no. CO89-1207A; Catalogue Raisonné no. 1446
Project management: Ken Farley, Mark Mahaffey, James Reid
Proofing and editioning: Ken Farley, Mark Mahaffey, James Reid, Carmen
 Schilaci, Phil Silverman, Claudio Stickar

78 *Profiterole*, 1990
Cast aluminum hand-painted by the artist
Size: 6″ × 8¹/8″ × 8⁵/8″ (15.24 × 20.65 × 21.92 cm)
Edition size: 75, 25 AC, 14 other copies
Gemini I.D. no. CO88-2152; Catalogue Raisonné no. 1457
Project management: James Reid
Proofing and editioning: Michael Cascadden, Richard Garst, Steve Glassman,
 Frank Grasso, James Reid
Published to benefit the Hereditary Disease Foundation

79 *Profiterole*, 1990
5-color lithograph on Koller HMP off-white
Size: 31¹/4″ × 41″ (79.38 × 104.14 cm)
Edition size: 57, 12 AP, 9 other proofs
Gemini I.D. no. CO89-1208; Catalogue Raisonné no. 1443
Project management: Ken Farley, Mark Mahaffey, James Reid
Proofing and editioning: Stan Baden, Mark Mahaffey, Mark Schultz, Claudio
 Stickar

80 *Profiterole — Grey State*, 1990
5-color lithograph on Koller HMP pale grey
Size: 31″ × 40¹/2″ (78.74 × 102.87 cm)
Edition size: 58, 12 AP, 9 other proofs
Gemini I.D. no. CO89-1215; Catalogue Raisonné no. 1444
Project management: Ken Farley, Mark Mahaffey, James Reid
Proofing and editioning: Stan Baden, Mark Mahaffey, Phil Silverman

81 *Sneaker Lace*, 1990
Stainless steel hand-painted by the artist
Size: 52″ × 24¹/2″ × 42″ (132.08 × 62.23 × 106.68 cm)
15 unique sculptures
Gemini I.D. no. CO90-171; Catalogue Raisonné no. 1458
Project management: James Reid
Proofing and editioning: Frank Grasso, Donald Lippincott, David Platzker,
 James Reid

82 *Sneaker Lace in Landscape — Blue*, 1990
4-color lithograph on Arches Cover white
Size: 57″ × 42¹/2″ (144.78 × 107.95 cm)
Edition size: 55, 12 AP, 10 other proofs
Gemini I.D. no. CO89-1212; Catalogue Raisonné no. 1495
Project management: James Reid
Proofing and editioning: Jim Baughman, Ken Farley, Mark Mahaffey,
 Margaret Parr, James Reid, Carmen Schilaci

83 *Sneaker Lace in Landscape — Grey*, 1990
4-color lithograph on Arches Cover white
Size: 57″ × 42½″ (144.78 × 107.95 cm)
Edition size: 55, 12 AP, 8 other proofs
Gemini I.D. no. CO89-1213; Catalogue Raisonné no. 1493
Project management: James Reid
Proofing and editioning: Jim Baughman, Ken Farley, Mark Mahaffey,
 Margaret Parr, James Reid, Carmen Schilaci

84 *Sneaker Lace in Landscape — Line State*, 1990
2-color lithograph on Arches 88 white
Size: 57″ × 42½″ (144.78 × 107.95 cm)
Edition size: 55, 14 AP, 12 other proofs
Gemini I.D. no. CO89-1234; Catalogue Raisonné no. 1520
Project management: James Reid, Claudio Stickar
Proofing and editioning: Jim Baughman, Mark Mahaffey, Carmen Schilaci,
 Mark Schultz, Claudio Stickar

85 *Sneaker Lace in Landscape — Red*, 1990
4-color lithograph on Arches Cover white
Size: 57″ × 42½″ (144.78 × 107.95 cm)
Edition size: 55, 12 AP, 8 other proofs
Gemini I.D. no. CO89-1214; Catalogue Raisonné no. 1496
Project management: James Reid
Proofing and editioning: Jim Baughman, Ken Farley, Mark Mahaffey,
 Margaret Parr, James Reid, Carmen Schilaci

86 *Sneaker Lace in Landscape with Palm Trees*, 1990
4-color lithograph on Arches Cover buff
Size: 57″ × 42½″ (144.78 × 107.95 cm)
Edition size: 55, 12 AP, 8 other proofs
Gemini I.D. no. CO89-1206; Catalogue Raisonné no. 1494
Project management: James Reid
Proofing and editioning: Ken Farley, Mark Mahaffey, Carmen Schilaci, Mark
 Schultz, Phil Silverman, Claudio Stickar, Robin Taylor

87 *Study for Sneaker Lace — Black*, 1990
3-color lithograph on Arches black
Size: 67″ × 41½″ (170.18 × 105.41 cm)
Edition size: 35, 10 AP, 21 other proofs
Gemini I.D. no. CO89-1233; Catalogue Raisonné no. 1521
Project management: James Reid
Proofing and editioning: Jim Baughman, Ken Farley, Diana Kingsley, Mark
 Mahaffey, Carlos Moreno, Ryu Okabayashi, Carmen Schilaci, Claudio
 Stickar

88 *Study for Sneaker Lace — White*, 1990
3-color lithograph on Arches 88 white
Size: 67″ × 41½″ (170.18 × 105.41 cm)
Edition size: 35, 10 AP, 17 other proofs
Gemini I.D. no. CO89-1232; Catalogue Raisonné no. 1522
Project management: James Reid
Proofing and editioning: Jim Baughman, Michael Cascadden, Ken Farley,
 Scott Griffith, Mark Mahaffey, Kyle Militzer, James Reid, Carmen Schilaci,
 Mark Schultz, Claudio Stickar

89 *Thrown Ink Bottle with Fly and Dropped Quill*, 1990
6-color lithograph on Arches 88 white
Size: 45″ × 35″ (114.3 × 88.9 cm)
Edition size: 75, 18 AP, 22 other proofs
Gemini I.D. no. CO90-1230; Catalogue Raisonné no. 1523
Project management: James Reid
Proofing and editioning: Stan Baden, Jim Baughman, Michael Cascadden,
 Ken Farley, Mark Mahaffey, James Reid, Carmen Schilaci, Claudio Stickar

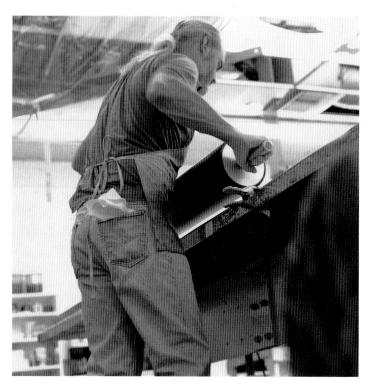

Gemini's James Reid in the lithography shop, November 1992

Ken Price
Born 1935, Los Angeles, CA
Resides Venice, CA

90 *California Cup*, 1991
Fired and glazed earthenware cup
Size: 4¹/₈" × 6" × 3" (10.47 × 15.24 × 7.62 cm)
Edition size: 25, 10 AC, 2 other copies
Gemini I.D. no. KP91-2176; Catalogue Raisonné no. 1537
Project management: Octavio Molina, James Reid
Proofing and editioning: Alan Brubaker, Happy Price, James Reid, Henry
 Takemoto

91 *Chet*, 1991
Fired and glazed earthenware cup
Size: 4¹/₈" × 6" × 3¹/₈" (10.47 × 15.24 × 7.94 cm)
Edition size: 25, 10 AC, 2 other copies
Gemini I.D. no. KP91-2178; Catalogue Raisonné no. 1539
Project management: Octavio Molina, James Reid
Proofing and editioning: Alan Brubaker, Happy Price, James Reid, Henry
 Takemoto

92 *The Fireworm Cup*, 1991
Fired and glazed earthenware cup
Size: 3⁷/₈" × 6¹/₄" × 3¹/₄" (9.84 × 15.88 × 8.26 cm)
Edition size: 25, 10 AC, 3 other copies
Gemini I.D. no. KP91-2177; Catalogue Raisonné no. 1538
Project management: Octavio Molina, James Reid
Proofing and editioning: Alan Brubaker, Happy Price, James Reid, Henry
 Takemoto

93 *Mildred*, 1991
Fired and glazed earthenware cup
Size: 4¹/₄" × 6" × 3" (10.8 × 15.24 × 7.62 cm)
Edition size: 25, 10 AC, 2 other copies
Gemini I.D. no. KP91-2175; Catalogue Raisonné no. 1536
Project management: Octavio Molina, James Reid
Proofing and editioning: Alan Brubaker, Happy Price, James Reid, Henry
 Takemoto

Robert Rauschenberg
Born 1925, Port Arthur, TX
Resides Captiva Island, FL

Illegal Tender L.A. (nos. 94–103)

94 *Blue Line Swinger*, 1991
12-color lithograph triptych on Dieu Donne charcoal grey
Size: 3 panels, each 30" × 22¹/₄"; overall 30" × 68¹/₂" (76.2 × 173.99 cm)
Edition size: 68, 12 AP, 21 other proofs
Gemini I.D. no. RR91-1282; Catalogue Raisonné no. 1531
Project management: Darryl Pottorf, James Reid
Proofing and editioning: Stan Baden, Ken Farley, Mark Mahaffey, Kyle
 Militzer, James Reid, Carmen Schilaci, Mark Schultz, Claudio Stickar

95 *Blues*, 1991
4-color lithograph on Koller HMP off-white
Size: approx. 41" × 31" (104.14 × 78.74 cm)
Edition size: 57, 10 AP, 16 other proofs
Gemini I.D. no. RR91-1280; Catalogue Raisonné no. 1529
Project management: Darryl Pottorf, James Reid
Proofing and editioning: Stan Baden, Ken Farley, Mark Mahaffey, Kyle
 Militzer, James Reid, Carmen Schilaci, Mark Schultz, Claudio Stickar

96 *Fence*, 1991
4-color lithograph on Arches Cover black
Size: approx. 44½" × 30¼" (113.03 × 76.83 cm)
Edition size: 57, 10 AP, 17 other proofs
Gemini I.D. no. RR91-1283; Catalogue Raisonné no. 1532
Project management: Darryl Pottorf, James Reid
Proofing and editioning: Stan Baden, Ken Farley, Mark Mahaffey, Kyle
 Militzer, James Reid, Carmen Schilaci, Mark Schultz, Claudio Stickar

97 *Fest*, 1991
4-color lithograph on Koller HMP off-white
Size: approx. 26" × 21" (66.04 × 53.34 cm)
Edition size: 51, 10 AP, 10 other proofs
Gemini I.D. no. RR91-1286; Catalogue Raisonné no. 1535
Project management: Darryl Pottorf, James Reid
Proofing and editioning: Stan Baden, Ken Farley, Mark Mahaffey, Kyle
 Militzer, James Reid, Carmen Schilaci, Mark Schultz, Claudio Stickar

98 *Hollywood Sphinx*, 1991
2-color lithograph on Koller HMP granite grey
Size: approx. 40" × 30" (101.6 × 76.2 cm)
Edition size: 58, 10 AP, 18 other proofs
Gemini I.D. no. RR91-1278; Catalogue Raisonné no. 1527
Project management: Darryl Pottorf, James Reid
Proofing and editioning: Stan Baden, Ken Farley, Mark Mahaffey, Kyle
 Militzer, James Reid, Carmen Schilaci, Mark Schultz, Claudio Stickar

99 *Marmont Flair*, 1991
4-color lithograph on Koller HMP off-white
Size: approx. 31" × 41" (78.74 × 104.14 cm)
Edition size: 59, 10 AP, 19 other proofs
Gemini I.D. no. RR91-1281; Catalogue Raisonné no. 1530
Project management: Darryl Pottorf, James Reid
Proofing and editioning: Stan Baden, Ken Farley, Mark Mahaffey, Kyle
 Militzer, James Reid, Carmen Schilaci, Mark Schultz, Claudio Stickar

100 *Murmurs*, 1991
3-color lithograph on Cotman handmade paper
Size: approx. 31½" × 23" (80.01 × 58.42 cm)
Edition size: 56, 10 AP, 18 other proofs
Gemini I.D. no. RR91-1279; Catalogue Raisonné no. 1528
Project management: Darryl Pottorf, James Reid
Proofing and editioning: Stan Baden, Ken Farley, Mark Mahaffey, Kyle
 Militzer, James Reid, Carmen Schilaci, Mark Schultz, Claudio Stickar

101 *Pressure Garden*, 1991
3-color lithograph on Koller HMP Moonstone
Size: approx. 32" × 24" (81.28 × 60.96 cm)
Edition size: 56, 10 AP, 21 other proofs
Gemini I.D. no. RR91-1284; Catalogue Raisonné no. 1533
Project management: Darryl Pottorf, James Reid
Proofing and editioning: Stan Baden, Ken Farley, Mark Mahaffey, Kyle
 Militzer, James Reid, Carmen Schilaci, Mark Schultz, Claudio Stickar

102 *Rust Pursuit*, 1991
4-color lithograph on Rives BFK grey
Size: approx. 30" × 44" (76.20 × 111.76 cm)
Edition size: 53, 10 AP, 10 other proofs
Gemini I.D. no. RR91-1277; Catalogue Raisonné no. 1526
Project management: Darryl Pottorf, James Reid
Proofing and editioning: Stan Baden, Ken Farley, Mark Mahaffey, Kyle
 Militzer, James Reid, Carmen Schilaci, Mark Schultz, Claudio Stickar

103 *Viaduct*, 1991
5-color lithograph on Lawrence Barker handmade grey
Size: approx. 40½" × 29" (102.87 × 73.66 cm)
Edition size: 54, 10 AP, 13 other proofs
Gemini I.D. no. RR91-1285; Catalogue Raisonné no. 1534
Project management: Darryl Pottorf, James Reid
Proofing and editioning: Stan Baden, Ken Farley, Mark Mahaffey, Kyle
 Militzer, James Reid, Carmen Schilaci, Mark Schultz, Claudio Stickar

104 *Borealis Shares I*, 1990
Screenprinted brass panel chair with aluminum, Lexan, and hand-painted
 patinas by the artist
Size: 75" × 40¾" × 23" (190.5 × 103.5 × 58.42 cm)
Edition size: 26
Gemini I.D. no. RR90-172; Catalogue Raisonné no. 1459
Project management: Stan Baden, Darryl Pottorf, James Reid
Proofing and editioning: Stan Baden, Jim Baughman, Michael Cascadden,
 Ken Farley, Scott Griffith, Mark Mahaffey, Kyle Militzer, Carlos Moreno,
 Darryl Pottorf, James Reid, Carmen Schilaci, Mark Schultz, Claudio
 Stickar, Robin Taylor, Lawrence Voytek

105 *Borealis Shares II*, 1990
Screenprinted brass panel chair with aluminum, Lexan, and hand-painted
 patinas by the artist
Size: 75" × 40¾" × 23" (190.5 × 103.5 × 58.42 cm)
Edition size: 26
Gemini I.D. no. RR90-173; Catalogue Raisonné no. 1460
Project management: Stan Baden, Darryl Pottorf, James Reid
Proofing and editioning: Stan Baden, Jim Baughman, Michael Cascadden,
 Ken Farley, Scott Griffith, Mark Mahaffey, Kyle Militzer, Carlos Moreno,
 Darryl Pottorf, James Reid, Carmen Schilaci, Mark Schultz, Claudio
 Stickar, Robin Taylor, Lawrence Voytek

106 *Earth Day 1990*, 1990
7-color screenprint with unique pochoir on Arches Cover white
Size: 64" × 42½" (162.56 × 107.95 cm)
Edition size: 75, 26 AP, 12 other proofs
Gemini I.D. no. RR90-5189; Catalogue Raisonné no. 1447
Project management: Sidney Felsen, Ron McPherson
Proofing and editioning: Cindee Bessman, Jim Bowling, Ken Herrand, Edan
 McPherson, Ron McPherson, Quin Roberts
Published to benefit Earth Day 1990

107 *For Ferraro*, 1992
6-color screenprint on Rives BFK white
Size: 10" × 8¼" (25.4 × 20.96 cm)
Edition size: 150, 50 AP, 29 other proofs
Gemini I.D. no. RR92-5198; Catalogue Raisonné no. 1559
Project management: James Reid
Proofing and editioning: Stan Baden, James Reid, Carmen Schilaci
Published for the Ferraro for U.S. Senate Campaign, 1992

108 *People for the American Way Print*, 1990
8-color lithograph/screenprint on Arches Cover white
Size: 48" × 35¾" (121.92 × 90.8 cm)
Edition size: 75, 25 AP, 19 other proofs
Gemini I.D. no. RR90-1229; Catalogue Raisonné no. 1525
Project management: Stan Baden, James Reid
Proofing and editioning: Aiko Baden, Stan Baden, Jim Baughman, Michael
 Cascadden, Dave Johnson, Kyle Militzer, Carlos Moreno, James Reid,
 Carmen Schilaci, Cecil Schmidt
Published to benefit the charitable purposes of People for the American Way

109 *Spackle*, 1990
3-color lithograph on Koller HMP cream
Size: 5¾" × 4½" (14.61 × 11.43 cm)
Edition size: 250, 50 AP, 22 other proofs
Gemini I.D. no. RL90-1240; Catalogue Raisonné no. 1449
Project management: Mark Mahaffey, James Reid
Proofing and editioning: Jim Baughman, Mark Mahaffey, Rae Pomeranz
 Mahaffey, James Reid
Published for the Harvey Gantt Campaign

Edward Ruscha
Born 1937, Omaha, NE
Resides Venice, CA

110 *Compass*, 1990
4-color screenprint on PTI Supra white
Size: 40⁹/₁₆″ × 29⁵/₁₆″ (103.02 × 74.44 cm)
Edition size: 60 (proofs TBD)
Gemini I.D. no. ER90-5188; Catalogue Raisonné no. 1448
Project management: Ron McPherson
Proofing and editioning: Cindee Bessman, Jim Bowling, Ken Herrand, Ron
 McPherson, Quin Roberts
Published to benefit Earth Day 1990

111 *Main Street*, 1990
1-color lithograph on Rives BFK grey
Size: 8¹/₄″ × 10¹/₄″ (20.95 × 26.03 cm)
Edition size: 250, 50 AP, 24 other proofs
Gemini I.D. no. ER90-1244; Catalogue Raisonné no. 1453
Project management: James Reid
Proofing and editioning: Jim Baughman, James Reid, Carmen Schilaci, Maia
 Terzian
Published for the Harvey Gantt Campaign

Richard Serra
Born 1939, San Francisco, CA
Resides New York, NY

Afangar Islandic Series (nos. 112–129)

112 *Eidid I*, 1991
1-color etching on Fabriano Murillo paper
Size: 25″ × 30³/₄″ (63.5 × 78.11 cm)
Edition size: 50, 10 AP, 12 other proofs
Gemini I.D. no. RS91-3184; Catalogue Raisonné no. 1556
Project management: James Reid, Claudio Stickar
Proofing and editioning: Mark Mahaffey, Claudio Stickar

113 *Eidid II*, 1991
1-color etching on Fabriano Murillo paper
Size: 25³/₈″ × 29⁷/₈″ (64.45 × 75.9 cm)
Edition size: 49, 10 AP, 12 other proofs
Gemini I.D. no. RS90-3183; Catalogue Raisonné no. 1555
Project management: James Reid, Claudio Stickar
Proofing and editioning: Jim Baughman, Michael Cascadden, Ken Farley,
 Scott Griffith, Karoline McKay, Mark Mahaffey, Carlos Moreno, James
 Reid, Carmen Schilaci, Cecil Schmidt, Mark Schultz, Claudio Stickar

114 *Eidid III*, 1991
1-color etching on Fabriano Murillo paper
Size: 25¹/₄″ × 30³/₄″ (64.14 × 78.11 cm)
Edition size: 54, 10 AP, 15 other proofs
Gemini I.D. no. RS90-3185; Catalogue Raisonné no. 1557
Project management: James Reid, Claudio Stickar
Proofing and editioning: Mark Mahaffey, Claudio Stickar

115 *Heimaey I*, 1991
1-color etching on Fabriano Murillo paper
Size: 23¹/₄″ × 24¹/₄″ (59.05 × 61.6 cm)
Edition size: 49, 10 AP, 13 other proofs
Gemini I.D. no. RS90-3177; Catalogue Raisonné no. 1549
Project management: James Reid, Claudio Stickar
Proofing and editioning: Mark Mahaffey, Claudio Stickar

116 *Heimaey II*, 1991
1-color etching on Fabriano Murillo paper
Size: 23³/₈″ × 24¹/₄″ (59.39 × 61.6 cm)
Edition size: 49, 10 AP, 15 other proofs
Gemini I.D. no. RS90-3178; Catalogue Raisonné no. 1550
Project management: James Reid, Claudio Stickar

117 *Heimaey III*, 1991
1-color etching on Fabriano Murillo paper
Size: 23⁷/₈″ × 23³/₄″ (60.62 × 60.32 cm)
Edition size: 45, 10 AP, 11 other proofs
Gemini I.D. no. RS90-3179; Catalogue Raisonné no. 1551
Project management: James Reid, Claudio Stickar
Proofing and editioning: Jim Baughman, Michael Cascadden, Ken Farley,
 Scott Griffith, Karoline McKay, Mark Mahaffey, Carlos Moreno, James
 Reid, Carmen Schilaci, Cecil Schmidt, Mark Schultz, Claudio Stickar

118 *Hreppholar I*, 1991
1-color intaglio construction on Fuji DHM-14 and Meirat Velasquez
 handmade papers
Size: 31¹/₄″ × 37¹/₂″ (79.37 × 95.25 cm)
Edition size: 36, 10 AP, 15 other proofs
Gemini I.D. no. RS90-3169; Catalogue Raisonné no. 1542
Project management: James Reid, Claudio Stickar
Proofing and editioning: Jim Baughman, Michael Cascadden, Ken Farley,
 Scott Griffith, Karoline McKay, Mark Mahaffey, Carlos Moreno, James
 Reid, Carmen Schilaci, Cecil Schmidt, Mark Schultz, Claudio Stickar

119 *Hreppholar II*, 1991
1-color intaglio construction on Fuji DHM-14 and Meirat Velasquez
 handmade papers
Size: 35″ × 45″ (88.9 × 114.3 cm)
Edition size: 35, 10 AP, 16 other proofs
Gemini I.D. no. RS90-3175; Catalogue Raisonné no. 1548
Project management: James Reid, Claudio Stickar
Proofing and editioning: Jim Baughman, Michael Cascadden, Ken Farley,
 Scott Griffith, Karoline McKay, Mark Mahaffey, Carlos Moreno, James
 Reid, Carmen Schilaci, Cecil Schmidt, Mark Schultz, Claudio Stickar

120 *Hreppholar III*, 1991
1-color intaglio construction on Fuji DHM-14 and Meirat Velasquez
 handmade papers
Size: 33″ × 42″ (83.82 × 106.68 cm)
Edition size: 38, 10 AP, 20 other proofs
Gemini I.D. no. RS90-3170; Catalogue Raisonné no. 1543
Project management: James Reid, Claudio Stickar
Proofing and editioning: Jim Baughman, Michael Cascadden, Ken Farley,
 Scott Griffith, Karoline McKay, Mark Mahaffey, Carlos Moreno, James
 Reid, Carmen Schilaci, Cecil Schmidt, Mark Schultz, Claudio Stickar

121 *Hreppholar IV*, 1991
1-color intaglio construction on Fuji DHM-14 and Meirat Velasquez
 handmade papers
Size: 31¹/₄″ × 39³/₄″ (79.37 × 100.96 cm)
Edition size: 35, 10 AP, 15 other proofs
Gemini I.D. no. RS90-3171; Catalogue Raisonné no. 1544
Project management: James Reid, Claudio Stickar
Proofing and editioning: Jim Baughman, Michael Cascadden, Ken Farley,
 Scott Griffith, Karoline McKay, Mark Mahaffey, Carlos Moreno, James
 Reid, Carmen Schilaci, Cecil Schmidt, Mark Schultz, Claudio Stickar

122 *Hreppholar V*, 1991
1-color intaglio construction on Fuji DHM-14 and Meirat Velasquez
 handmade papers
Size: 35″ × 44″ (88.9 × 111.76 cm)
Edition size: 36, 10 AP, 14 other proofs
Gemini I.D. no. RS91-3182; Catalogue Raisonné no. 1554
Project management: James Reid, Claudio Stickar
Proofing and editioning: Mark Mahaffey, Claudio Stickar

123 *Hreppholar VI*, 1991
1-color intaglio construction on Fuji DHM-14 and Meirat Velasquez
 handmade papers
Size: 34³/4″ × 43¹/4″ (88.26 × 109.85 cm)
Edition size: 36, 10 AP, 10 other proofs
Gemini I.D. no. RS90-3168; Catalogue Raisonné no. 1541
Project management: James Reid, Claudio Stickar
Proofing and editioning: Jim Baughman, Michael Cascadden, Ken Farley,
 Scott Griffith, Karoline McKay, Mark Mahaffey, Carlos Moreno, James
 Reid, Carmen Schilaci, Cecil Schmidt, Mark Schultz, Claudio Stickar

124 *Hreppholar VII*, 1991
1-color intaglio construction on Fuji DHM-14 and Meirat Velasquez
 handmade papers
Size: 31¹/4″ × 42″ (78.89 × 106.68 cm)
Edition size: 35, 10 AP, 13 other proofs
Gemini I.D. no. RS90-3167; Catalogue Raisonné no. 1540
Project management: James Reid, Claudio Stickar
Proofing and editioning: Jim Baughman, Michael Cascadden, Ken Farley,
 Scott Griffith, Karoline McKay, Mark Mahaffey, Carlos Moreno, James
 Reid, Carmen Schilaci, Cecil Schmidt, Mark Schultz, Claudio Stickar

125 *Hreppholar VIII*, 1991
1-color intaglio construction on Fuji DHM-14 and Meirat Velasquez
 handmade papers
Size: 34³/4″ × 43¹/4″ (88.26 × 109.85 cm)
Edition size: 35, 10 AP, 15 other proofs
Gemini I.D. no. RS90-3172; Catalogue Raisonné no. 1545
Project management: James Reid, Claudio Stickar
Proofing and editioning: Jim Baughman, Michael Cascadden, Ken Farley,
 Scott Griffith, Karoline McKay, Mark Mahaffey, Carlos Moreno, James
 Reid, Carmen Schilaci, Cecil Schmidt, Mark Schultz, Claudio Stickar

126 *Iceland*, 1991
1-color intaglio construction on Meirat Velasquez and Fuji DHM-14
 handmade papers
Size: 35¹/4″ × 55¹/2″ (90.17 × 140.97 cm)
Edition size: 46, 12 AP, 16 other proofs
Gemini I.D. no. RS90-3174; Catalogue Raisonné no. 1547
Project management: James Reid, Claudio Stickar
Proofing and editioning: Scott Griffith, Mark Mahaffey, Cecil Schmidt, Mark
 Schultz, Claudio Stickar

127 *Vesturey I*, 1991
1-color intaglio construction on Meirat Velasquez handmade and Fabriano
 Murillo papers
Size: 71¹/4″ × 35¹/4″ (180.98 × 89.54 cm)
Edition size: 35, 10 AP, 9 other proofs
Gemini I.D. no. RS90-3173; Catalogue Raisonné no. 1546
Project management: James Reid, Claudio Stickar
Proofing and editioning: Jim Baughman, Michael Cascadden, Scott Griffith,
 Mark Mahaffey, Carlos Moreno, Carmen Schilaci, Cecil Schmidt, Mark
 Schultz, Claudio Stickar

128 *Vesturey II*, 1991
1-color intaglio construction on Meirat Velasquez handmade and Fabriano
 Murillo papers
Size: 71¹/4″ × 35¹/4″ (180.98 × 89.54 cm)
Edition size: 35, 10 AP, 19 other proofs
Gemini I.D. no. RS91-3180; Catalogue Raisonné no. 1552
Project management: James Reid, Claudio Stickar
Proofing and editioning: Scott Griffith, Mark Mahaffey, Carmen Schilaci,
 Cecil Schmidt, Mark Schultz, Claudio Stickar

129 *Vesturey III*, 1991
1-color intaglio construction on Meirat Velasquez handmade and Fabriano
 Murillo papers
Size: 71¹/4″ × 35¹/4″ (180.98 × 89.54 cm)
Edition size: 35, 10 AP, 9 other proofs
Gemini I.D. no. RS91-3181; Catalogue Raisonné no. 1553
Project management: James Reid, Claudio Stickar
Proofing and editioning: Scott Griffith, Mark Mahaffey, Mark Schultz,
 Claudio Stickar

Paintstiks 1990 (nos. 130–134)

130 *Double Black*, 1990
Paintstik on Fuji DHM-14 handmade coated paper
Size: 2 panels; overall 6′1″ × 11′ (185.42 × 335.28 cm)
Edition size: 20, 8 AP, 4 other proofs
Gemini I.D. no. RS90-5191; Catalogue Raisonné no. 1488
Project management: Ron McPherson
Proofing and editioning: Julie Bach, John Fitzgerald, Ken Herrand, Joe
 Lewandowski, Edan McPherson, Ron McPherson

131 *Esna*, 1990
Paintstik on Fuji DHM-14 handmade coated paper
Size: 2 panels; overall 76¹/2″ × 76¹/2″ (194.31 × 194.31 cm)
Edition size: 31, 8 AP, 8 other proofs
Gemini I.D. no. RS90-5193; Catalogue Raisonné no. 1490
Project management: Ron McPherson
Proofing and editioning: Joe Lewandowski, Edan McPherson, Ron
 McPherson

132 *Reykjavik*, 1991
Paintstik on Fuji DHM-14 handmade coated paper
Size: 67″ × 76¹/2″ (170.18 × 194.31 cm)
Edition size: 46, 8 AP, 13 other proofs
Gemini I.D. no. RS90-5195; Catalogue Raisonné no. 1492
Project management: Ron McPherson
Proofing and editioning: Julie Bach, John Fitzgerald, Ken Herrand, Joe
 Lewandowski, Edan McPherson, Ron McPherson, Quin Roberts

133 *Spike*, 1990
Paintstik on Fuji DHM-14 handmade coated paper
Size: 11′6″ × 7′11¹/2″ (350.52 × 242.57 cm)
Edition size: 10, 4 AP, 2 other proofs
Gemini I.D. no. RS90-5194; Catalogue Raisonné no. 1491
Project management: Ron McPherson
Proofing and editioning: Joe Lewandowski, Edan McPherson, Ron
 McPherson, Jeff Podolski

134 *Untitled*, 1990
Paintstik on Fuji DHM-14 handmade coated paper
Size: 2 panels; overall 6′7″ × 12′8″ (200.66 × 386.08 cm)
Edition size: 20, 8 AP, 4 other proofs
Gemini I.D. no. RS90-5192: Catalogue Raisonné no. 1489
Project management: Ron McPherson
Proofing and editioning: Julie Bach, John Fitzgerald, Ken Herrand, Joe
 Lewandowski, Edan McPherson, Ron McPherson

Videy Afangar Series (nos. 135–144)

135 *Videy Afangar #1*, 1991
1-color etching on German etching white
Size: 10¹/2″ × 12″ (26.67 × 30.48 cm)
Edition size: 75, 20 AP, 17 other proofs
Gemini I.D. no. RS90-3157; Catalogue Raisonné no. 1510
Project management: James Reid, Claudio Stickar
Proofing and editioning: Jim Baughman, Michael Cascadden, Ken Farley,
 Scott Griffith, Karoline McKay, Mark Mahaffey, Carlos Moreno, James
 Reid, Carmen Schilaci, Cecil Schmidt, Mark Schultz, Claudio Stickar

136 *Videy Afangar #2*, 1991
1-color etching on German etching white
Size: 10¹/2″ × 12″ (26.67 × 30.48 cm)
Edition size: 75, 20 AP, 15 other proofs
Gemini I.D. no. RS90-3158; Catalogue Raisonné no. 1511
Project management: James Reid, Claudio Stickar
Proofing and editioning: Jim Baughman, Michael Cascadden, Ken Farley,
 Scott Griffith, Karoline McKay, Mark Mahaffey, Carlos Moreno, James
 Reid, Carmen Schilaci, Cecil Schmidt, Mark Schultz, Claudio Stickar

137 *Videy Afangar #3*, 1991
1-color etching on German etching white
Size: 10¹/₂″ × 12″ (26.67 × 30.48 cm)
Edition size: 75, 20 AP, 17 other proofs
Gemini I.D. no. RS90-3159; Catalogue Raisonné no. 1512
Project management: James Reid, Claudio Stickar
Proofing and editioning: Jim Baughman, Michael Cascadden, Ken Farley,
 Scott Griffith, Karoline McKay, Mark Mahaffey, Carlos Moreno, James
 Reid, Carmen Schilaci, Cecil Schmidt, Mark Schultz, Claudio Stickar

138 *Videy Afangar #4*, 1991
1-color etching on German etching white
Size: 10¹/₂″ × 12″ (26.67 × 30.48 cm)
Edition size: 75, 20 AP, 12 other proofs
Gemini I.D. no. RS90-3160; Catalogue Raisonné no. 1513
Project management: James Reid, Claudio Stickar
Proofing and editioning: Jim Baughman, Michael Cascadden, Ken Farley,
 Scott Griffith, Karoline McKay, Mark Mahaffey, Carlos Moreno, James
 Reid, Carmen Schilaci, Cecil Schmidt, Mark Schultz, Claudio Stickar

139 *Videy Afangar #5*, 1991
1-color etching on German etching white
Size: 10¹/₂″ × 12″ (26.67 × 30.48 cm)
Edition size: 75, 20 AP, 18 other proofs
Gemini I.D. no. RS90-3161; Catalogue Raisonné no. 1514
Project management: James Reid, Claudio Stickar
Proofing and editioning: Jim Baughman, Michael Cascadden, Ken Farley,
 Scott Griffith, Karoline McKay, Mark Mahaffey, Carlos Moreno, James
 Reid, Carmen Schilaci, Cecil Schmidt, Mark Schultz, Claudio Stickar

140 *Videy Afangar #6*, 1991
1-color etching on German etching white
Size: 10¹/₂″ × 12″ (26.67 × 30.48 cm)
Edition size: 75, 20 AP, 9 other proofs
Gemini I.D. no. RS90-3162; Catalogue Raisonné no. 1515
Project management: James Reid, Claudio Stickar
Proofing and editioning: Jim Baughman, Michael Cascadden, Ken Farley,
 Scott Griffith, Karoline McKay, Mark Mahaffey, Carlos Moreno, James
 Reid, Carmen Schilaci, Cecil Schmidt, Mark Schultz, Claudio Stickar

141 *Videy Afangar #7*, 1991
1-color etching on German etching white
Size: 10¹/₂″ × 12″ (26.67 × 30.48 cm)
Edition size: 75, 20 AP, 17 other proofs
Gemini I.D. no. RS90-3163; Catalogue Raisonné no. 1516
Project management: James Reid, Claudio Stickar
Proofing and editioning: Jim Baughman, Michael Cascadden, Ken Farley,
 Scott Griffith, Karoline McKay, Mark Mahaffey, Carlos Moreno, James
 Reid, Carmen Schilaci, Cecil Schmidt, Mark Schultz, Claudio Stickar

142 *Videy Afangar #8*, 1991
1-color etching on German etching white
Size: 12³/₄″ × 14¹/₄″ (32.38 × 36.19 cm)
Edition size: 75, 20 AP, 13 other proofs
Gemini I.D. no. RS90-3164; Catalogue Raisonné no. 1517
Project management: James Reid, Claudio Stickar
Proofing and editioning: Jim Baughman, Michael Cascadden, Ken Farley,
 Scott Griffith, Karoline McKay, Mark Mahaffey, Carlos Moreno, James
 Reid, Carmen Schilaci, Cecil Schmidt, Mark Schultz, Claudio Stickar

143 *Videy Afangar #9*, 1991
1-color etching on German etching white
Size: 13¹/₂″ × 10¹/₂″ (34.29 × 26.67 cm)
Edition size: 75, 20 AP, 14 other proofs
Gemini I.D. no. RS90-3165; Catalogue Raisonné no. 1518
Project management: James Reid, Claudio Stickar
Proofing and editioning: Mark Mahaffey, James Reid, Mark Schultz, Claudio
 Stickar

144 *Videy Afangar #10*, 1991
1-color etching on German etching white
Size: 11″ × 12″ (27.94 × 30.48 cm)
Edition size: 75, 20 AP, 13 other proofs
Gemini I.D. no. RS90-3166: Catalogue Raisonné no. 1519
Project management: James Reid, Claudio Stickar
Proofing and editioning: Mark Mahaffey, James Reid, Mark Schultz, Claudio
 Stickar

145 *Fuck Helms*, 1990
1-color screenprint with embossment on Arches Cover buff
Size: 14″ × 15″ (35.56 × 38.1 cm)
Edition size: 250, 50 AP, 16 other proofs
Gemini I.D. no. RS90-1245; Catalogue Raisonné no. 1454
Project management: James Reid
Proofing and editioning: Stan Baden, Jim Baughman, Ken Farley
Published for the Harvey Gantt Campaign

Saul Steinberg
Born 1914, Bucharest, Romania
Resides New York, NY

146 *Legs*, 1992
6-color etching on Rives BFK white
Size: 21¹/₄″ × 25³/₄″ (53.98 × 65.41 cm)
Edition size: 50, 8 AP, 7 other proofs
Gemini I.D. no. ST83-3106; Catalogue Raisonné no. 1563
Project management: Ken Farley, Doris Simmelink
Proofing and editioning: Ken Farley, Doris Simmelink

Designed by Nathan Garland.

All color reproductions were photographed
by the Douglas M. Parker Studio.

All photographs of the artists and of Gemini G.E.L.,
unless otherwise noted, are by Sidney B. Felsen.

Set in Janson by the Southern New England
Typographic Service, Incorporated.